The World of Delacroix

TIME-LIFE LIBRARY OF ART

The World of Delacroix

1798-1863

by Tom Prideaux
and
the Editors of TIME-LIFE BOOKS

TIME-LIFE BOOKS B.V.

About the Author:

Tom Prideaux came to his interest in Eugène Delacroix through reading the painter's *Journal*, with its many observations on music and theater. For more than 25 years an editor and drama critic for LIFE, Mr. Prideaux retired from that magazine in 1970 to become a full-time freelance writer.

The Consulting Editor:

H. W. Janson is Professor of Fine Arts at New York University. Among his numerous books and publications are his definitive *History of Art*, which ranges from prehistory to the present day, *The Sculpture of Donatello* and *The Story of Painting for Young People*, which he co-authored with his wife.

Cover:

A detail from Delacroix's 1824 painting *Massacre at Chios* shows one of the marauding Turkish horsemen reining in his nervous steed.

End Papers:

Front: This sheet of pen sketches is one of many preparatory studies Delacroix made for his enormous composition, *Death of Sardanapalus*. *Back:* An undated watercolor shows the corner of one of Delacroix's many Paris studios.

Contents

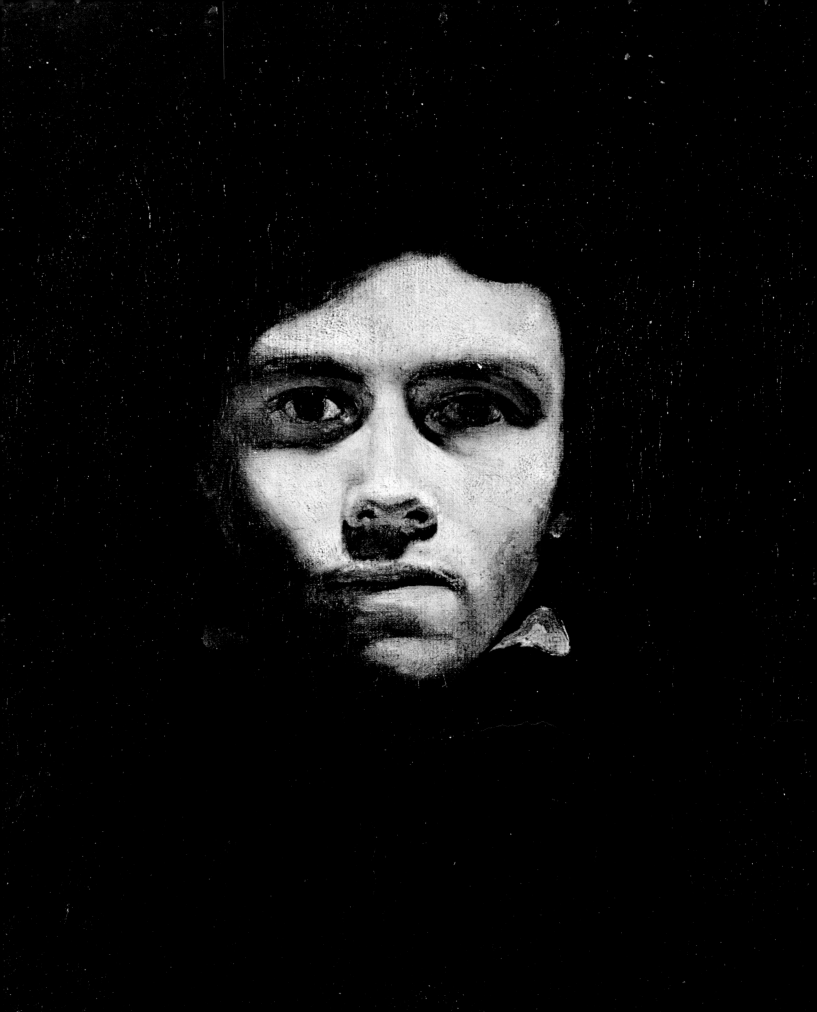

I

The Great Romantic

On a winter night in Paris in 1859 Eugène Delacroix attended a grand ball given by the Emperor Napoleon III to celebrate the marriage of his cousin to Princess Clotilde of Savoy. More than 8,000 guests swept through the Hôtel de Ville, met on the splendid stairways, whirled in the ballrooms, and chatted in the alcoves. According to a Paris journal of the day, the scene was a glory of brilliant lights and white lilac. During the evening Delacroix was sought out by the composer Daniel Auber, who told him that one of the Napoleonic princesses had asked to see him: she wanted to meet the great artist.

What the Princess saw, moving toward her through the crowd, was a man whom his friends and enemies never tired of describing. They spoke almost warningly of his "pale olive complexion . . . thick dark hair . . . fierce eyes . . . feline expression . . . magnificent teeth . . . wild, strange, exotic, almost disquieting beauty . . . velvety and winning, like one of those tigers whose supple, formidable grace he excelled at rendering." They compared him to an educated Maharajah, and to Montezuma. They called him "a volcanic crater artistically concealed behind bouquets of flowers." They said he exuded a diabolic smell of sulphur. If all this were true, the Princess might have imagined herself being clawed, chewed, suffocated, and boiled in lava, and might have run screaming from the hall. But when she was confronted with her great artist, he gave her a disarming smile and cut himself down by saying, "You see, he is not very big."

Today Delacroix's stature in the world of art is assured, but the paradoxes of his personality and talent have always made him hard to know. Called "the Great Romantic," he insisted he was a pure classicist. Caught up in the revolutionary ferment of his world, he remained aristocratically aloof. His outward reserve masked passionate inner fires. He could be a lover of women and an ascetic; a gadabout and a work fanatic; an adept at social trivia and a man of wide-ranging erudition whose personal journal—certainly among the most remarkable ever kept by an artist—revealed not only his mastery of esthetics but an impressive grasp of music, theater and literature, and acuity as a critic.

"The wickedness of my expression," the 20-year-old Delacroix once commented, "almost frightens me." Still one year away from his first commission, the restless youth spent much time in Théodore Géricault's studio, where this somber portrait was painted.

Théodore Géricault:
Portrait of Eugène Delacroix, c. 1818

Delacroix stood at an abrupt swerve in the course of art. To painters of the next generation, sunlight on a water lily would be more important than the slaughter of Greek freedom fighters; private experience and individual sensation were to be the new creed. Delacroix was the last major painter with a sure feel and ardor for subject matter: myth, allegory, high drama, historical event. Yet he was able to synthesize his sense of membership in the whole world with his own strong individualism. He was the last painter in whom the humanist Renaissance conception of man as a totality manifested itself with poetic fervor. He was the last painter who moved freely from myth to modern reality, a cosmopolite in time and space who reached out to hold past and future in one embrace.

The past, that night of Napoleon's ball, was represented in considerable glory on the very ceiling below which beautiful Parisiennes in crinolines danced to the new waltzes of Offenbach. Looking down on the guests in the Salon de la Paix were Venus, Jupiter, Cybele and Hercules, along with allegorical figures of Peace and Abundance and a full choir of the Muses. Delacroix had been commissioned to paint this ceiling in 1851, and, by preference, he had turned for his theme to the gods and goddesses of antiquity. To him they were fixed stars; they personified timeless truths. If the people on the ceiling had been invited down to join the ball, it would have been Delacroix who welcomed them most cordially and naturally, who would have congratulated Hercules on his labors and led Venus to the waltz.

The future, that same night, took the form of 19-year-old Odilon Redon, who, along with his younger brother, had come up to Paris from Bordeaux and had somehow managed to be present at the party. Soon to become a Symbolist painter of strange charm, Odilon was manifestly awed by the sight of Delacroix. "All evening," he recalled years later, "we followed him from group to group in order to hear every word. . . . When he left the ball my brother and I still wanted to see more of him, so we walked behind him through the streets. . . . There had been a rain, and I remember how he picked his steps to avoid the wet places. But when he reached the house on the Right Bank where he had lived for so many years, he seemed to realize that he had taken his way toward it out of habit, and he turned back and walked, still slowly and pensively, through the city and across the river, to the Rue de Fürstenberg."

Redon told this story many times, with varying details. But he always claimed that Delacroix wandered off toward his former studio in a spell of absent-mindedness. Other writers on Delacroix, intrigued by this same little episode, believe he may have been going to visit his cousin and onetime mistress, the Baronne Joséphine de Forget, whose house was only a few steps from his old quarters. Be that as it may, the image of Delacroix walking the dark streets alone after the glitter of the ball is a compelling one. It epitomizes the dual Delacroix, his outer and inner needs, the public and private man. Compelling, too, is the image of the boys from Bordeaux, watching excitedly as he stops to examine a poster in a shop window, hoping he won't look back and discover them. In the same vein Delacroix was to exert his fascination on many others in the succeeding generations of painters—Manet, Monet, Cézanne, Van Gogh,

Matisse, Picasso—impelling them to follow along his way. Modern art, that night in 1859, was sniffing at his heels.

Since Delacroix has been inexorably labeled a Romantic, it will be useful to consider what the term really means. The word "romantic" first appeared in the English language in the mid-17th Century, in reference to romances—tales of wild adventure and chivalrous sentiments. For a while it was in ill repute, connoting false emotionalism, bombast and general wooziness. Gradually, however, the word became an honest woman, still rather flighty, but conveying something attractive and pleasing to the imagination.

Beyond this accepted definition, however, "romantic" had a special meaning determined by the historical circumstances of the era in which the word came into common use, and to which, indeed, it was generally applied: the end of the 18th Century and the first half of the 19th. The overriding problem of the Romantic period was to create a new world on the wreckage of the old. With a shattering impact, the stage had been blasted clean by the French Revolution; the authority symbols of God and King had been toppled. Now, as never before, was the time for innovation, experiment, new social systems, Utopias, new concepts of morality, forays into the supernatural and the morbid, and even probings into the subconscious—by means of opium and hypnotism—that pointed the way for Freud. A surge of energy was released, not always wisely, but with boundless hope and zeal; one notable example of a romantic enterprise was the settling of the American West. A Romantic, then, was one who had broken loose from the rigid controls of the past, and felt free to move ahead. Here is the nub of our meaning: Romanticism was an attitude of mind that was not inclined to recognize limits.

The Romantic intelligence was sharply aware of antitheses, and groped toward synthesis. In contrast to today's existentialist, who holds that in a world devoid of meaning it is man's job to create his own meanings, the Romantic felt that the world was full of meanings if he could only see it whole. With his do-it-yourself kit, the existentialist must make his own universe. The Romantic usually assumed that God had already done a lot of the work.

Nothing, however, could be more misleading than the notion that a Romantic was a dreamer rather than a doer. On the contrary, his awareness of possibilities, of things to be done, urged him into action, just as his way of paradox-boxing toned up his intellectual muscles for hard work. As Jacques Barzun reminds us, the output of such men as Sir Walter Scott, Victor Hugo, Hector Berlioz, Alexandre Dumas and, considering their short lives, of Byron, Keats and Shelley, was prodigious. Delacroix himself was demoniacally industrious, turning out more than 850 paintings, not including his many murals, and thousands of watercolors, drawings and sketches. Not much time for dreaming.

To see Delacroix in the context of his own period is essential but not enough. He must also be understood in the stream of French painting in the centuries just preceding. This stream was composed of two currents, more often than not running directly counter to each other. While entire volumes have been written on the subject, the basic differences

The 19th Century conflict between classical and Romantic painters, which climaxed during Delacroix's day, is satirized in this cartoon of 1833. The classicist, dressed with Puritan severity, stands by his picture, a simply framed linear study of a nude warrior. The bearded Romantic, bedecked as a dandy, carries an elaborately carved baroque frame for his tiny, crowded canvas.

between the two can perhaps be measured most simply as the distance between the rational and the irrational, the disciplined and the untrammeled, the explicit and the implicit, the well-ordered and the vague.

The first current flowed from the fountainhead of Greece and Rome, producing the stately dramas of Corneille, the rationalistic philosophy of Descartes, and, in painting, the serene vistas of Nicolas Poussin. Poussin's enchanted suburbs, peopled with gods and mortals calmly wending their way among temples and shrines, were not intended to enchant so much as to edify. They were moral lessons, maxims, guides for ethical conduct. They were reminders that time is fleeting, ambition vain, and simple virtue is what really matters—all of which had its effect on 17th Century viewers who had begun to worry about grace and salvation.

The second strain in French painting sprang spontaneously from such men as Antoine Watteau, Nicolas Lancret, Jean-Honoré Fragonard and François Boucher, who during the 18th Century decorated the walls of Parisian public buildings and town houses with nymphs and swains, cupids and roses, flung together for no other purpose than to ravish the senses and create a boudoir euphoria. Among these gifted spellbinders the finest by far was Watteau, a poet of the evanescent, whose brush was dipped in the rose-gold of twilight. His haunted harlequins, gazing at us with a tragic prescience, give us a sense of unease: beyond the laughter of the dancers and the tinkle of mandolins we hear the thud of the guillotine.

Delacroix was to embrace both Poussin and Watteau. He considered Poussin unique as a scrupulous observer of history; he kept a Watteau painting (proved later to be a copy) hanging in his studio to the end of his life. The 18th Century Encyclopedist Denis Diderot had railed against works which he deemed to be a feast to the eye but a famine to the spirit, crying: "First move me, astonish me, break my heart, let me tremble, weep, stare, be enraged—only then regale my eyes." Delacroix, a century later, sprang to the defense, declaring: "The first merit of a picture is to be a feast for the eyes." Then, however, he characteristically conceded the inadequacy of this point of view, adding: "That is not to say that reason is not needed in it. . . . In many people, the eye is false or inert." These sentences were penciled in a sketchbook a few weeks before he died; until the last, Delacroix was trying to reconcile opposites, to see art whole.

Up to a few decades before Delacroix's birth in 1798, the sparkling rococo elegance of Watteau and his followers predominated in French painting. But as the 18th Century drew to an end, the time came to dismiss the valentine shepherdesses, dispatch the cupids, and sweep up the rose petals. It was closing time in Arcadia. The foreboding visions of Watteau's harlequins were coming true. Restive mobs muttered in the streets. Citizens long outraged at the extravagance of the court of Louis XVI and its chill unconcern for the common welfare had at last gathered enough strength to strike. In art, the rational, moralistic current began to reassert itself. And with it, on the eve of the Revolution, appeared the painter Jacques-Louis David, who was to become the

prime exponent of the new classicism and, after the fall of the Bourbon monarchy, dictator of the arts in France.

As a young student, David had won the opportunity to steep himself in antiquity on its own home ground by capturing the first prize in painting annually awarded by the Académie des Beaux-Arts—the Prix de Rome, which permitted him to live and study in Italy under a royal scholarship from the French King. In five years there he absorbed the lessons of classical times in everything from sculpture and architecture to ornaments and household furnishings, and he grew familiar with the stories of all the great personages of the past from Socrates to Belisarius. His mind became a storehouse of classical lore, and within a few years after his return home he put it to powerful use. In 1785, as Revolutionary fevers began to run high, he ignited his countrymen with the *Oath of the Horatii*, which depicted a Roman nobleman and his sons swearing to fight to defend Rome against the enemy city of Alba, the stronghold of the Curiatii clan, even though the two families had intermarried. With its stern call to sacrifice private interest for public good, the *Oath* was as rousing as a recruiting poster *(page 22)*. Beyond its impact as propaganda, the painting, with its precisely rendered noble figures modeled as fully as statues in the round, represented a dynamic shift from the merely decorative wraiths of the rococo style. Art critics hailed David as "Messiah," and pronounced the *Oath* "the most beautiful picture of the century."

In the year of the Revolution itself, 1789, David forged another propaganda weapon, another modern parable in classic dress, in the *Lictors Bringing Back to Brutus the Bodies of His Sons*, who had been executed at Brutus' own order for betraying the Roman Republic. But once the Revolution was accomplished fact, David took a temporary leave from the ancient world and began to chronicle the events of his own time. In the *Oath of the Tennis Court*, which was projected as a huge painting but never was completed, he memorialized the first overt, organized act of resistance against Louis XVI, when a group of wildly gesturing commoners, along with some sympathizers from the clergy and nobility, met in an indoor tennis court in Versailles and swore never to separate until they had won a constitution for France. In the *Death of Marat*, David showed the fiery pamphleteer of the Revolution as he lay, murdered, in the tin tub where he had soaked himself to soothe a terrible skin disease (acquired as a result of hiding out from his foes in the Paris sewers); in his hand is the note by which his young assassin, Charlotte Corday, insinuated herself into his presence, allegedly to report on anti-Revolutionary activities in her home town of Caen *(page 23)*. This painting, perhaps because of its reproduction in so many school texts, has often been dismissed as a dull old chestnut. In fact, it is a masterpiece of stark tragedy, demonstrating David's ability to purify his art into a simple statement of form in space.

David continued to show his reportorial bent, although in more elaborate fashion, when a strutting Corsican general took over as First Consul of the French and soon afterward as their new Emperor. For Napoleon, David produced some magnificent set-pieces celebrating such

events as his bestowal of a crown on himself and on Josephine and his award of commissions to his officers. David and lesser artists thrived handsomely under Napoleon's aegis. The downfall of Louis XVI had put an end to court patronage, but Napoleon took pains to assure that art should not lose caste. Like empire-builders before and since, he put a high value on art as a means of enhancing his own image and that of his regime, and he imbued his countrymen with the idea that artists deserved both honor and subsidies.

The Emperor's beneficent influence on art took many forms. He hired painters to record his own flamboyant career in detail; he stocked French museums with the spoils of conquest from Belgium, Germany, Spain and, most notably, from his campaigns in Italy. Great works of art, selected by a commission of specialists, were yielded up by the Italians under the terms of armistice or as payment in place of taxes. Napoleon was a connoisseur as well as a pillager; among his trophies were the *Venus de' Medici*, the *Laocoön*—triumphantly brought to the Louvre by chariot—and a host of priceless Renaissance works which, until their return to their former owners after Napoleon's downfall, were to provide firsthand inspiration for French painters.

Except for two brief terms in jail, incurred as a result of backing the losing side in a Revolutionary factional fight, David held sway as ringmaster of French artistic activity from the start of the Revolution until the end of Napoleon's reign. His word was law and his touch evident in all matters deemed worthy of esthetic attention, from the staging of Marat's funeral to the planning of triumphal parades; David gave his personal supervision even to the weaving of victory garlands. Of more lasting import, the neoclassical movement which he led transformed, for a time, the entire French way of life. France derived intense satisfaction from comparing itself to imperial Rome. Women gave up their corsets and high heels in favor of flowing garb and bacchante hairdos. Men put aside their powdered wigs and cropped their heads close in the manner of the Emperor Titus (and Napoleon). Children were named Gracchus and Scaevola. Table legs were disguised as Roman columns, headboards of beds as pediments. The new diggings at Pompeii and Herculaneum helped spur the new fashions, but the French had an arbiter closer to home; if anyone wanted to know how a Roman looked or acted, he had but to study the perfect details in a David painting.

After Waterloo and the restoration of the Bourbon monarchy in 1815, David was banished to Brussels, where he died in 1825. But while his person could be removed, his influence would be felt for long decades. Years later Delacroix saluted him as a "singular composite of realism and the ideal . . . the father of the whole modern school, in painting and in sculpture," adding, "He still reigns in some respects and, despite certain apparent transformations in the taste of what is the school today, it is manifest that everything still derives from him and from his principles."

Among the transformations noted by Delacroix, some were wrought by less talented disciples of David, who continued to paint Davidian

This anonymous cartoon of the early 19th Century shows the classical craze at its height: the tragic actor Talma is teaching Napoleon how to stand like a true Roman emperor. The position Napoleon tries ineffectually to learn is the basic *contrapposto* stance, adapted from Greek statuary, in which hips, head and shoulders twist away from one another to give a feeling of action and vitality to the body.

pictures that emphasized his neoclassical precision without his power or warmth. It was these stilted academicians, becoming more fiercely defensive as they felt their forces waning, whom Delacroix and his more vigorous contemporaries had to combat.

Eugène Delacroix was born in a Paris suburb then called Charenton-Saint-Maurice, close to the River Seine. His mother, Victoire Oeben, came from a noted family of royal cabinetmakers called *ébénistes*. His father, Charles, was an upper bourgeois who began his career as a schoolteacher, became secretary to a provincial governor, then plunged himself into the Revolution and voted for the execution of King Louis XVI in 1793. In 1795, under the new regime, he was appointed Minister for Foreign Affairs, and after a year and a half became Ambassador of the French Republic to Holland. He was, indeed, at his post there when Victoire gave birth to Eugène.

Curious circumstances surrounded the birth, and merit a close look. Charles was then 57, Victoire 40. They had been married for two decades, and had three much older children, Charles, Henriette and Henri. Although their relations were amicable, the parents had not lived as man and wife for years; in the Delacroix circle it was well known that Charles had been deprived of "all the advantages of virility" because of a tumor on his testicles.

On September 14, 1797, Charles underwent a major operation, lasting two and a half hours, to have the tumor removed—a harrowing ordeal in those days before anesthesia. The operation was performed in Paris after a luncheon party at which the patient himself played the genial host. Years later Eugène wrote with special pride of the courage this took, describing Charles as "previously lunching with friends and physicians, then directing the workers. . . . The operation was done in five stages. He said after the fourth: 'My friends, here are four acts done—may the fifth not be a tragedy.'"

The fifth act ended happily: the patient recovered.

Two months later, on November 12, in the presence of servants as witnesses, Charles and Victoire—by now obviously pregnant—signed a document that described the operation and announced the patient's return to complete health.

In December a brochure was published "by order of the Government," written by a surgeon and genital specialist, describing the operation on Citizen Charles Delacroix. It was reprinted—and the tumor illustrated—in a government periodical, *Le Moniteur Universel*, on April 13, 1798.

Eugène was born on the 26th of that month, barely seven months after Charles's operation. The baby was presumed to be premature, and the subject was closed.

Some scholars of Delacroix accept these facts at their face value. Others, however, assert that his real father was none other than the aristocratic Charles Maurice de Talleyrand, who had thrown in his lot with the Revolutionists and who was to become the most brilliant statesman of 19th Century Europe. Talleyrand was 13 years younger than Charles Delacroix, lived in his house at one time, and was responsible

for his appointment to the embassy in Holland after he himself had taken over the Ministry of Foreign Affairs.

Exponents of the Talleyrand theory argue that the operation to which Charles Delacroix suddenly submitted himself after he had borne with his affliction for years may have been a gallant strategem to protect the family honor. They also argue that the unprecedented but timely publication of the details of the operation—in a government periodical over which Talleyrand as a high official may have had influence—may have been Talleyrand's part in a campaign to convince Paris that Delacroix senior could once more father a child (and, coincidentally, to absolve himself). In a time when social mores set great store by surface appearances, such intricate maneuvers were not unthinkable.

Finally, there are those who call attention to the cogent matter of physical similarities. René Huyghe, in his massive biography of Delacroix, comments: "That the painter's features have hardly any resemblance to those of Charles Delacroix, or indeed to his mother's, whereas his distant bearing, the proud and aristocratic set of his head, his 'constrained smile,' his 'yellowish pallor' and his whole cast of features irresistibly suggest the illustrious diplomat, is obvious to anyone who compares their portraits."

Although rumors about his paternity were heard in Paris for many years—and some of his official commissions were attributed to Talleyrand's tacit sponsorship—Eugène Delacroix hardly comported himself like a man under a shadow. How much of the story he knew, and how much of it he believed, can only be conjectured. If he believed Talleyrand to be his real father, he nevertheless displayed great pride in the man he called father, and whom he described in his journal as "admirable and noble."

Two years after Eugène's birth, the Delacroix family moved to Marseilles, where Charles had been appointed prefect. By his own account, Eugène's early childhood was not dull: "In succession I was nearly burned in my bed, nearly drowned in the port of Marseilles, poisoned by verdigris, hanged by the neck with a real rope and almost choked by a bunch of grapes." In quieter moments, he showed an exceptional talent for music—so said the old cathedral organist who had been a friend of Mozart and who was giving music lessons to Henriette Delacroix—and eventually he learned to play the piano, violin and guitar.

When he was seven, Charles Delacroix died. The two older sons were off soldiering with Napoleon. Madame Delacroix packed up Eugène and Henriette and returned to Paris to live. Although the family finances were tied up in lawsuits over real estate, Eugène was sent to one of the best schools, the Lycée Impérial, where he ran off with prizes in Latin, Greek and drawing. His earliest sketches were the doodles of a schoolboy—lively and nervous, as if his pen had darted like a water fly across the surface of the page: medieval horsemen galloping between antique Roman busts, startled nudes being jostled by officers in cocked hats. One of young Eugène's school notebooks contains this self-appraisal: "Eugène Delacroix, a good boy . . . in spite of what jealous people say."

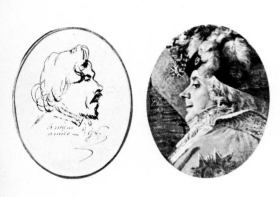

Was Charles Delacroix the artist's real father or was Talleyrand? Charles, shown at the top in a medallion, bears little resemblance to Eugène, who appears at left in a sketch by George Sand. But Talleyrand, portrayed at right in a detail from a painting by David, has the same nose, brows and lordly mien as Eugène.

He was only nine or ten years old, according to his friend, the critic Théophile Silvestre, when he went to the Louvre "on one of his free days.... The sight of those pictures decided his vocation; when he left the museum, he was a painter." It may seem unlikely that any 10-year-old should decide on a career quite that conclusively. But the fact was that thanks to Napoleon's victories in the field the Louvre had just acquired a magnificent haul of treasures—Rubens, Titian, Tintoretto—which dazzled Eugène and drew him toward the realms of art.

Another strong influence was his Uncle Henri Riesener (his mother's half-brother), who had studied with David and was a successful portrait painter himself. When his nephew became 15, Riesener introduced him to the famous Baron François-Pascal-Simon Gérard who, aside from painting Madame Récamier and other elegant ladies of the era, held a midnight salon where Delacroix was later to meet many great men of letters—Balzac, Stendhal, Mérimée—and probably also Talleyrand. Through his Uncle Henri, he also met the illustrious teacher-painter, Pierre-Narcisse Guérin, who ran his school for art students, the best in Paris, on the Davidian principles of sound drawing and constant reference to classical sources. Promptly Eugène wrote a schoolmate that after finishing up at the Lycée he hoped to study with Guérin: "I mean to go to him for a time so as to have at least a small amateur talent."

But history had a hard jolt in store for Eugène. Even as he wrote his confident message, France was once more going through cataclysmic changes. Napoleon was defeated at the Battle of Leipzig, and in a few months his Empire crumbled. The next year, in 1814, the Bourbons returned; a brother of Louis XVI was rushed out of exile and proclaimed King Louis XVIII. Napoleon's magnificent *Arc de Triomphe* stood half-finished, like a broken promise, on the Champs Elysées, an insistent reminder to the youngsters of Delacroix's generation that Paris was an exciting but not very stable place to grow up in. Invading Russian troops camped near the Arch: Paris was occupied by foreign enemies for the first time since the reign of Henry IV, more than 200 years before. Most Frenchmen, feeling ruined or disgraced, split into two opposing groups: Bonapartists or Royalists.

By 1815, when Delacroix joined Guérin's atelier, Napoleon had tried and failed to make his comeback and had been finally crushed by his British and Prussian foes near the village of Waterloo; Louis XVIII was settling back for what was to be a 10-year reign. Sensibly, he did not try to deprive the French of the many liberties and reforms they had won during the Revolution and under the subsequent rule of Napoleon; but, also sensibly, he expected all the loyalty he could get. Since Delacroix was known as the son of a man who had voted for Louis XVI's execution, and since his family was openly opposed to the Bourbon restoration, the boy could not expect an official career or favors from the King. Nor was there any family fortune to fall back on. No longer could he afford to have just "a small amateur talent." Now he had to support himself. He could hardly have picked a more turbulent, unsettling, but stimulating time to be an artist. Delacroix threw himself into the riptide, knowing he must paint or sink.

Delacroix's Heritage

When young Delacroix began to paint, the dominant school in French art was neoclassicism. Its leader was Jacques-Louis David, whose studio had become the focus of the classical revival. To it came young talents, some to listen, others to study and assist. In their own work they emulated the master's sober coloring, meticulous surfaces and formal compositions. Like David, they sought inspiration in Greek and Roman history and in the tragic drama. They were encouraged by the Emperor himself, who had long been infatuated with the ideals of ancient Rome, and who backed his taste with commissions to memorialize his Empire. But despite official patronage and David's power, new forces were surging into French painting. Under the Emperor, the nation was regaining the self-confidence it had lost with the downfall of the Bourbon kings. Napoleon's military campaigns from Moscow to Cairo opened windows on new landscapes and the captured treasures of exotic capitals dazzled provincial eyes. Rebellious young artists like Théodore Géricault were given a sudden and invigorating sense of their contemporary world. And it was between that lively world and the imitation of an ancient one that Delacroix, on the brink of his career, had to choose.

Candles burn low and a clock shows 4:13 a.m. as Napoleon poses after a long night's work. A draft of his legal code lies on the desk, a copy of Plutarch's *Lives* below. The artist took pains to include the symbols of the Emperor's authority: a sword, general's epaulettes, the Legion of Honor medal.

Jacques-Louis David:
Napoleon in His Study, 1812

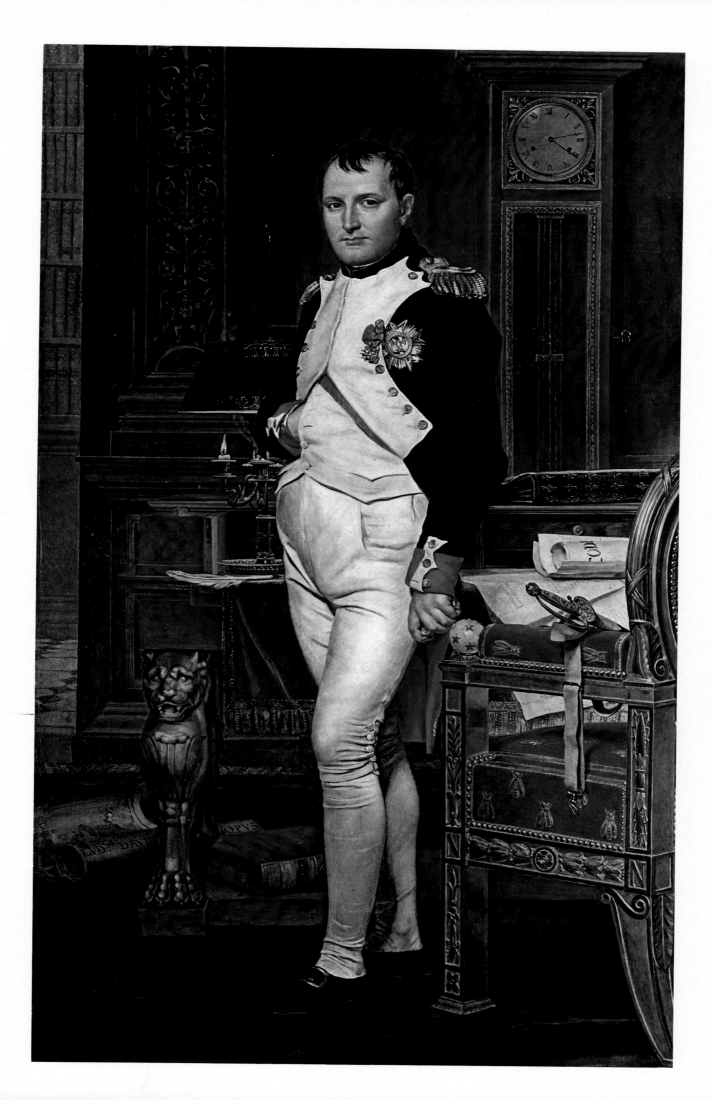

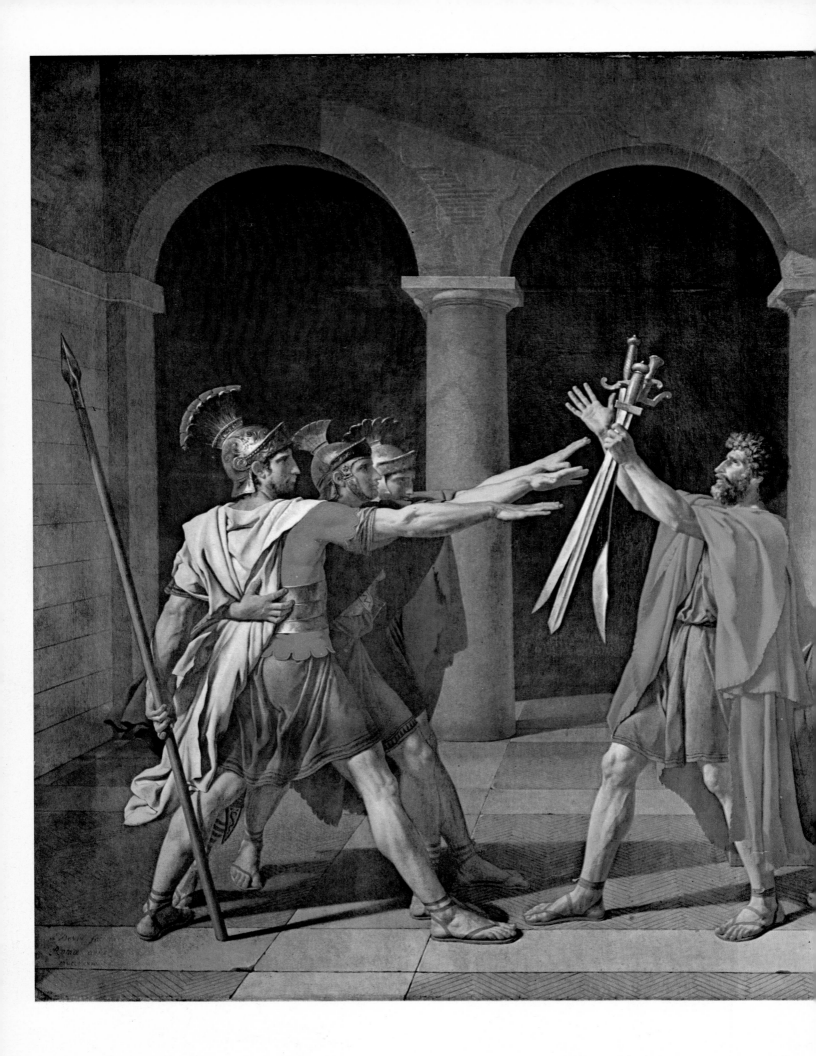

In one of his masterpieces, the *Oath of the Horatii (left)*, David shows the dramatic moment when the aged Horatius deals out swords to his sons, swearing them to defend Rome against the rival city of Alba. The women weep: one of them, Horatius' daughter, is engaged to an enemy; the other is an Alban married to one of the Horatii, so that their loyalties are divided. David began this work in Paris but found that he could not finish it until he returned to Rome, where he had studied, for inspiration. He worked for two more years, regrouping the figures and eliminating nonessential details. He dressed dummies in Roman costumes to study the drapery, and had swords and helmets made to copy. The result is pure neoclassicism: austere, posed somewhat stiffly, but with a striking air of dignity and drama. Hung in the 1785 Salon, the picture electrified the French in the last days before the Revolution. As rousing as a vibrant call to arms, it preached the need of putting civic duty before family sympathy.

"Drawn into the Revolutionary whirlwind," as he put it, David startlingly portrayed the patriot Marat *(below)*, stabbed in his bath by a fanatic. The artist, who knew Marat well and had seen him only the day before his murder, endowed the starkly simple work with the poignance of a religious martyrdom.

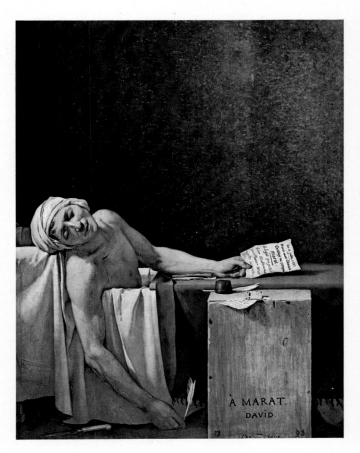

Jacques-Louis David: *Oath of the Horatii*, 1784

Jacques-Louis David: *Death of Marat*, 1793

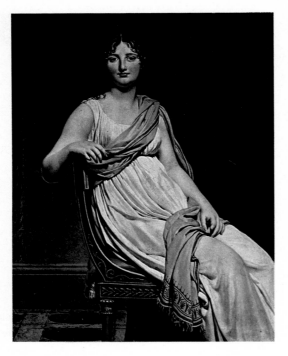

Taking advantage of loose-gowned neoclassical fashions, the grand ladies of France shed their corsets and tight shoes and had their pictures painted. Flowing robes and simple hair styles revealed the subjects' natural beauty, seductively at odds with the severe furniture and sedate backgrounds. David portrayed Delacroix's sister, Henriette *(left)*, with a classic hauteur, which may explain why her brother never felt very close to her. David also began an arresting composition of Madame Récamier *(below)*, the 23-year-old wife of a banker. Although his favorite student, Jean-Auguste-Dominique Ingres, assisted with the painting (he did some accessories),

Jacques-Louis David: *Portrait of Madame de Verninac*, 1799

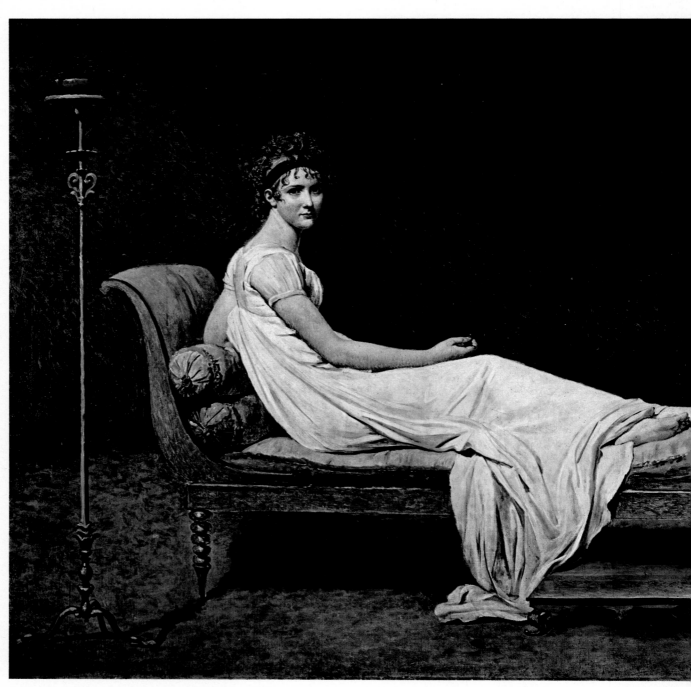

Jacques-Louis David: *Portrait of Madame Récamier*, 1800

it was never finished because David became impatient with the flighty Madame's criticism and capriciousness. The canvas lacks David's usual surface polish and final details in the furniture and background.

Madame Récamier also asked François-Pascal-Simon Gérard to do her portrait *(below)*, which shows her more décolleté and comfortably cushioned. In a variant of this pose, Prud'hon painted Napoleon's wife Josephine *(right)* reclining in a sunset reverie. Prud'hon, whose inclinations were poetic rather than neoclassical, did not fit neatly into any school. But he was a personal favorite of Delacroix, who admired his light, lyrical touch.

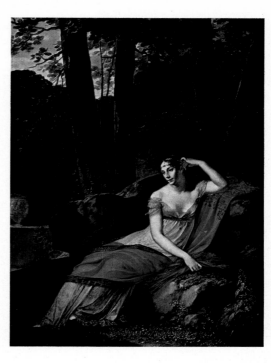

Pierre-Paul Prud'hon: *Empress Josephine at Malmaison*, 1805

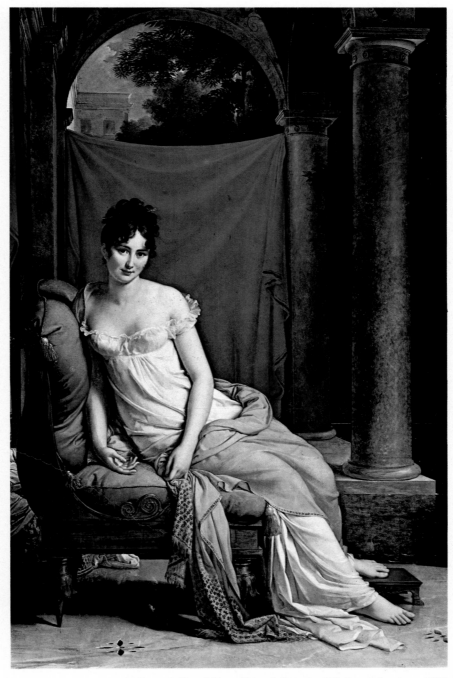

François-Pascal-Simon Gérard: *Portrait of Madame Récamier*, c. 1802

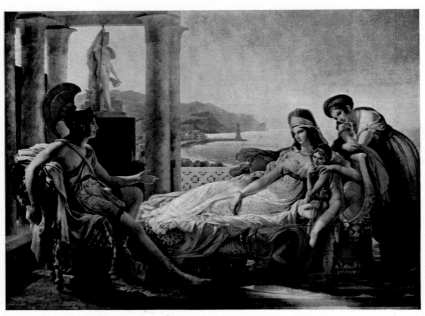

Pierre-Narcisse Guérin: *Aeneas Telling Dido the Disasters of the City of Troy*, 1815

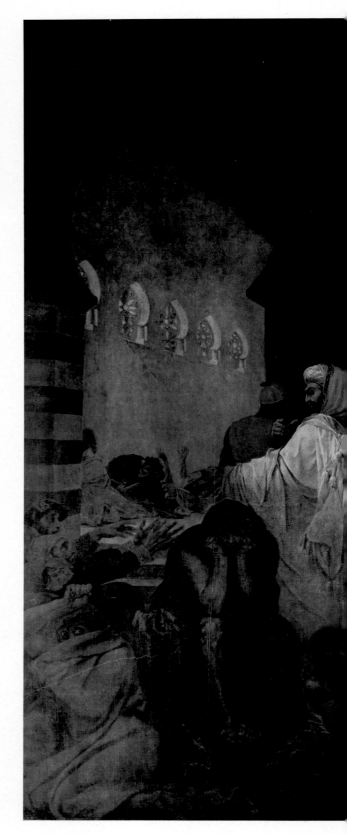

When Delacroix at 17 studied in Pierre-Narcisse Guérin's atelier, he probably saw his teacher at work on the painting above, showing Queen Dido on her terrace in Carthage with her lover Aeneas, fresh from the Trojan War. Exhibited in the 1817 Salon, Guérin's large work was greatly admired, though modern critics rate it as little more than a sumptuous theatrical tableau.

Another success of its day, and a touchstone for Delacroix's artistic rebellion, was the 24-foot canvas, *Napoleon Visiting the Pest-House at Jaffa (right)*, which the Emperor ordered from his official painter, Baron Gros. Though Gros often accompanied Napoleon, he was not present during the Egyptian campaign. But he learned from eyewitnesses how the Emperor had captured Jaffa and visited a hospital to comfort his wounded soldiers and other plague victims. Napoleon bravely touches an infected man, giving the mystical impression that he has a healing power and is immune to harm.

In this work, Gros showed himself to be probing toward Romanticism in his use of Moorish arches, intense colors, and in the overall emotional tone and misty, suggestive background. In the foreground he created a grim frieze of suffering and death, from the stricken French doctor holding a dying man *(far right)* to the blinded officer groping among the dead, and the heaped-up corpses and turbaned officials *(far left)*. The impact of this painting was tremendous. Gros's students festooned the picture with garlands and applauded their master at a banquet. And 20 years later, Delacroix paid it the sincerest homage. In his large work, the *Massacre at Chios (page 54)*, he shows his debt to Gros.

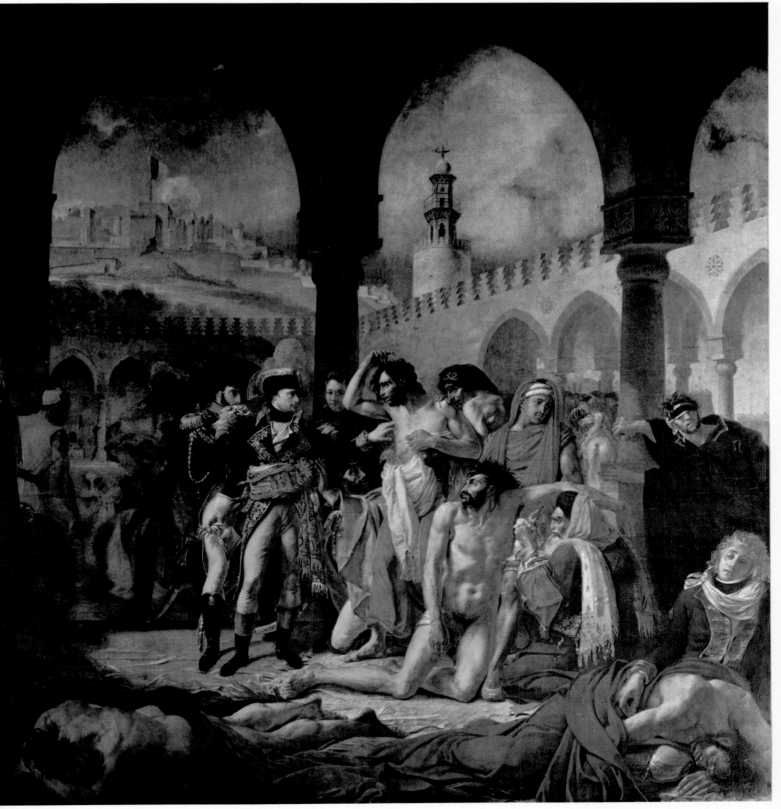

Baron Antoine-Jean Gros: *Napoleon Visiting the Pest-House at Jaffa*, 1804

27

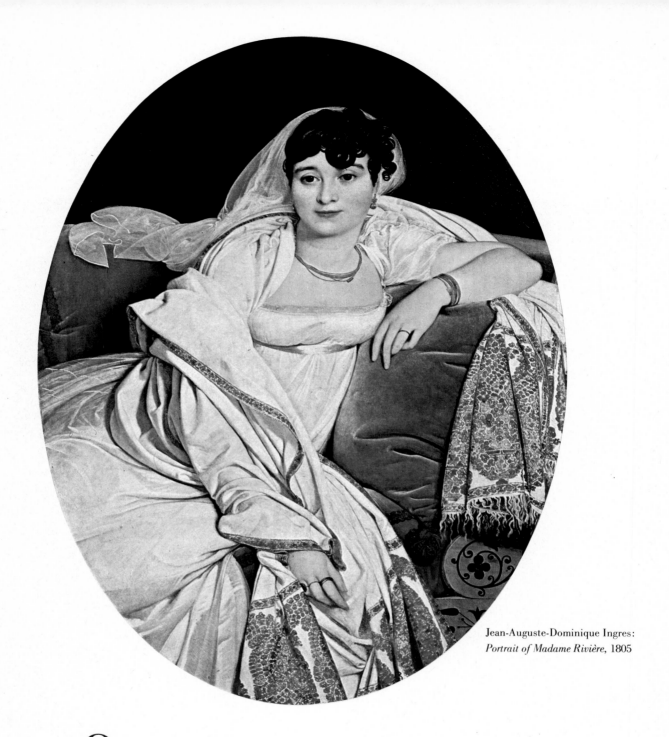

Jean-Auguste-Dominique Ingres:
Portrait of Madame Rivière, 1805

Only five years from the time he assisted David on Madame Récamier's portrait, Ingres became a master in his own right with his painting of Madame Rivière *(above)*. His progress had been stunning. At 25 he could handle paint like a virtuoso, and his drawing was superb. He was well aware, too, of sensuous values, as seen in Madame Rivière's pearly flesh tones, her downy cashmere shawl and the nappy velvet sofa. In this respect he departed from David's influence, although he remained a militant classicist all his life.

By contrast, Théodore Géricault, at 21, portrayed his *Officer of the Imperial Guard (right)* at a peak of tense action, with lines of swirling motion, and rough, bright daubs of paint. The picture foreshadows the Romantic style, of which Géricault was a forerunner. Thus, these two works represent the dominant strains in early 19th Century French art—the highly polished, cool and idealized, and the free, vivid evocation of emotion.

Théodore Géricault: *Officer of the Imperial Guard*, 1812

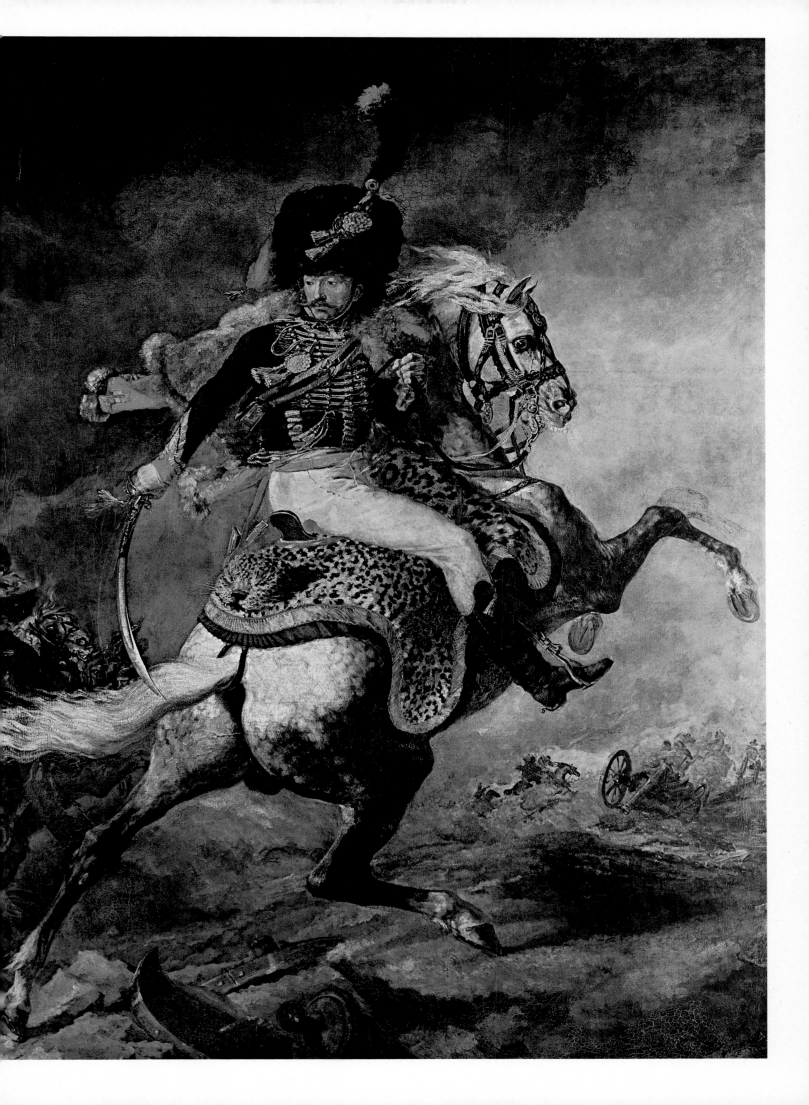

II

Scattering the Rainbow

Delacroix's first decade in the world of art produced results enough to please even a young painter in a hurry. In 1815, when he enrolled at Guérin's studio, he was 17, untried, just one of a score or so of students knocking at art's door. By 1825 he was a celebrity and a storm center. That Mecca of French painting, the periodic official exhibition known as the Salon, had accepted and shown two of his works; the French government had paid him the signal honor of buying both of them for its permanent collection; and Parisian critics had given him the accolade of their abuse.

The leap from obscurity to fame in so short a time at so young an age might well be explained in words Delacroix himself once wrote about another artist: "There are talents that come into the world fully prepared and armed at every point." The period at Guérin's atelier served only to strengthen Delacroix's natural armor. He submitted dutifully to the customary disciplines of drawing from the antique, copying ancient busts and coins, and mastering the rules of classical composition; yet even then, as he confessed years later, he had little taste for Guérin's orthodoxy. By his own account, he was already a Romantic—"if by my Romanticism is meant the free expression of my personal feelings, my remoteness from the standardized types of painting prescribed in the schools, and my dislike of academic formulae."

Study under Guérin had its advantages nonetheless. Unlike many of his colleagues, Guérin was too wise a teacher to squelch his more radical pupils if they had talent. The school itself provided excitement and ideas; with artists being recruited to portray important personages and to depict faraway battles and other momentous events of current history, a big atelier was almost as much in the swirl of affairs as a modern newspaper office. Famous painters dropped in to chat with the master and relay rumors about who was being painted by whom, and the young Delacroix relished both the shop talk and the gossip.

He also enjoyed a much-needed sense of belonging. His family was breaking up. His mother had died in 1814. His brother Henri had been killed in battle. His eldest brother Charles had retired from the army

Mademoiselle Rose, a pretty model who worked in Guérin's atelier, posed many times for Delacroix. This undated *académie*, or nude study, was done merely for practice; later she was to turn up several times as a figure in his large paintings.

Mademoiselle Rose, 1817-1824

and moved to a village near Tours. His Uncle Henri, hoping to improve his fortunes as a portrait painter, had gone off to Russia, where, under Czar Alexander I, the market for French culture was booming. Eugène was living in the family house on the Rue de l'Université in Paris with his sister Henriette, who had married the year he was born and by now was the quite grand Madame Raymond de Verninac, wife of a former Minister to Switzerland and Ambassador to Constantinople. Although he scrupulously paid the Verninacs 100 francs a month for bed, board, laundry and incidentals, at times he was probably a nuisance. For one thing, he was desperately in love with Henriette's English housemaid Elizabeth Salter, and seemed always to be spooking about backstairs trying to smuggle a word or a kiss to her.

Money matters may have motivated his decision to leave Guérin's after five months and enroll at the Ecole des Beaux-Arts, where the atmosphere was starchier but the tuition less costly. This school, part of the august Académie des Beaux-Arts which had ruled France esthetically for almost two centuries, was by far the most celebrated artististic hatchery of its time. It was under the direct patronage of the government, and under the firm hand of a faculty relentlessly devoted to tradition. All the professors were Academicians of high standing; some also served on the formidable Salon juries whose rebuffs could cast an artist into outer darkness—and perennial insolvency.

The Ecole taught one subject only: how to paint history, allegory and myth in the grand manner of the old masters. As at Guérin's, Delacroix proved a responsive pupil with private reservations. Probably as an antidote to the traditionalists' confining cult of form, he embarked on a search for greater spontaneity through the mediums of engraving, etching, and particularly the new process of lithography, introduced into France only a year before he began his formal art training.

Lithographs and caricatures, sold to *Le Miroir* and other Parisian journals, provided Delacroix with a small if spotty source of income. These earnings were not noticeably augmented by the 15 francs paid him for a project he undertook in 1819; it was, however, his very first commission for a painting, the *Virgin of the Harvest*, and as such is worthy of record. His patron, a resident of the village of Orcemont, 28 miles from Paris, asked Delacroix to execute this work for the little local church. Delacroix chose to regard the assignment as homage to Raphael, and as a warming-up exercise copied the master's *La Belle Jardinière*. The result, very much in the Raphael manner, was engaging, conventional and quite undistinguished. It showed no signs of the spectacular talent that was soon to burst forth and that events even then were preparing for display.

During his brief stay at Guérin's, Delacroix had met the painter Théodore Géricault. It was to be one of the most fruitful and fateful encounters of his life. Géricault, an alumnus of the atelier, came back from time to time to work in the life classes. Seven years Delacroix's senior, he was a merry, gregarious man whose tastes as a *bon vivant* did not preclude a deep-seated sympathy for the underdog. He headed the vanguard of young artists who were trying to throw off the inhibitions

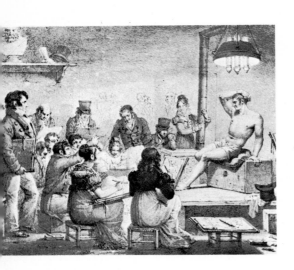

Art students of Delacroix's time studied in ateliers like this one shown in a lithograph by Marlet. The main activities in such classically oriented schools as Guérin's, where Delacroix spent a half year, were studying anatomy, drawing nude models, male and female, and copying casts of antique statues, busts and coins—with emphasis on precise, linear drawing.

of the Davidian style and restore freedom and sensuousness to French art. Géricault piled on paint so thickly, and with such gusto, that his fellow students called him "Rubens' chief cook." Guérin conceded his gifts but was wary of his influence on the school. "Why do you want to follow him?" he asked his pupils. "Let him go his own way; he has enough stuff in him for three or four painters."

Delacroix turned a deaf ear to Guérin's injunction; from the first, he felt an instinctive affinity for Géricault's ideas. The friendship they struck up had not long to flourish; less than 10 years after they met, Géricault, at 32, was dead. In a sense, he burned himself out; he had, perhaps, lived too well. Among his passions were horses—owning them, taming them, painting them—and his fatal illness grew out of a riding fall which injured his spine and caused him to waste into a pitiful invalid. Delacroix, on the news of his death, was to write: "Poor Géricault, I will think of you very often! I imagine that your spirit will often come to hover about my work."

But Géricault's influence on Delacroix did not have to await this grievous outcome to manifest itself. In July 1816, a long way from Paris, a disaster occurred that was to link their work for all time.

The event was the foundering of the French frigate *Méduse* off the coast of West Africa. Bound for Senegal, the *Méduse* had drifted into shallows while the crew celebrated the crossing of the equator. The ship's lifeboats could not hold the entire complement of 400 men. The captain and officers piled into the boats; 152 members of the crew were assigned to a large, hastily constructed raft. After a while the raft's tow-ropes were cut and it was set adrift. For 12 days its human cargo was exposed to hideous torments on stormy seas. Some perished from exposure and starvation, others at the hands of crazed companions: only 15 weathered the ordeal. This calamity was reported in the French press, and two survivors went on to tell the full story, in all its graphic horror, in a widely read pamphlet. Of special interest was the fact that the *Méduse*'s captain was an elderly incompetent who had secured his post through government pull. Thus, the whole business could be regarded as an indictment of the bureaucratic bungling, if not downright negligence, of the recently restored Bourbon monarchy.

For a painter of Géricault's sensibilities, the *Méduse* affair was a made-to-order opportunity. Into its depiction he could pour all the tensions of the human psyche under stress, all the emotion-charged action dear to a Romantic's heart. The work, once begun, absorbed his total energies for 16 months. It sent him to the seashore at Le Havre to study the effects of light on waves and the effects of waves on a raft he had had specially built; it sent him prowling through Paris hospitals and morgues to reinforce his skill at anatomy. His friend Delacroix observed his efforts with unflagging interest. Delacroix, indeed, was drawn into the picture literally. At Géricault's invitation, he posed for several sketches, and was eventually painted into the canvas as the figure lying face down in the central foreground, with his left arm thrust toward the raft's edge *(page 49)*.

Géricault had chosen to portray the *Raft of the Medusa* at the mo-

To broaden his drawing style from the narrow confines of classical training, Delacroix studied the work of other fine draftsmen —notably Goya's satirical series of etchings, *Los Caprichos*, and English caricatures by Thomas Rowlandson. Above is a sketch he made after Goya's *Love and Death;* below his copy of Rowlandson's *Ridiculous Kiss.*

ment of the survivors' deliverance. Presumably viewers of the finished work might have construed its message as a reminder that humanity could outride a holocaust into a hopeful future—a hardly radical theme. Such, however, was not the painting's effect. The 1819 Salon agreed to show Géricault's canvas only on condition that the title be changed to *Shipwreck Scene,* to dissociate it from the real disaster. Most critics deplored it, and the government refused to consider its purchase—a decision it was to reverse within a year after Géricault's death. Géricault, in short, had served up too raw a slice of life; the French public was not yet ready for reality unadorned.

Perhaps to console Géricault for snubbing his *Medusa,* or to lead him into the paths of righteousness, Beaux-Arts officials offered him a commission for a religious painting. Géricault refused the job, but passed it on to Delacroix. The *Virgin of the Sacred Heart,* now at the cathedral at Ajaccio in Corsica, is an oddly unattractive work, with hydrocephalic cherubs and a buck-toothed worshiper. It netted Delacroix 1,500 francs—certainly the only time in his life he was overpaid. This was also the last time his work would seem merely perfunctory. For under the stimulus of Géricault and his own broadening outlook he was about to essay his most ambitious effort to date.

In 1821 Delacroix began to plan a major picture to be submitted to the Salon the following year. He chose a scene from Canto VIII of Dante's *Inferno,* showing the poet Virgil standing protectively beside Dante in a boat while the oarsman, Phlegyas, steers them across an infernal lake clogged with the souls of sinners, all clawing and biting at the gunwales, trying to clamber aboard. Delacroix's debt to Géricault is everywhere evident in the *Bark of Dante (page 50):* in the exploitation of the dramatic potential of a waterscape, in the use of diagonals to convey a sense of struggle and movement, in the pyramidal arrangement of the figures, and in the bold emphasis on their musculature. On one important score, however, Delacroix departed from Géricault: the theme itself was a thoroughly respectable one, free of any implications that might rile officialdom.

If he hoped thereby to avoid controversy, he was doomed to disappointment. Delacroix had deliberately set out to paint a picture that would attract attention, and he succeeded; but the attention was not all favorable. The appearance of the *Bark* set up a pattern for what would be the critical response to Delacroix throughout his career: acclaim or excoriation with little in between, for people found it hard to be dispassionate about him. In general, art criticism in the Paris journals was low and lurid, and the public reveled in the carnival of invective. When one critic damned the *Bark* as a "veritable daub," his readers agreed with insolent laughter. The murky ambiance of the painting, its less than crystal clarity, its demands on the viewer's imagination—all these were unsettling matters, and Delacroix's detractors would have none of them.

But the *Bark* won two supporters whose value offset the rest. The first was the celebrated painter of Napoleon, Baron Antoine-Jean Gros, who was a member of the Salon jury, and to whom Delacroix had been

introduced by the ever-helpful Géricault. "Chastened Rubens," was Gros's graceful compliment for the *Bark*, and for Delacroix, who had long admired Gros as a colorist and a Rubens follower, this was praise indeed. His second supporter was an ambitious young journalist—later to become Premier and President of France—Adolphe Thiers, who wrote in *Le Constitutionnel:* "Delacroix has received the gift of genius. . . . Let him advance with assurance, let him devote himself to immense tasks. . . ." After the *Bark*'s exhibit at the Salon, the French government bought it for 2,000 francs. It was to have an almost mesmeric effect on progressive painters of oncoming generations. Among those who copied it were Courbet, Manet, Dégas, Cézanne, Gauguin and countless lesser artists.

Looking back on this work in later years, Delacroix declared that the drops of water which he had painted on the figures in the foreground were his starting point as a colorist. They were inspired, he said, by the sea nymphs of Rubens and by a careful study of the rainbow. When scrutinized closely, Delacroix's drops reveal that they are each composed of four bands of pigment: red, yellow, green and white. But from a little distance they blend into a unit, a single drop, that glistens with light. Putting this principle into wider practice, future painters would carry French art into one of its richest periods. From little drops of water, it appears, came the mighty ocean of Impressionism.

At 24, Delacroix was well launched in his public life. In his private life he was still uncertain and immature. Somehow the passions which he had begun to pour into his painting could not be channeled for his personal fulfillment. His romance with his sister's maid was typical. Elizabeth Salter returned to England in 1818, but he was still writing her in 1820. Their backstairs wooing had been a miserable business, although on the surface it was pure comic opera: in one attempt to meet her secretly at night he fell over a workman's ladder and landed in a tub of wet plaster. His efforts to win her with love letters written in English were doubly frustrating, since he was able to conquer neither the girl nor her language. "I conceive you are wearied to see me in stairs . . ." he once wrote, "and I confess it not please me much. . . . Often when I go near the kitchen I hear your fits of laughing, and I laugh in no wise. . . . I will go out this evening. Prithee come a few, I hope God will remove our enemies. I beg him for that. My whisker not sting more."

Elizabeth had not been his first love. At 17 he had written to a friend, Achille Piron, that he was smitten with a Mademoiselle Villemessant, and that he mooned inconsolably under her window; he had begged Achille to write back "at a gallop," instructing him how to go about seeing such an angel. That he should have expressed himself thus is hardly surprising; the age of 17 is right for that sort of thing. But what is surprising is that seven years later, after the *Bark of Dante* had carried him to renown, he was still writing like a schoolboy about his troubles with a peasant girl named Lisette, who mended his shirts, reminded him of a Raphael Madonna, and worked for his brother Charles.

These early infatuations are worth lingering over because nowhere

While still a student at the Ecole des Beaux-Arts (1816-1817), Delacroix began to publish caricatures in a Paris newspaper, *Le Nain Jaune*, noted for its nonpartisan social satire. Delacroix's etching *(above)* shows "three literary dwarfs" fighting above a tomb which held the remains of *Le Nain Jaune*, a reference to a lawsuit which then threatened to close the paper.

else does the young Delacroix reveal so clearly his ardent but inhibited nature and his hunger for affection. He met Lisette while spending some summer months with Charles near Tours. It was there, on September 3, 1822, that he started his journal, and although he chose the date because it was the anniversary of his mother's death, he honored his peasant laundress by mentioning her on the very first page. "I heard Lisette's voice in the distance. It . . . is like that of Elizabeth Salter, whom I am beginning to forget." He reported that he kissed Lisette "in the dark passage of the house," but that the next time they met she resisted him. "I am indignant and want to make her sorry for her conduct. . . . I had planned to watch her washing tomorrow. Shall I give in . . . shall I be ass enough to go back to her? I certainly hope not." Several days later he wrote, "I was reconciled with Lisette, and so danced with her late into the night."

The following morning he left for Paris, anxious to see how the *Bark of Dante* looked now that it was installed in the Luxembourg gallery, yet convinced that he would find in Paris "dissembled envy, satiety after triumph, but never a Lisette like mine, never moonlight and the peace that I breathe here."

But in Paris he soon found a woman who made him forget Lisette. She had been the mistress of Delacroix's good friend Raymond Soulier, and although her identity is still in dispute, she was a lady of fashion and probably the wife of a certain General de Coëtlosquet. Since Soulier had gone off to Italy for two years, Delacroix grew ever closer to the lady, whom he discreetly referred to only as "*la Cara*"—"the dear one."

Upon Soulier's return the affair took on a sudden piquancy and passion which it may not have had before. Delacroix rushed through a gamut of emotions. He hated himself for having betrayed Soulier, and then to ease his guilt he decided, after all, that Soulier was "not my sort of man"—an opinion he soon forgot. He begged Cara to go on seeing him, and then blamed her because she did. They parted for six months; then he noted in his journal: "Saw my darling again. She came to my studio. . . . *Eh bien!*" Early on Monday he wrote Cara that he waited impatiently to see her on Thursday. Later on Monday he wrote Cara to come back Tuesday. In five more weeks the fires began to cool. He apologized for his delay in answering her last letter, called her "friend," asked solicitously after her sick child, and ended "Farewell and tender regards." It was all over.

Delacroix in his lifetime was to have many more affairs, some of them enduring and deeply felt. He longed "to identify my soul with that of another," and declared: "A wife of your own stature is the greatest of all blessings." But he was never truly interested in marriage. Did he perhaps unconsciously bestow his favors on models or married women who would not tie him down? To his nephew Charles de Verninac he wrote in the guise of avuncular advice what is patently a self-apology: "A woman is only a woman, always basically very like the next one. . . . This delicious passion . . . can destroy a man in the nicest possible way."

Delacroix's real passion was for friendship. "I am not happy, not

really happy, except when I am with a friend." He had a quartet of comrades—Soulier, the brothers Félix and Louis Guillemardet, and Jean-Baptiste Pierret, none of them artists—who met every New Year's Eve for guitar-playing, songs and flaming punch. To all of them, but especially to Pierret, he wrote ardent avowals of affection in a style that has gone out of fashion but was common in his day. He poured out his heart in letters, waited impatiently for answers, and fell easily into a sort of epistolary ecstasy. "The joy I feel when somebody hands me a letter that has just come can be compared to the most charming emotions of the most charming of passions." If in his youth Delacroix gave himself more unstintingly to friends than to sweethearts, was it not because friends threatened no real emotional involvement, no danger to his liberty or obstacle to his work?

Keeping himself mentally and physically fit for work was a major recurrent theme of his journal. If at times the theme sounds obsessive, it should be remembered that a young man in Paris during the early 1820s needed to guard himself against the city's superabundance of distractions. The city itself was being ripped apart and rebuilt under plans laid down by Napoleon. It was a no man's land which belonged neither to the restored Bourbon sitting warily on the throne nor, as yet, to the new bourgeoisie. The best thing a man could do was to direct himself, to feel that he belonged to himself, as Delacroix indicates by some of his random journal musings from 1822 to 1826:

"I return from *The Marriage of Figaro* full of sublime ideas. . . . I should like to resume piano and violin study. . . . Last Tuesday morning . . . a little baggage named Marie—19 years old—came to pose. I took a big chance of a disease with her. . . . I want to paint *Milton and His Daughters* for the Society of the Friends of Art. . . . Go to see the stage off, to make some studies of horses. . . . As usual, my slight build abashes me. I cannot see my nephew's beauty without feeling envy. . . . I believe that here is the sovereign evil of life:—it is this inevitable loneliness to which the heart is doomed. . . . The repairing of my stove made me take a walk to the Museum . . . admired Poussin, then Paolo Veronese, standing on a stool. . . . I saw several fragments of figures by Michelangelo, drawn by Drolling. God! what a man! . . . A strange thing, and a very beautiful one, would be joining Michelangelo's style to that of Velázquez. . . . Played billiards, or rather, gossiped while I pushed the balls around. . . . In the forenoon practiced jumping and casting the javelin. . . . Construed *Childe Harold* with my aunt. . . . The human heart is an ugly pigsty. . . . When a thing bores you, do not do it. . . . I saw myself in the glass, and I was almost scared by the wickedness in my features. . . . I dined at Uncle Pascot's Thursday or Friday. I had not drunk much, but enough to be dizzy. It is a pleasant state to be in, no matter what the puritans say. . . . Want to spread out some good thick, fat paint."

In its first years, the journal presupposed the perfectibility of man or, at least, of Eugène Delacroix. "When you have found a weakness in yourself, instead of dissembling it, cut short your acting and idle circumlocutions—correct yourself! . . . be strong, simple, and true. . . .

Go to bed early. . . . Habitual orderliness of ideas is your sole road to happiness. . . . I must live soberly as Plato did. . . . I got up about seven o'clock. A thing I ought to do more often. . . . You respect yourself only by being open and above board. . . . Go to bed very early, and get up very early."

Then, as we might have foreseen, comes an entry for June 6, 1824, copied carefully in English:

Early to bed and early rise
Makes a man healthy, wealthy, and wise.

After this appeared the words, "Do not forget to buy *Poor Richard's Almanac.*" Incongruous as it seems, there was a good deal of Benjamin Franklin in Eugène Delacroix.

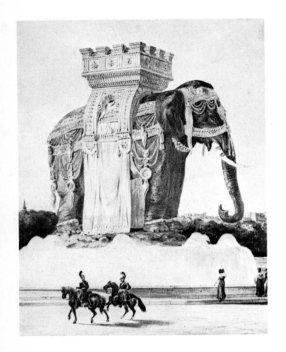

French fascination with the exotic reached a climax of sorts in 1808 when Napoleon commissioned an 80-foot-high bronze elephant to decorate the Place de la Bastille. Shown here in an artist's conception, it was never cast, but a wood-and-plaster model stood for some 40 years.

In May 1823 Delacroix decided to paint another picture to submit to the Salon. For his subject he turned to the recently renewed Greek struggle to wrest independence from the Ottoman Empire. The specific incident he had in mind had occurred a year earlier, when the Turks had butchered 20,000 Greeks on the little island of Chios in the Eastern Mediterranean.

After talking to an eyewitness of the slaughter, Delacroix set in motion the whole complicated machinery of creating a major work: doing historical research about the island itself; studying costumes, weapons, accessories; making dozens of preliminary sketches, watercolors, chalk drawings and finished portraits of people he planned to put into the painting. For this purpose he was able to hire native Greek models, who, along with models from Africa, the Near East and the Orient, were in growing vogue in Paris studios as a by-product of the Romantic interest in exotic foreign settings.

The Greek cause had kindled strong sympathies among the French. As the cradle of classicism, Greece seemed to them as much worth defending as Jerusalem to the Crusaders. Moreover, its fight against heavy odds to free itself of its centuries-old Turkish yoke seemed irresistibly dramatic to the Romantics, and its bid for liberty and democracy appealed to political liberals; indeed, the resurgence of Greek nationalism owed much to the influence of the French Revolution. Many of the young idealists of Delacroix's time headed for Greece to join the struggle. Among them the most notable, of course, was England's great Romantic poet, Lord Byron, who not only fought but died for Greek independence. Byron was a particular idol of Delacroix, who was to paint a number of works based directly on his poems and plays.

While all these considerations entered into Delacroix's decision to paint the *Massacre at Chios (page 54),* his primary reason for choosing the particular theme was its human tragedy, its appalling demonstration of man's inhumanity to man. At the outset, he started with a thickly massed group of victims that practically filled the painting, with a suggestion of mountains in the background. But as his work progressed, the mountains gave place to a vast, luminous sky set off by an uncluttered horizon. It was as if he had decided that the dying victims of the massacre were more poignant huddled beneath an open sky, and

the brutality of man more despicable beneath a majestic firmament.

Because the opening of the 1824 Salon was postponed from the spring to the summer, three paintings by the English landscape painter John Constable which had been sent over for the Salon were put on preliminary exhibit by a Paris picture dealer. Delacroix went to see them, and wrote in his journal, "That Constable did me much good." A week later he noted, "Saw the Constables again."

What happened then has since been garbled in the retelling, but according to the most authoritative sources Delacroix did a considerable amount of repainting of the still-unfinished *Chios* canvas immediately after his exposure to the Englishman's work, and some further minor retouching at the Louvre just prior to the Salon opening; for this purpose Museum officials obligingly moved his painting into another room.

What Delacroix did, simply, was to paint out some of "that good black" that he loved but used to excess, and adapt from Constable his way of painting a landscape so that it seemed to shimmer with natural daylight. To achieve this effect, Constable would forego the customary blending of pigments, and would, instead, juxtapose minute specks of different color tones. He was outspoken in his disapproval of the traditional French painters who "make painful studies of individual articles: leaves, rocks, stones, etc., singly so that they look cut out, without belonging to the whole." Painted "à la Constable," as French enthusiasts of his work began to phrase it, an entire picture with all its separate elements was bound together and bathed in the same light, and an atmospheric unity was established.

Constable's impact on Delacroix's *Chios* cannot, of course, be measured with any precision; the technique of juxtaposing colors had been used by Delacroix in the water drops of the *Bark of Dante* well before the arrival in Paris of Constable's *Hay Wain* and his other works. The Englishman served Delacroix best, perhaps, as a catalyst, setting loose his own inchoate ideas of the role color could play in painting and inspiring him to forge further ahead. The sheer variety of color in the completed *Chios* was greater than in Constable's work, almost as if Delacroix had wrung out the rainbow and shaken it over the canvas; and by contrast with Constable's cool hues, Delacroix's were dazzlingly warm and bright, instantly conjuring up the Mediterranean locale of his Greek victims. Henceforth Delacroix's color would be an independent entity, an expression of a mood; as his staunchest celebrant, the critic Charles Baudelaire, would later write, his color "thinks for itself."

The exhibit of the *Massacre at Chios* evoked a mixed response. Possibly put off by Delacroix's seeming total abandonment to color, his erstwhile admirer, Baron Gros, called it "the massacre of painting." Adolphe Thiers stood fast by his earlier judgment of Delacroix's talents, and the government apparently agreed: it acquired the painting for the impressive sum of 6,000 francs (about equal to $1,200 today). Looked at in retrospect, *Chios* seems less a battleground where Greeks were slaughtered than a battleground where Delacroix began to be liberated.

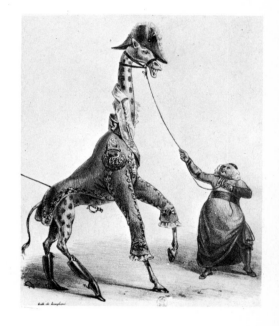

A live giraffe, the gift of the Pasha of Egypt to the King, was a sensation in France in 1827. This cartoon, showing the poor animal shod in boots, wearing a general's uniform and led by a priest, pokes fun at the inordinate attention paid to it by the public. It was brought by ship to Marseilles; its route from there to Paris is still marked by the inns that changed their names to "A La Girafe" in honor of its passage.

A Budding Artist

A wide variety of influences pour into the making of any great artist. But because Delacroix lived at a crossroads of history where many forces converged, the growth of his talent was more than usually interesting and complex. Neoclassicism served him well. It enriched his knowledge of art history, composition and drawing. Another less tangible force emanated from the magnificent Gothic ruins on his cousin's estate at Valmont. There, in his boyhood, he indulged in the Romantic penchant for deserted ruins, "all tenantless," as Byron wrote, "save to the crannying wind." Also, in his youth, the Italian Renaissance shed a benign influence on his first work, which he painted in a style so close to Raphael that it was almost a copy. Equally important to him was Michelangelo, whose heroic forms echoed in his Salon debut, the *Bark of Dante*. Delacroix's strongest affinity was for Peter Paul Rubens, whose burning colors and swirling compositions seemed to reflect his own emotions. From his friend Géricault he caught a passionate sense of drama. The glowing landscapes of England's John Constable stimulated him to study and experiment with color. All this helped him. For part of Delacroix's genius lay in his capacity to learn from others.

In its statuesque solidity, this early study of a model shows Delacroix's firm grounding in neoclassical draftsmanship, but he adds a luminous sense of "color" in tones and shadows that is wholly original.

Head of a Man, 1818

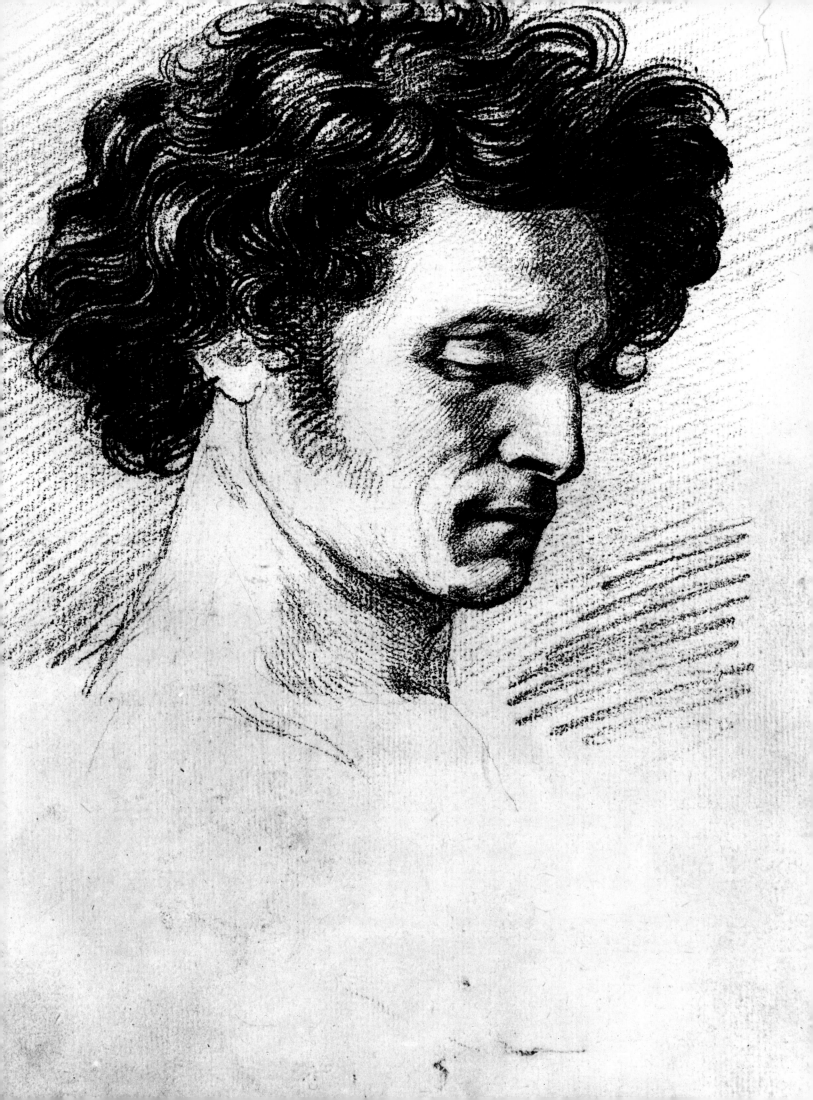

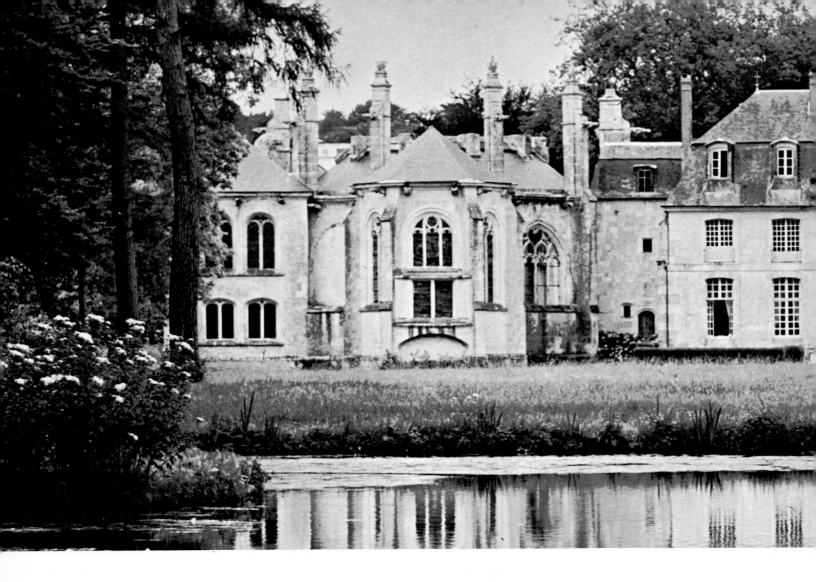

A Romantic Haven for a Young Artist

Delacroix's first known work is this etching,
reproduced in its actual size, made on the bottom of a
copper saucepan when he was 16. In such experiments
he perfected techniques that only a year
later earned him his first commissions for
caricatures and drawings in popular magazines.

During his youth Delacroix spent several summers at
Valmont, an estate belonging to cousins in Normandy about
90 miles from Paris. The family lived in the manor house,
which was first built as an 18th Century monastery
adjoining an ancient gothic Abbey. Eugène loved this
half-ruined chapel, especially at night with the wind
moaning and owls hooting. "These things," he wrote at 15,
"inspired in me a multitude of wholly romantic ideas."
A cousin, Léon Riesener, told how he and Eugène ventured
out at night to take plaster casts of the tomb carvings.
"The rays of the moon came in through the church roof and
sparkled on the dewy foliage in the nave. We amused each
other by throwing giant shadows on the colonnades in the
aisles." Delacroix treasured Valmont with the same part
of his being that was soon to respond to the haunting
tales of Sir Walter Scott, the legend of Faust and the
grave scene in *Hamlet*. He painted the Abbey often, and
returned to it affectionately for most of his life.

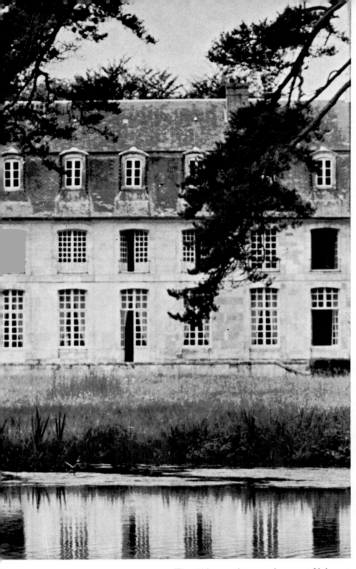

The Abbey and manor house at Valmont

The artist painting Valmont Abbey, 1831.

Doodles and sketches in a school notebook suggest that Delacroix was more interested in art than arithmetic. But these crude drawings show, in their curling, vigorous lines, the boy's maturing temperament and hint at his future style as a painter.

43

Delacroix's first painting commission, which earned him the trifling sum of 15 francs, was for a village church in the suburbs of Paris. For this rural community, he appropriately painted a *Virgin of the Harvest*. Desiring to do well, he virtually copied *La Belle Jardinière*, a painting by Raphael he saw in the Louvre. Raphael was a favorite of the neoclassicists and extravagantly esteemed by Ingres; his calm perfection seems out of tune with the tumultuous nature of Delacroix, who was more apt to admire Michelangelo, Veronese and Titian. Yet Delacroix recognized Raphael's greatness, and in 1830 published an essay praising "the sublimity of his talent . . . the most perfect order . . . a bewitching harmony."

In his second commission *(right)* Delacroix two years later began to show his originality. The *Virgin of the Sacred Heart* is a rather awkward composition and the cherubs are not well drawn, but in the emotional attitudes of the figures at the bottom, the striking silhouettes and the dramatic lighting, it points to the excitement of his later work.

Preliminary sketch for an infant Jesus

Raphael: *La Belle Jardinière*, 1507

Virgin of the Harvest, 1819

Virgin of the Sacred Heart, c. 1821

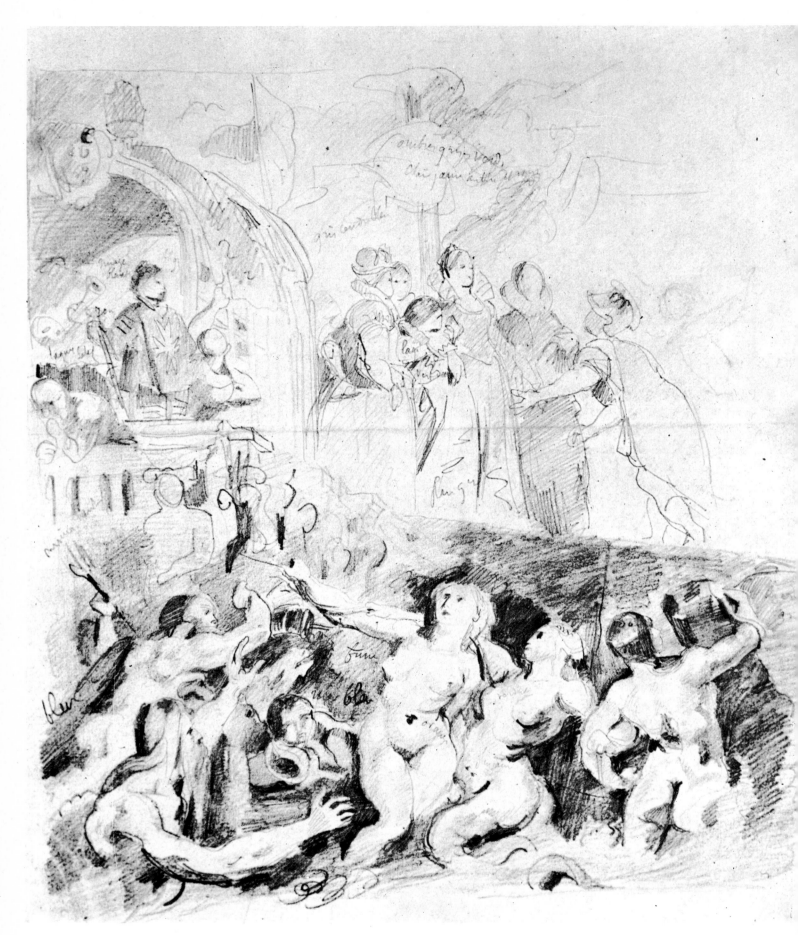

Sketch after Rubens

Peter Paul Rubens, the great 17th Century Flemish painter, was more than a hero to Delacroix—his works served Delacroix as a storehouse of knowledge and energy. Delacroix claimed that the way Rubens painted water drops on a nymph *(below)* affected his whole theory of color. Delacroix also studied the master's organization of large paintings of historical events, in pencil sketches such as that he made of the *Debarkation (left)*. In his *Journal*, which mentions Rubens more often than any other artist, Delacroix wrote, "What an enchanter! I get out of sorts with him, have words with him because of his heavy forms, his lack of research and elegance. But how superior he is to all those little qualities which make up the whole baggage of others! By permitting himself everything, he carries you beyond the limit scarcely attained by the greatest painters . . . he overpowers you with all his liberty and boldness."

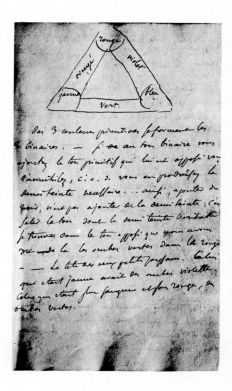

The Pursuit of Color

Delacroix studied color constantly, often noting details he found both in nature and art. A "color triangle" *(above)* from one of his notebooks shows how he diagramed basic principles: mixing two of the primary colors (red, yellow, blue) forms the secondaries (orange, green, violet). Complementary colors are opposite each other: red—green, blue—orange. Below his sketch Delacroix noted that the addition of black to a color merely dirties it—to produce a true half-tone one must mix in the complementary of that color. And he knew that juxtaposing a primary and a complementary intensifies both. Progressively, he used pure colors to achieve his tonal effects.

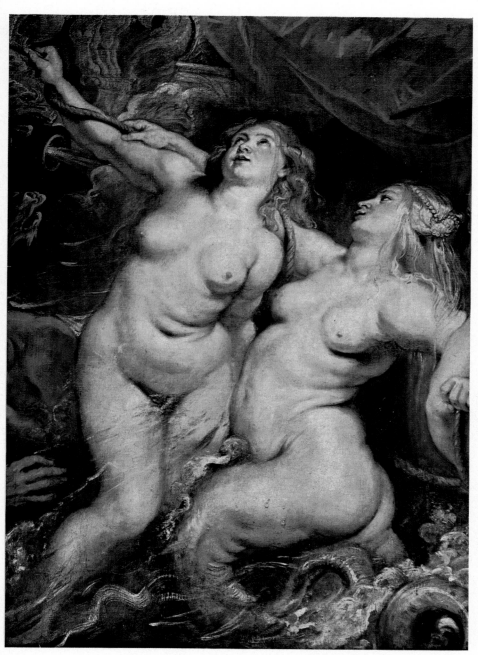

Peter Paul Rubens: *Debarkation of Marie de' Medici at Marseilles*, detail, c. 1625

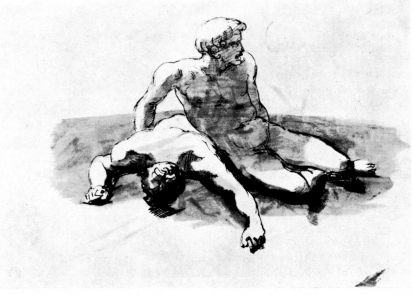

Face down, Delacroix posed as a *Medusa* survivor.

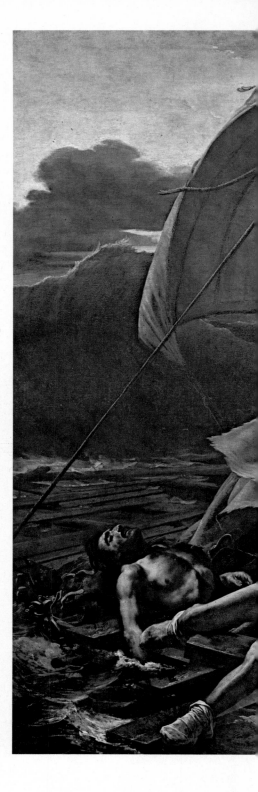

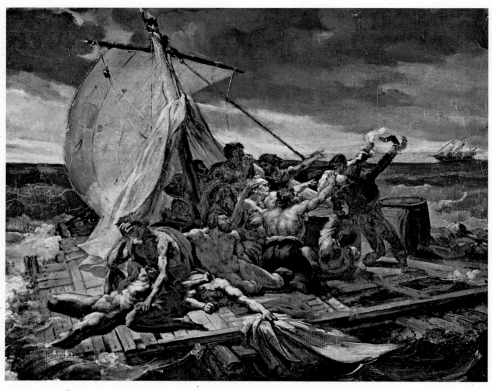

An early study for the *Raft* suggests how Géricault developed it.

Lessons of a Romantic Shipwreck

Studying in the same ateliers, exhibiting their paintings at the same Salon and competing alike for government favors, French artists in the early 19th Century were tightly bound together, both in their aspirations and rivalries. Delacroix was particularly friendly with Théodore Géricault, and he benefited greatly by watching the older man rough out and

plan his masterwork, *Raft of the Medusa*, painted for the 1819 Salon. The neophyte artist saw how Géricault planned the colossal 378-square-foot canvas in a large, especially rented studio. He saw the composition revised in successive sketches and saw how Géricault achieved his climactic effect by building two stressful pyramids—one based on the fallen

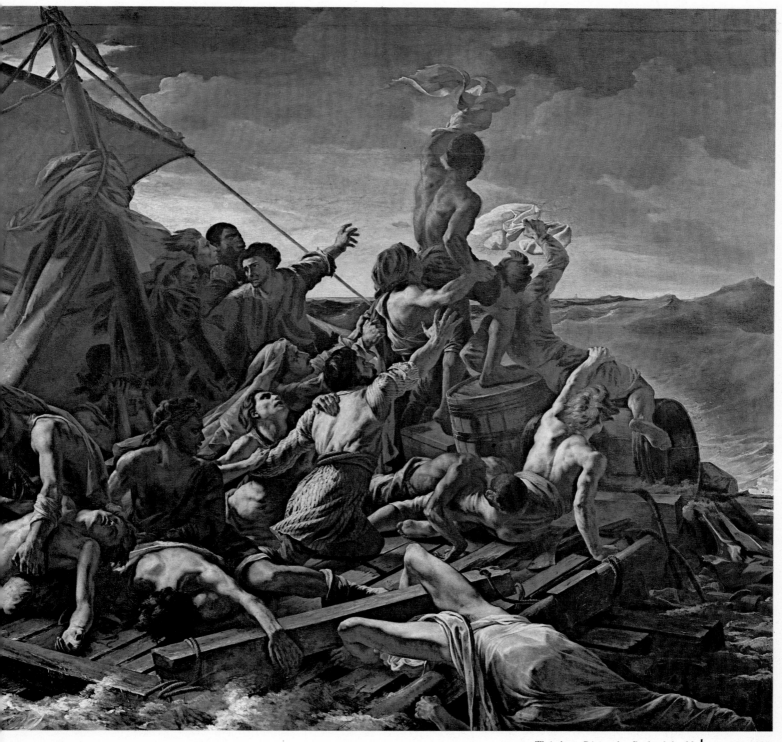

Théodore Géricault: *Raft of the Medusa*, 1818-1819

bodies of dead and dying, topped by the Negro
signaling a far-off rescue ship; the other formed
by the tilting raft, the guy lines and the mast. And
he saw how Géricault heightened the sense of drama,
in a truly Romantic fashion, by picking a moment of
maximum anguish and hope as the rescue ship
first appears on the horizon. He even saw the

picture from a model's point of view, posing as one
of the castaways.

It was five years before the *Raft* was bought by
the State, since many regarded it as a subversive
comment on the French Navy. Meanwhile, however, it
was a huge success in England: exhibited on tour,
it brought Géricault a fortune in admission fees.

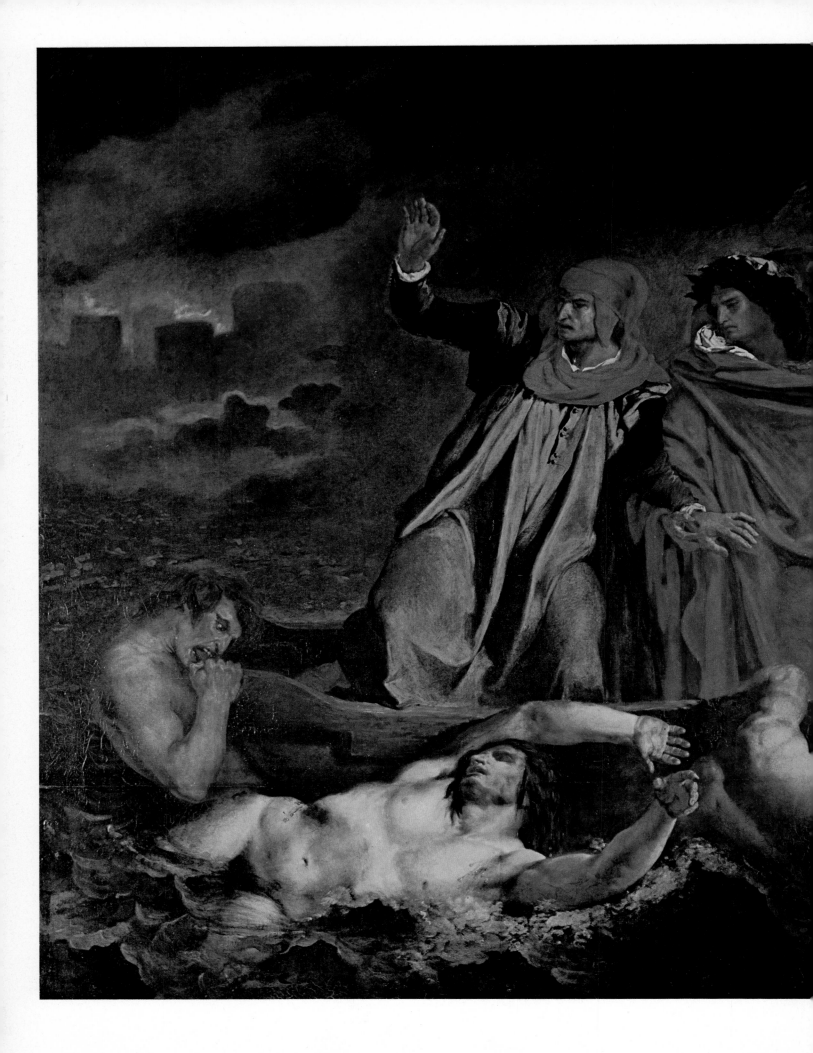

Magnified water drops
on woman's torso *(right foreground)*

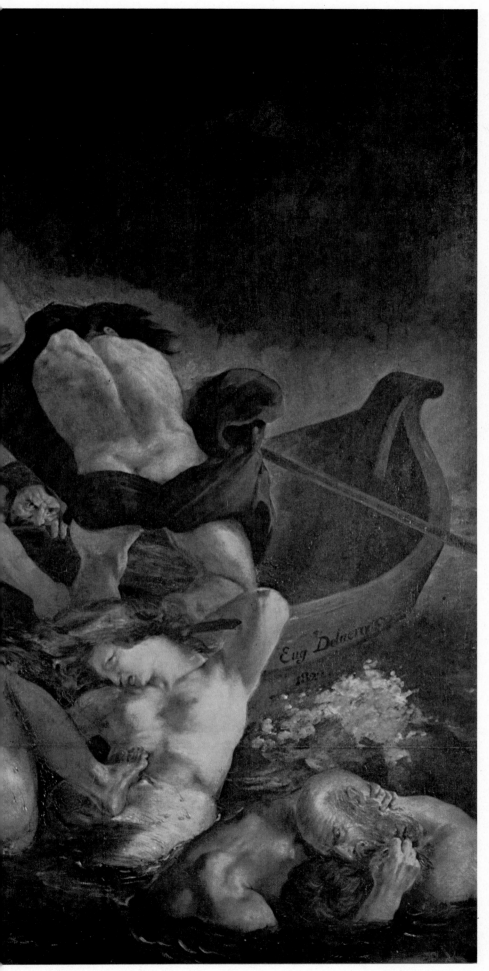

Bark of Dante, 1822

Sudden triumph came to Delacroix
at the age of 24 when he submitted his
first entry, the *Bark of Dante,* to
the 1822 Paris Salon. It was not
only accepted for hanging but also
purchased for the state's collection.
Delacroix, inspired by his wide
reading, took his theme from a
nonclassical source, Dante's *Inferno.*
He showed the Latin poet Virgil,
crowned with laurel, guiding Dante
through the underworld, while the
doomed souls of wicked Florentines
struggle to climb aboard their boat.
In its monumental figures the picture
owes a debt to Michelangelo; in mood
and treatment it recalls Géricault.
The water drops *(above)* show the
influence of Rubens: each is painted
with slashes of pure pigment which
at a short distance blend to create
an effect of glistening wetness
heightened by the use of complementary
colors. But the canvas is more than
the sum of its sources; Delacroix's
genius made it brilliantly his own.

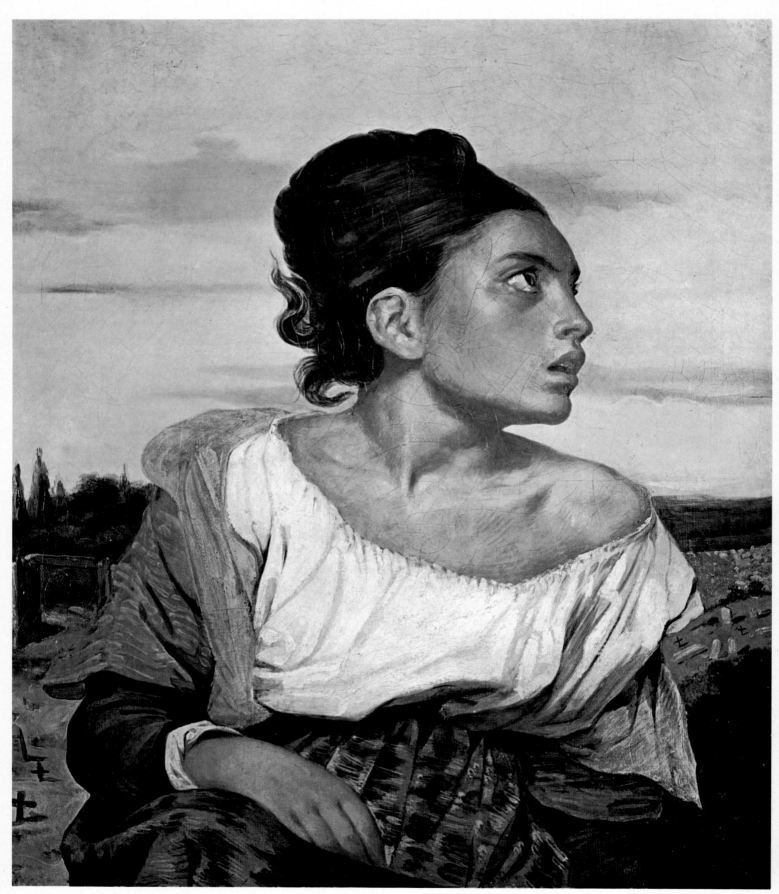

Orphan Girl in the Graveyard, 1823

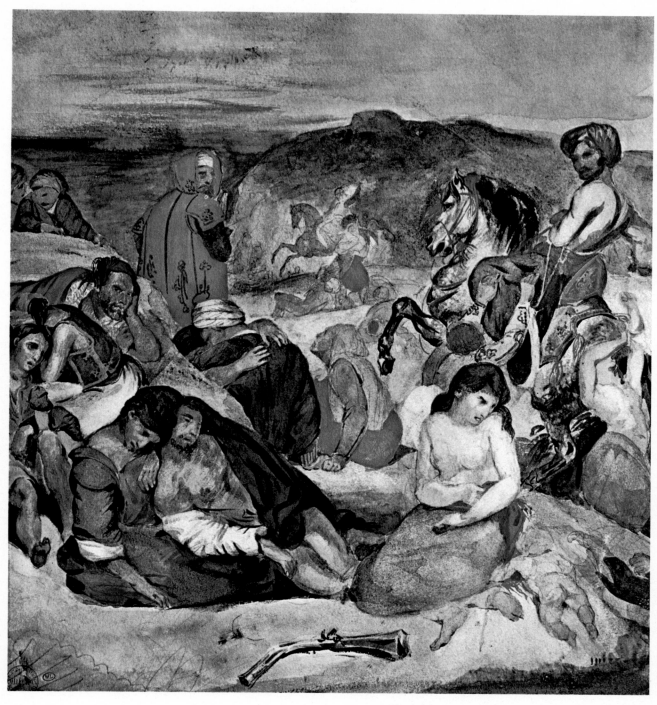

Watercolor compositional sketch for *Massacre at Chios*

Preparations for a Masterpiece

In theme and treatment, Delacroix's second Salon entry was a radical departure from his successful *Bark of Dante*. The massacre of innocent Greeks on the island of Chios by Turkish troops was a horror still fresh in European minds, and Delacroix determined to fix it forever in a large, dramatic work—not a historical set-piece, but a painting that would convey human suffering and dignify the individual by proclaiming his anguish. To sharpen his sensibilities, he painted several preliminary portraits, including that of the Greek model shown opposite, her face stunned with grief. He worked painstakingly over a color plan that would emphasize the contrast between the bloody slaughter and the island's cool light: a watercolor sketch *(above)* shows his predominant use of reds, blues and browns. Yet while he kept these basic colors in the final work, the accidental discovery of some new ideas led him to revise his treatment of them and of the composition, as shown on the following pages.

Delacroix lowered the horizon in
his final version of *Chios (below)*
to give it a vaster feeling of
natural light and open air
—a device which Constable used in
his landscape *Hay Wain (right)*.

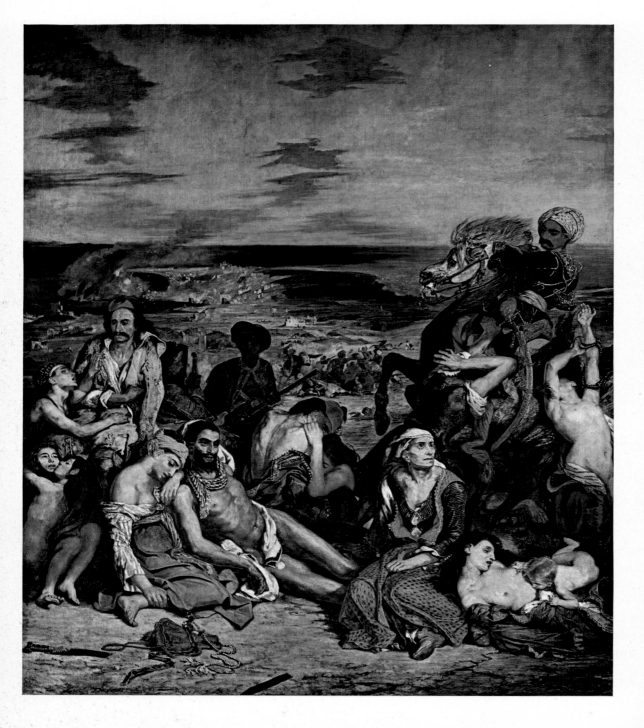

The postponement of the 1824 Salon because of the death of Louis XVIII and the almost simultaneous arrival in Paris of three paintings by the English landscapist John Constable proved to be crucial factors in the successful completion of the *Massacre at Chios*. With more time to work on his entry, Delacroix was now able to apply an important technique he found in the Englishman's work: his use of color to lend unity to his composition. Especially in the *Hay Wain (left)*, Delacroix was struck by Constable's touches of different shades of green, yellow and brown, side by side, to create the effect of trees and grass seen in the natural light of outdoors. These dabs of bright color reflected light in a way no smoothly blended pigments could, creating the flickering, vibrating sensation of real sunlight on real greenery. Delacroix immediately saw how the technique could be applied in *Chios*, also an outdoor picture under a wide sky. He tried it and liked it so well that he revised parts of the painting in the few weeks left before the Salon opened. The results are especially evident in the old woman in an orange dress in the foreground. A close-up of her arm *(below)* reveals hatchings of pink, orange-yellow and light blue, with flecks of green and red in the shadow of her elbow. Orange and blue are spattered over the skirt and over the sandy background. Delacroix was on his way to becoming one of the finest colorists of all time.

A Corner of the Studio, c. 1830

56

III

An English Journey

Like most artists before and since, Delacroix had persistently dreamed of seeing Italy. A visit to the Florence of Michelangelo, the Venice of Titian, Tintoretto and Veronese, the Mantua where the master he most admired, Rubens, had scored some of his finest triumphs, had seemed a pilgrimage altogether fitting and proper. As it happened, Delacroix was never to set foot in Italy. His first foreign journey took him in an opposite direction, to a country almost entirely antithetical—England.

Delacroix's immediate decision to go there was based on the urgings of Thales Fielding, a young Yorkshire painter who, with his brothers Copley, Theodore and Newton—also painters—had come to Paris to study and work. But there were other reasons why Delacroix's interest should have been aroused, among them the Romantic's sheer delight in the unfamiliar. During his boyhood England had been *terra incognita* to Frenchmen, off limits except to those well-born *émigrés,* refugees from the Revolution and from Napoleon, who sought asylum on its shores. War, blockade and embargo had cut off intercourse between the two nations until such time as England could best the man it had first derided as "Little Boney," but soon recognized as a threat to its supremacy.

With the restoration of a Bourbon king in France in 1815. the French and the English resumed the cultural rapport which had marked, and would continue to mark, their relations between periods of political enmity. Along with a renewed traffic in goods came a renewed flow of travelers and ideas. Homecoming *émigrés* brought back the cult of dandyism, the pursuit of fashion and formal excellence. Men of art, music, theater and letters made contact again. The works of Scott and Byron appeared in French editions. Shakespeare—whose plays had been translated in a great 20-volume work in the years just prior to the blackout imposed by the Revolution—was rehabilitated and indeed raised to new heights; on behalf of the literary avant-garde, Stendhal pronounced him superior even to the hallowed Racine.

As these new currents reached Paris, Delacroix embraced them with all the fervor of his youth and all the vigor of his sharpening intellect. He studied English with his friend Soulier, who as the son of an *émigré*

This little oil of his studio at 15 Quai Voltaire, where he lived and worked from 1829 to 1835, is one of many such "limbering-up" exercises Delacroix did while painting larger, more complex canvases for the Salons.

had grown up in London. Soulier also taught him watercolor painting —a technique he had picked up in England, where it had reached an advanced stage. It was through Soulier, too, that Delacroix met the Fieldings; for a time in 1823 he shared an attic studio in the Rue Jacob with Thales, and there first heard the glowing accounts of England that led to his trip.

On his own, Delacroix made friends with another young Britisher whom he had first noticed at the Louvre in 1816, "a tall adolescent in a short jacket, making some studies in watercolors from the Flemish landscapes." This was Richard Bonington, whose brilliant marine and architectural views were to enrich the mainstream of English art; Delacroix, ever alert to useful influences, observed the quick, almost carefree brush stroke and the fresh sparkle of the colors. Bonington's works, he wrote later, were "in a certain sense diamonds, by which the eye is pleased and fascinated quite independently of the subject and the particular representation of nature."

If Delacroix had any remaining doubt as to the value of a foray across the Channel, his encounter in 1824 with Constable's canvases dispelled it. Having assimilated Constable's ideas in his *Massacre at Chios*, and having won added fame as a result of this work, he was ripe for new experiences, and particularly in a land to which he already owed much.

Toward the end of May 1825 Delacroix boarded a boat for the Calais-Dover crossing of the Channel into which, over the ages, so much celebrated bile has been heaved; he wrote home proudly to friends that he had not been moved to contribute to it. His first reactions to London would be familiar to many a modern tourist. He arrived with a cold that hung on. The sun, he complained, was always in a state of eclipse. He didn't think much of English architecture, or of the lower classes. He found, as he wrote his friend Pierret, "something sad and uncouth in all this, which does not fit in with what we have in France."

On the other hand, he loved the "noble politeness" and hospitality of his English friends, and they saw to it that he was never bored. Almost every day brought novel enjoyments that he would put to future use on sketchpad or canvas.

He took in London's perennial pride, the theater, adored English actresses for their "divine beauty," admired the actor Edmund Kean in *Richard III* and *Othello*, and wrote Pierret: "Words fail to express my admiration for the genius of Shakespeare." If words failed, pen and brush would not; in his lifetime he would produce more than 20 works inspired by Shakespeare. Although he scorned English music—too many horns and trumpets—he extolled a version of *Faust*, "as diabolic as one could imagine," with a highly intelligent Mephistopheles, organ music and chanting priests offstage. The excitement of this production lingered; three years later it would help inspire his 17 celebrated lithographs of *Faust*, with all their stagey flamboyance.

The Fieldings took him boating on the Thames—his biggest thrill, "worth the whole trip"—in a six-oared scull, built, he rhapsodically reported, with the grace and delicacy of an Italian violin; he was further entranced by a yachting trip provided by an acquaintance of noble

rank. The combined experience made him, in his own words, *un fou de la marine*, a marine madman; his love of the sea would persist, and later fortify such works as the *Shipwreck of Don Juan*.

Even his choice of lodgings had its import for the future. He had already rented quarters when he met a Mr. Elmore, a professional horse dealer, who had a house on Edgware Road with stables nearby. He promptly moved in with Elmore, learned to ride—a skill which would profit him seven years hence on the sands of the Moroccan desert—and, more important, began to avail himself of the magnificent models on hand to indulge a passion formed prior to his English visit: the depiction of the horse in all its heroic grandeur.

It is difficult, in the mechanistic 20th Century, to grasp the extent of the 19th Century's fascination with the horse, but the phenomenon is one that deserves examination. The Romantics drew sustenance from the Platonic myth of the soul as a charioteer driving a team of wild horses. To them it epitomized the struggle between Reason and Emotion within every human breast. They loved to identify their emotions with glorious steeds, pawing, snorting, breathing fire through their nostrils. The Romantic mind was moved, too, by the bonds between horse and man. Did not the horse add stature to any man who mounted him? Did not man owe more of his conquests to the horse than to other men? In the recent Napoleonic Wars, cavalry forces had roared like triumphal tidal waves across Europe. Before long, doomed like a tragic hero, the horse was to be replaced by bloodless machines. In art he was having his last splendid victory, his apotheosis.

Classicists and Romantics alike had chosen to portray this noble animal according to their own lights. Among the themes most favored by Romantic artists was Byron's poem *Mazeppa*, published in 1819, which tells of a jealous Polish count who bound his wife's Cossack lover, Mazeppa, to the back of a wild horse and sent him forth to die in the wilderness. After a terrifying ride through burning desert and icy streams, the horse finally drops exhausted, and the dying Mazeppa is rescued by a Cossack maiden with a sure hand at practical nursing. Franz Liszt made Mazeppa the subject of a symphonic poem. Géricault headed a long list of painters who put the tale on canvas; Delacroix was to follow suit several years after his exposure to the Elmore stables.

Delacroix made relatively little direct contact with major English artists during his stay in their country—a matter of perhaps less moment than it might have been without his busy schedule of self-instruction. Constable was away from London; so was the other titan of English painting, J.M.W. Turner. Delacroix did call on the fashionable portraitist, Sir Thomas Lawrence, noted that he was "the most gracious of men except when anyone criticized his pictures," and characteristically came away with an idea for portraiture—a single figure posed elegantly against a background of sky—that he was to exploit effectively in his own work in this field.

For the most part, however, Delacroix was content to make the rounds of galleries, public and private, sometimes alone, sometimes in the company of three young fellow painters from Paris—Eugène Isabey,

Free, instinctual and passionate, the horse was a natural symbol for Romantic painters. In neoclassicist hands it had been rigidly restrained, reined in by man, as in the detail at top from David's *Sabines*, where even its mane is tightly bound in classical curls. But Géricault's *Head of a Napoleonic Horse (bottom)* is quite a different animal: though still restrained, it is wild-eyed, with flaring nostrils and a free-flowing mane.

Hippolyte Poterlet and Eugène Lami—who were drinking in English art and ale. Spread before him on the gallery walls was ample evidence of England's own brand of Romanticism. Delacroix could recognize kindred spirits, but on the whole English Romantic painters tended to express themselves in terms more personal than their French allies. For one thing, the shocks of history had not jolted them so rudely out of their private visions. For another, the Englishman—despite his show of conformity—retained a stubborn individualism that sometimes, indeed, carried him to the wildest shores of eccentricity.

There is no record that Delacroix saw any of the works of that visionary genius, William Blake. But some of Turner's luminous fantasies which had begun to hint at a total disintegration of form were on display. And so were the works of the remarkable Swiss-born artist, John Henry Fuseli, who had lived in England most of his life, and who had died just a month before Delacroix arrived; he had been buried with high honors in St. Paul's Cathedral next to Sir Joshua Reynolds. Fuseli specialized in ghoulish scenes that might have been taken from Gothic horror fiction. In one of his more celebrated efforts, the *Nightmare*, painted in 1781, a phosphorescent horse's head—a literal night mare—rises up like a swamp light to inflict some nameless horror on a sleeping girl on whom a monstrous dwarf is perched. The theme was not one that Delacroix would care to emulate, but he came to admire Fuseli and to salute his manifest objective—a search into the hidden corners of the human mind.

England served Delacroix well, just as it had served so many Frenchmen, from Voltaire to Chateaubriand, who had gone there to escape their enemies or enliven their minds. His visit spanned only three months; its benefits lasted a lifetime. The dry strictures of the French Academicians were left behind for good. The images he had stored up of racing horses and river trips, the memory of resplendent theater, the example of painters unbridled in the exercise of their imaginations—all had become part of him, all would help mature an art that must, he now insisted, be always fluid and dramatic.

Half a century hence a Monet would paint canvas after canvas devoted exclusively to haystacks; a Cézanne would repeatedly memorialize his beloved Mont Sainte-Victoire. Such whole-souled dedication to a single theme was not for Delacroix. The English journey had widened his world and whetted his curiosity; when he took up his palette on his return home, few subjects escaped his scrutiny. Over the next years his painting achieved a variety and versatility seldom rivaled in the annals of art: in a rich succession of pictures he ranged from nudes to narrative fiction, fashionable portraiture to historic tragedy, still life to the sufferings of Christ.

In an age when nakedness was usually made to look as polite as formal dress, Delacroix produced a number of nudes remarkable for their honest sexual vitality. Painted with the tenderness of a gentleman and the appreciation of a man, Delacroix's models—his Émilie, Marie, Hélène, Rose, Laure and Adeline—join the great series of supine beauties who recline through the history of art from Titian onward.

Three of these reclining ladies by other artists achieved special renown during Delacroix's lifetime: Goya's *Maja Desnuda*, Ingres' *Grande Odalisque*, and Manet's *Olympia*. At least two of Delacroix's women merit a place in their company. His *Woman with a Parrot*, lying like Venus on shell-pink silk, set off with splashes of tangerine, yellow and violet, is not only a sumptuous feast of color but a miracle of delicacy and animal charm. His *Odalisque* is a very small work, scarcely more than a passionate little agitation of his brush. But of all the would-be seductresses who have assumed this pose, Delacroix's girl is one of the few, along with Goya's *Maja* and Manet's *Olympia*, who looks as if she were present for any other purpose than to have her likeness painted.

Concurrent with these paeans to womanhood, Delacroix was creating a series of lamentations on man's injustice to man. Apparently he worked at each to suit his mood of the moment; no painter ever put the fluctuations of his temperament to better use. Delacroix's moods swooped up and down like a kite in a hurricane, lifting him to the brightest heights and plunging him to the blackest depths—and none of it ever went to waste.

The most notable of the lamentations concerned the tragic fate of the 16th Century Italian poet Tasso, author of the epic *Jerusalem Delivered*, who had been imprisoned as a lunatic for seven years. "What tears of rage and indignation he must have shed," Delacroix wrote. "How often he must have beaten his head against the bars when he thought of the baseness of human beings!" Delacroix produced three pictures of *Tasso in the Madhouse*, tormented and baited by brutish keepers and inmates. In the same desolate vein he painted *Christ in the Garden of Olives*, in which an infinitely weary Christ turns his head away from three weeping angels.

The strain of melancholy running through these works was in tune with Delacroix's era. Early 19th Century Romantics specialized in melancholy: it represented a patriotism of the soul, indicating that a man was intelligent enough to discern and deplore the world's woes and sensitive enough to grieve over the disparity between how good life could be and how bad it usually is. "How can this world, which is so beautiful, include so much horror?" Delacroix once cried out to a friend. But, as with most Romantics, he did not find that melancholy dampened his ardor for life. To suffer with Tasso and Christ was part of the richness of living.

Delacroix was not, of course, forever in the depths—or, for that matter, on the heights. Much of his time during these fertile years of the middle 1820s was spent in simple absorption in his art. The astonishingly diverse results are exemplified in three paintings executed—along with the nudes and lamentations—between 1825 and 1827.

The first, *Tam O'Shanter*, is a scene from the Robert Burns ballad of the farmer who manages to elude a witch and ride home safely to his wife. Delacroix shows the tipsy and terrified man on horseback speeding through the misty night as the beautiful young witch, feet off the ground and flying like a streamer in the wind, clutches the horse's tail. This is melodrama in high humor; Delacroix painted it as if he had

In English hands—as Delacroix discovered —the horse was even wilder than Géricault's *(opposite, bottom)*. George Stubbs, whose *White Horse Frightened by a Lion (top)* was painted in 1770, anticipated the Romantic mood; and Henry Fuseli, in a horse from his *Nightmare (bottom)*, added a fearful fantasy which Delacroix admired. And all these sources contributed to Delacroix's own vision of the Romantic steed.

61

squeezed out blobs of fog on his palette and swept them across his canvas with the witch chasing his brush.

The second, the *Execution of the Doge Marino Faliero (page 73),* depicts the headless body of the ruler of Venice lying at the bottom of the marble stairs of his palace, barely noticed by his functionaries. The scene—a fanfare of Venetian color—seems at first to be merely a spectacular episode from grand opera. It is, rather, a stately saraband of slaughter danced out in frozen splendor, chilling as the little black sphinx whose head is turned away from the bleeding heap of death. All of Delacroix's love of the stage is fused in this work; it marks a triumph of theatricality.

The third, *Still Life with Lobsters,* was painted for General de Coëtlosquet, husband of the woman who was presumably Delacroix's once beloved "Cara." The general, indeed, may have helped decide what should go into the work: two cooked lobsters, a pheasant, a rabbit, a tartan game bag and a handsome landscape with four red-coated hunters moving across the blue-green hills. Also included is the general's rifle, which he lent to Delacroix to copy. Apparently the edible ingredients represent the hunters' lunch; it is harder to account for the little wriggling lizard in the foreground, except perhaps as a bow to tradition—lizards frequently appeared in still lifes of previous centuries. In a genre which can be notably trite, Delacroix achieves great originality *(page 75).* He combines the intimate elements with a grand sweep of landscape; he effects a startling change of scale which permits the tiny lizard to occupy more space than the four hunters. Despite—or perhaps because of—its somewhat bizarre admixture, the painting has firm authority and a mysterious dramatic life of its own.

In his youth, Delacroix once recalled, he would bargain with himself to do a day's work only if he were rewarded with a night's play: "I was unable to get down to work unless I had the promise of some pleasure for the evening—some music, dancing, or any other conceivable diversion." And so it was after his return from England; the diversions were more mature, but the need—in view of his furious pace of work—no less urgent.

He became a familiar figure at the Paris salons—those amiable gatherings at private homes where politics and literature and art were discussed for the pure pleasure of discussion. He also grew closer to Richard Bonington, with whom he shared a studio for a time, and from whom he secured invaluable help on the architectural details of *Marino Faliero.* Bonington proved a boon in another way as well. He introduced Delacroix to Eugénie Dalton, a dancer at the Opéra, who became Delacroix's adoring mistress. Married to an Englishman, Eugénie had achieved some fame as an angel who gazed with piercing soulfulness at Christ in a theatrical religious spectacle. She had been a mistress of the painter Horace Vernet, and Bonington had felt moved to do a delightful pencil sketch of her *(page 135),* looking angelic indeed with her soft curls, tender smile and a hospitable sweetness. Of her openheartedness there was little doubt. She once sent Delacroix an invitation which showed surprising frankness for an age when frankness was more

These costume sketches, possibly copies of 16th Century German prints, are among hundreds Delacroix drew in doing research for his large paintings of historical and literary subjects. Using old books, paintings and engravings, he tracked down useful details of dress, gesture and accessory.

often put into action than into writing. "We will dine together," she wrote, "and then go to bed."

Their affair and subsequent friendship lasted for 15 years. It was for Eugénie that he painted *Tam O'Shanter*. Ever *simpatica*, she took up painting and lithography herself and exhibited at the Salon. At one point she even won a medal with her *Landscape with Figures*, which showed evidences of her lover's helpfulness in correcting her work.

Eventually, their relationship would founder, partly as a result of his cooling interest, partly because of a faithful servant he acquired named Jenny Le Guillou. A peasant woman, Jenny guarded her master with watchdog ferocity, and was to figure more and more importantly in his life. When Eugénie came to call one day, Jenny barred her at the door, saying that such visitations left Delacroix too exhausted for his own good. Eugénie soon thereafter left France. In 1859 she died in Algiers of a breast cancer. Her daughter Charlotte wrote to Delacroix asking for a portrait of her mother, and went on to say, "Near her, I found all the drawings and paintings she had from you. She sent you her farewells, and bade me to tell you that she always remembered your kind friendship." Delacroix sent Charlotte the requested portrait.

Fortunately, however, when Eugénie and Delacroix first met no hint of their star-crossed finale was discernible. He was nearing 30, happy, confident, busy, on the brink of mature fulfillment as an artist —and he devised a plan to bring him closer to that point.

As the 1827 Salon approached, Delacroix decided that he would submit not one or two, but fourteen of his paintings. Among them were three already noted: *Christ in the Garden of Olives, Marino Faliero,* and *Still Life with Lobsters.* Ten others give testimony, by their titles alone, to the enormous range of his interest: *Milton Dictating "Paradise Lost" to His Daughters; Faust; Two Horses of an English Farm; Head Study of an Indian Woman; Emperor Justinian Composing the Institutes; Young Turk Fondling His Horse; A Herdsman from the Roman Countryside, Wounded Mortally, Crawls to the Bank of a Marsh to Quench His Thirst; Scenes from the Present War Between the Turks and the Greeks; Baron Schwiter* and *Portrait of the Count Palatiano in the Costume of a Palikare.*

The 14th painting—a work which was to stir up more of a storm than anything else Delacroix ever produced—was the *Death of Sardanapalus (pages 76-77).*

Sardanapalus was influenced strongly by Byron's play of the same name, which had been suggested, in turn, by a description by the ancient historian Diodorus of Sicily of the luxurious life and lurid death of an Assyrian king whose enemies were about to destroy him. "He built an enormous pyre in his palace," wrote Diodorus, "heaped upon it all his gold and silver as well as every article of the royal wardrobe, and then, shutting his concubines and eunuchs in the room which had been built in the middle of the pyre, he consigned both them and himself and his palace to the flames."

The story obviously held an enormous appeal to the Romantic mind. Its visual trappings are exotic and magnificent. Its violence is appalling. In Delacroix's version, Sardanapalus orders his retinue to be slain

before cremation, presumably to make their deaths less painful. In the midst of carnage the King lies on his royal bed, oblivious of the massacre he has commanded, in a state of total renunciation, perceiving the futility of trying to fight off his enemies, forswearing the world in all its beauty, all its delights, all its strife.

Delacroix identified himself with the King, even in appearance, and called him "My friend Sardanapalus." It is doubtful if he conceived of him, as some art historians have since, as a vengeful monarch intent only on destroying life. It would seem rather that Sardanapalus, like Delacroix in his own black spells of depression, was sated with the life of the senses and overcome by utter hopelessness.

Other writers on *Sardanapalus* have seen its writhing nudes, submitting their bodies to torment and death, as a pictorial paraphrase of a sadistic orgy. Whatever the case, it is a measure of the picture's interest that it reverberates with not one but many meanings.

In every pose, in every act of violence he depicted, Delacroix sought for variety within an all-encompassing concept. The full-length nude with her body bent backward to receive the dagger in her breast is complemented by the Ionian slave Myrrha, the King's favorite, bent forward at the bed to receive another *coup de grâce*. The concubine about to be strangled with a green scarf is a close variation on the other concubine about to hang herself with a white scarf. The chaotic, indiscriminate quality of violence is emphasized by the magnificent horse with its braided, tasseled mane, its golden harness, rearing in panic as it is about to be stabbed by a turbaned blackamoor. Two orange reins, drawing the horse forward, stand out against his slayer's dark flesh—two taut, straight lines in a welter of serpentine curves.

Sardanapalus, indeed, is a fugue of curves. The curve of the golden lyre on the floor echoes the curve of the slave girl's hips. The curve of a falling drapery is repeated in the curve of a shoulder or breast. Perhaps most ingeniously, the shape of a headdress, only dimly visible in the background, is seen again in the shape of an elephant's head carved on the King's bedpost. But all this profusion of detail is never allowed to detract from the picture's total impact. It is probably the best organized clutter in art history.

For Delacroix, *Sardanapalus* was a supreme statement of the Romantic dilemma and, like *Massacre at Chios*, it was another milestone in his career. He called it, in fact, "Massacre number two." Achieving his full command of color, he referred to his palette as "an instrument that plays only what I want to make it play," and chose to create a symphony of vermilion and gold, shifting into umberish minor keys and back into bravura passages of dazzling whites and flesh tones. One of his friends reported that the picture was originally much darker, but that Delacroix was so bewitched by Myrrha's luminous flesh that he lightened the whole painting to match her radiance. If true, the story strikingly exemplifies the tenacity of his belief that a picture should create a harmonious unit, with every part fitted into the whole. No white body should stand out unduly; no separate element, no matter how beautiful, should steal the show. This sense of unity, he believed, should govern

every brush stroke, every color tone, and dominate—even obsess—the artist's mind.

Working on *Sardanapalus*, Delacroix himself entered the spirit of the painting. He stinted nothing, tried everything. His own unrestrained outpouring shows up in his earliest pen-and-ink drawings—swirling arabesques that are exciting as pure abstractions—in his experimental pastel and watercolor sketches, in the reckless abandon with which he flung aside the laws of perspective in order to fit figures into a diagonal composition shaped like a cornucopia spilling its riches across the canvas. In the completed work, he filled the lower part with all kinds of objects and props, easily observable at eye level. The moral lessons of the picture are higher up; one can see them only by stepping back and tilting one's head toward heaven. But the floor of the painting looks like an explosion in an oriental bazaar, any square yard of which would make a sumptuous still life.

The Salon jury accepted *Sardanapalus* for hanging, but was obviously stunned, and the public shouted, "Scandal!" Delacroix was compared to Icarus, who had tried to fly too high and crashed to earth. Even his usual admirers among the critics were aghast; one cried, "He has been carried away beyond all limits." As if in shame, the picture vanished for nearly a century; finally, in 1921, the Louvre bought it from Baron Vitta, a Delacroix devotee who had been guarding it for years in his private collection.

Delacroix himself was frightened by his "damned picture." He confessed to Soulier, "When I arrived in front of it, it gave me a terrible shock . . . it feels to me like the first night of a play that may well be hissed off the stage." A month later, he looked at it more soberly: "A real fiasco? . . . I am not at all sure. . . . If there are things that I could wish improved, there are a good many others that I think myself happy to have done."

At the same time the Salon accepted *Sardanapalus*, it rejected another picture by Delacroix that was its exact opposite: a portrait of his friend, young Baron Schwiter *(page 74)*. A superb evocation of a French dandy, the work could not have been painted prior to Delacroix's English visit; it is clearly in the tradition of the full-length portraits in landscape that had been an English speciality ever since Gainsborough.

Had *Sardanapalus* and *Schwiter* been hung side by side, the contrast would have been astonishing. While *Sardanapalus* was all flame and tumult, *Schwiter* was as cool as a country lake. Its liquid greens could have extinguished all those vermilion fires. Here, in contrast to the King's gaudiness, Delacroix distilled the essence of aristocratic reserve. The Baron all in black, with his pinched waist, the discreet flash of red in his hat, one glove on, the other glove off, a hint of primness in his stance—all this added up to more than a personal portrait. It was the portrait of a social attitude, a phase of the Romantic era that Delacroix personified in himself. He, too, could be aloof and over-refined. But, like the Baron, he also had self-discipline and staying power. Within himself Delacroix had his own cures for his own excesses. His *Baron Schwiter* was an antidote to *Sardanapalus*.

For generations of French artists, the Salon exhibitions planned by the Académie des Beaux-Arts were fateful events. Here their talents were submitted to a trial whose verdicts could mean life or death to their careers. Begun in 1667, when the Academy was founded, Salons were sponsored by the King and held in his palace, the Louvre. At first they were open only to Academy members, but later all artists were eligible. Salon juries, composed of Academy members, decided which works would be shown, and awarded prizes —and success meant more than prestige alone. Portrait painters, for example, were often paid a bonus of 20 per cent if their patron's picture was hung at the Salon, 50 per cent more if it won a prize.

The prize system and the conservative tastes of the Academy put a premium on conformity, leading many artists to crank out imitations of the previous Salon's successes. Nonetheless, for many years the Salon was beneficial, stimulating much public interest and encouraging young artists.

Following his triumphs at the Salons of 1822 and 1824, Delacroix exhibited regularly. He sold many works and received lucrative commissions. But he applied eight times and had to wait for 30 years before the Academicians granted him the final accolade: in 1857, in continuous bad health, and only six years away from death, Delacroix was at last elected to membership in the Academy.

Life and Death at the Salon

In the 1785 Salon, David's *Oath of the Horatii (page 22)* occupied a central position, high up on the Louvre's crowded wall. Admission was free to all, but the nobility sometimes had private showings.

A contemporary engraving of the Salon of 1785

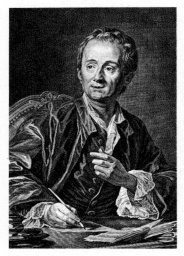

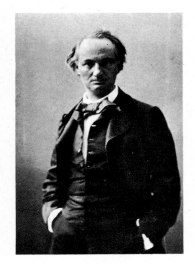

Denis Diderot Pierre-Charles Baudelaire

Art criticism was unknown before the first Salons, but as public interest developed, newspapers and magazines began to publish essays and comments about the paintings shown there. Diderot, the French Encyclopedist, set high standards in Salon reviews he wrote beginning in 1759. But Baudelaire, who was a friend of Delacroix's, may be considered the first modern art critic: he used his intuitive appreciation of paintings and withheld moral judgments.

Honoré Daumier: *Before the Print Seller's*, c. 1860

By 1824 the Salon was an integral part of French cultural life. That year, Charles X handed out prizes at the closing ceremonies *(above)*, and flocks of visitors crowded the Louvre galleries buying catalogues which identified and pictured the works on view. Art critics meted out praise or condemnation in newspapers and popular magazines. Engravers worked overtime making copies of the most popular works which were sold in print shops along the Seine; Honoré Daumier, the great chronicler of middle-class life, later pictured one such stall with copies on display *(left)*.

In 1824 Ingres won Academy membership for his painting, the *Vow of Louis XIII*. Delacroix was awarded a medal, second class, for his *Massacre at Chios*.

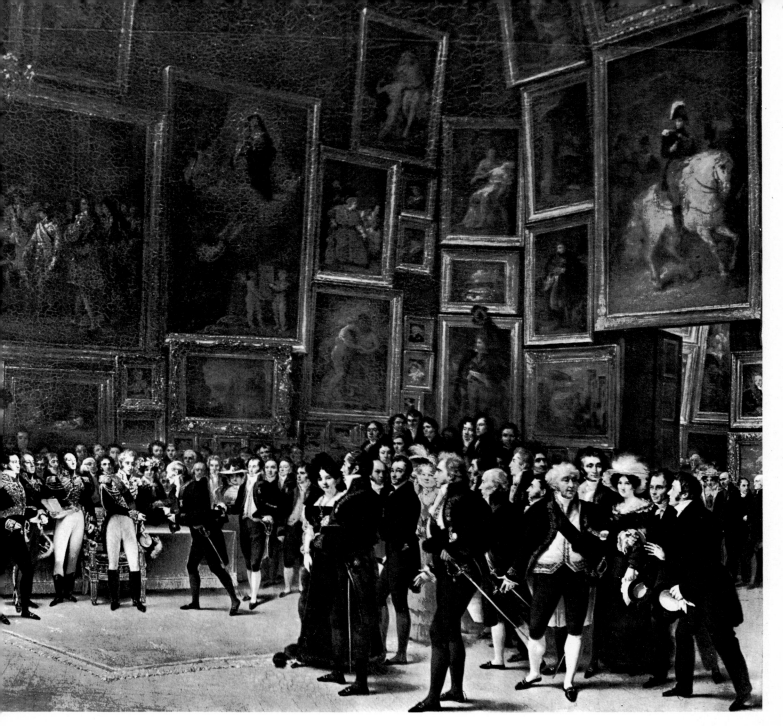

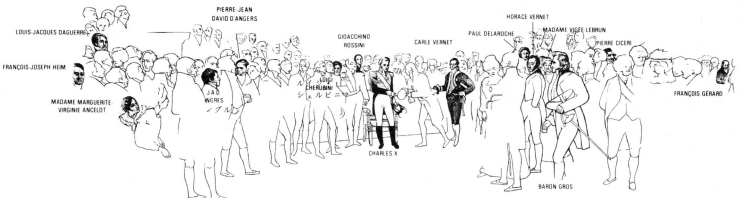

LOUIS-JACQUES DAGUERRE

PIERRE-JEAN
DAVID D ANGERS

FRANÇOIS-JOSEPH HEIM

MADAME MARGUERITE-
VIRGINIE ANCELOT

J A D
INGRES

LUIGI
CHERUBINI
シェルビニ

GIOACCHINO
ROSSINI

CARLE VERNET

CHARLES X

PAUL DELAROCHE

HORACE VERNET

MADAME VIGÉE-LEBRUN

PIERRE CICERI

FRANÇOIS GÉRARD

BARON GROS

Salon award ceremonies brought together the cream of Paris society. Pictured at the 1824 Salon were the hostess Madame Ancelot, the Italian composers Rossini and Cherubini, and the famous stage designer Ciceri. The painter who made

this portrait gallery included himself *(far left)*, along with fellow artists Delaroche, the Vernet brothers, the fine woman painter Vigée-Lebrun, Gros, Gérard, Ingres, David d'Angers and the painter-photographer Daguerre. Delacroix was not included.

François Picot: *Amour and Psyche*, 1819 Salon

The Salon," wrote Ingres, "stifles and corrupts the feeling for the great, the beautiful; artists are driven to exhibit there by . . . the desire to get themselves noticed at any price. Thus, the Salon is literally no more than a picture shop, a bazaar in which . . . business rules instead of art."
Ingres was embittered by the critical rejection of a painting in 1834; and although he had been highly praised for his *Oedipus (right)* and had been made a member of the Academy, he withdrew from competition for 20 years. The situation he deplored had developed over the years. By the middle of the 19th Century, almost 9,000 works were submitted for each Salon, and due to limited exhibition space, juries had to reject nearly 4,000 of these. Artists were forced to find ways of assuring acceptance.

Théodore Chassériau: *Toilet of Esther*, 1842 Salon.

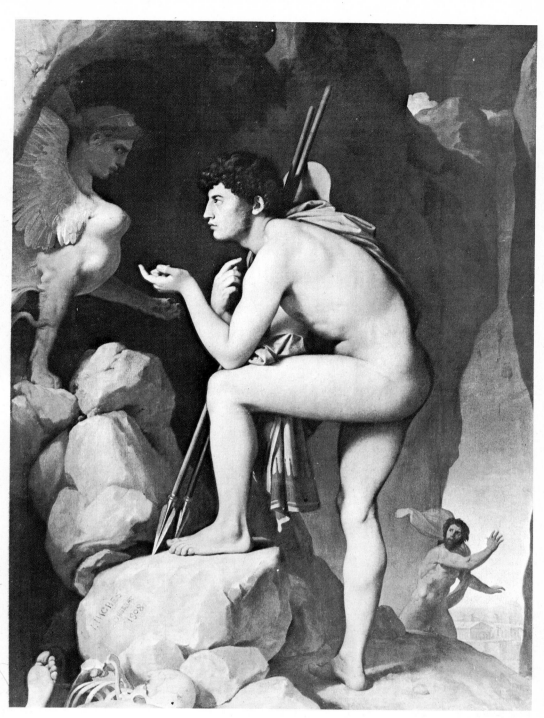

Charles Callandé de Champmartin:
Remus and Romulus, 1842 Salon.

Ingres: *Oedipus Solving the Riddle of the Sphinx*, 1827 Salon.

Simply to attract attention on overcrowded walls, some of them painted
huge historical epics. But if the state neglected to buy the canvas for its
collections, it was rolled up and stored away. Few artists dared to strike
out with new subjects or techniques. Each Salon abounded in nubile maidens,
muscular youths and chubby babies set in anecdotal scenes of classical and
Biblical history like those shown here—all variants on previous successes.
Serious painters interested in the human figure had to pretty up their nudes
or work them into a mythological story to avoid being denounced as "vulgar."
Banal as they were, however, almost all the works shown were competently
painted. While the Academy juries discouraged innovation, they denounced
incompetence, and technical excellence was remarkably common.

Delacroix's Riches at the 1827 Salon

The Salon of 1827 was a milestone for Delacroix. He submitted entries displaying a dazzling diversity of techniques and subjects. The Salon jury chose 11— an impressively large number—and when the show was held over for another year, permitted him to make changes and bring his total to 13. Six of the pictures are shown here and on following pages. The watercolor of Faust *(right)*, different in style from the lithographs he did later, shows how he explored a subject in various media. His Christ scene *(below)*, painted for a Paris church, was admired by the critics for its angels. The sumptuous tableau of *Marino Faliero (far right)* was a souvenir of his recent journey to England. Its theme is from Byron and its treatment shows the influence of Bonington, an English watercolorist who, unlike Delacroix, had seen Venice. In its bold color patterns it also echoes the Venetian master Veronese.

Faust, 1826

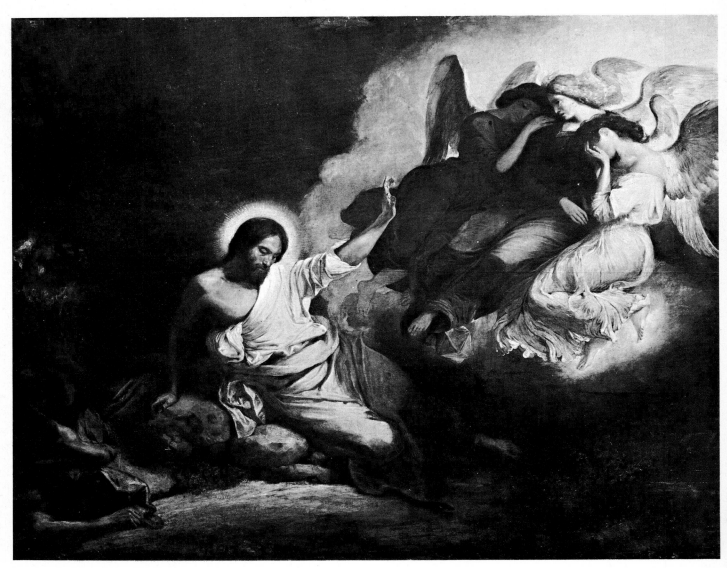

Christ in the Garden of Olives, 1827

72

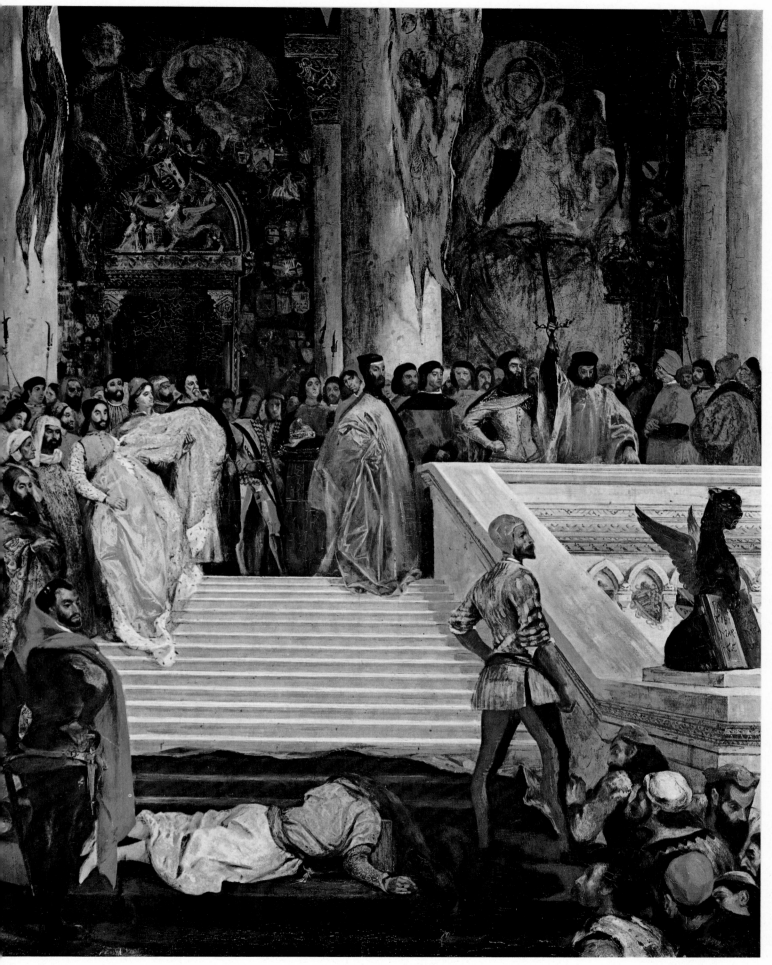

Execution of the Doge Marino Faliero, 1827

73

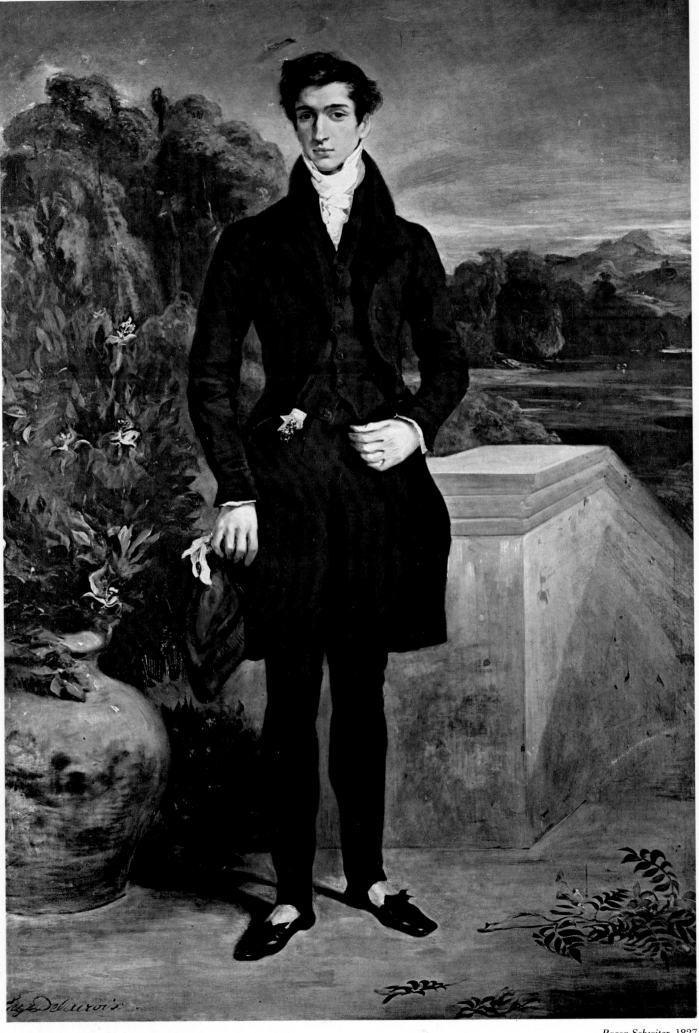

Baron Schwiter, 1827

The Salon refused this portrait of a Parisian dandy, which would have been Delacroix's 14th entry. The shape and color of the figure led Delacroix's assistants to nickname the painting "The Violin Case."

Stimulated by his English trip and a reading of a new translation of Milton's *Paradise Lost*, Delacroix re-created a scene showing the great poet, totally blind, dictating his epic to two diligent daughters.

More interested in human drama than in inanimate objects, Delacroix painted few still lifes. In this unusual one, he placed his objects in a sweeping landscape, deftly combining two distinct genres.

Milton Dictating "Paradise Lost" to His Daughters, c. 1826

Still Life with Lobsters, 1827

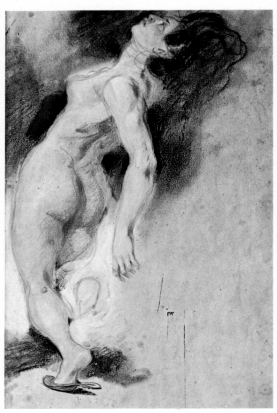

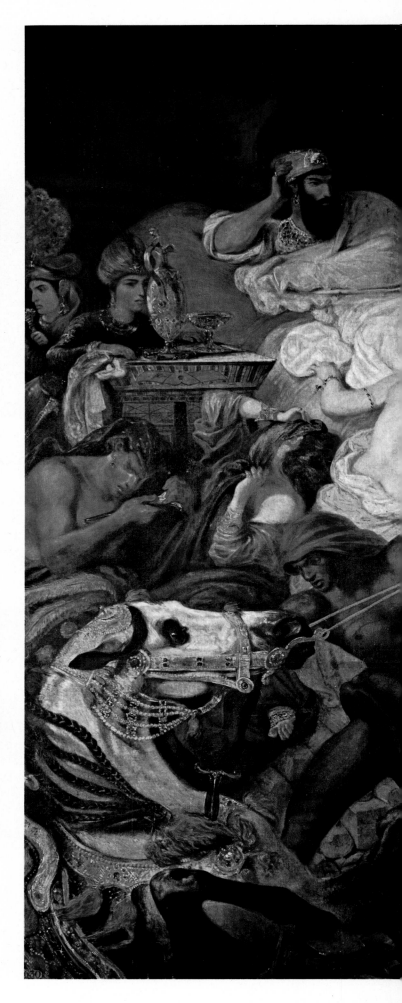

Pastel sketches for *Sardanapalus*

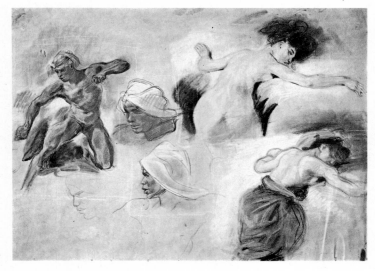

The *Death of Sardanapalus*, Delacroix's most
ambitious and sensational entry in the 1827 Salon,
was partly inspired by a Byron play. Its hero, a
disillusioned Assyrian King, gathers around him
all his treasures—women, horses and costly
baubles—and sets fire to them all, including
himself, to escape the world's madness.

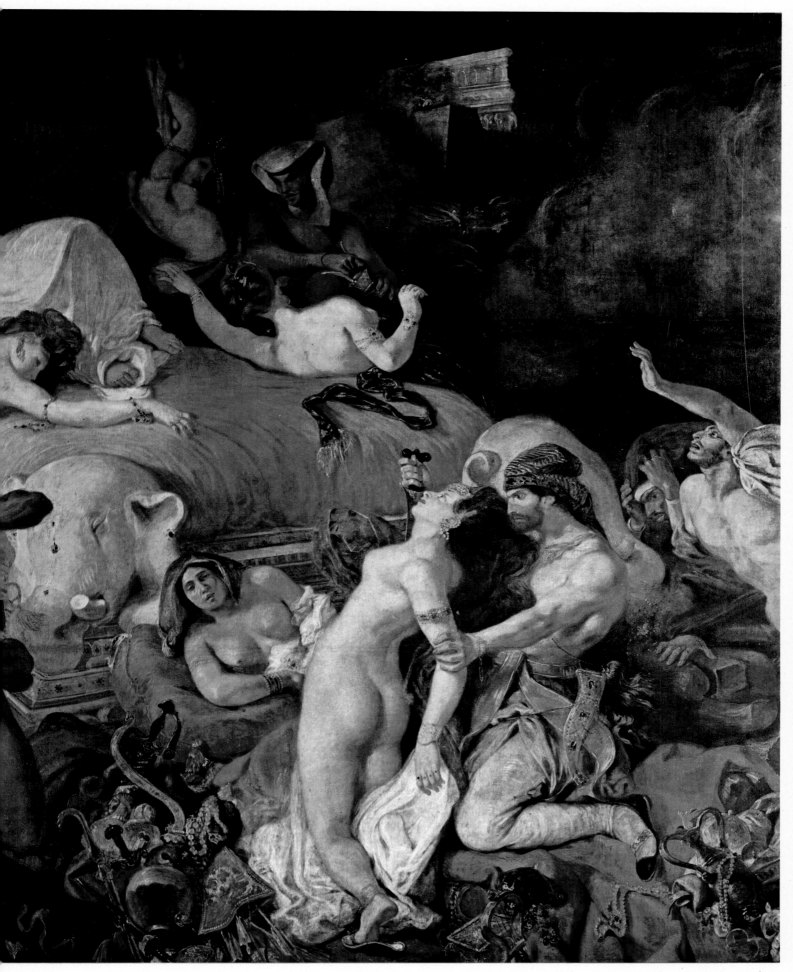

Death of Sardanapalus, 1826

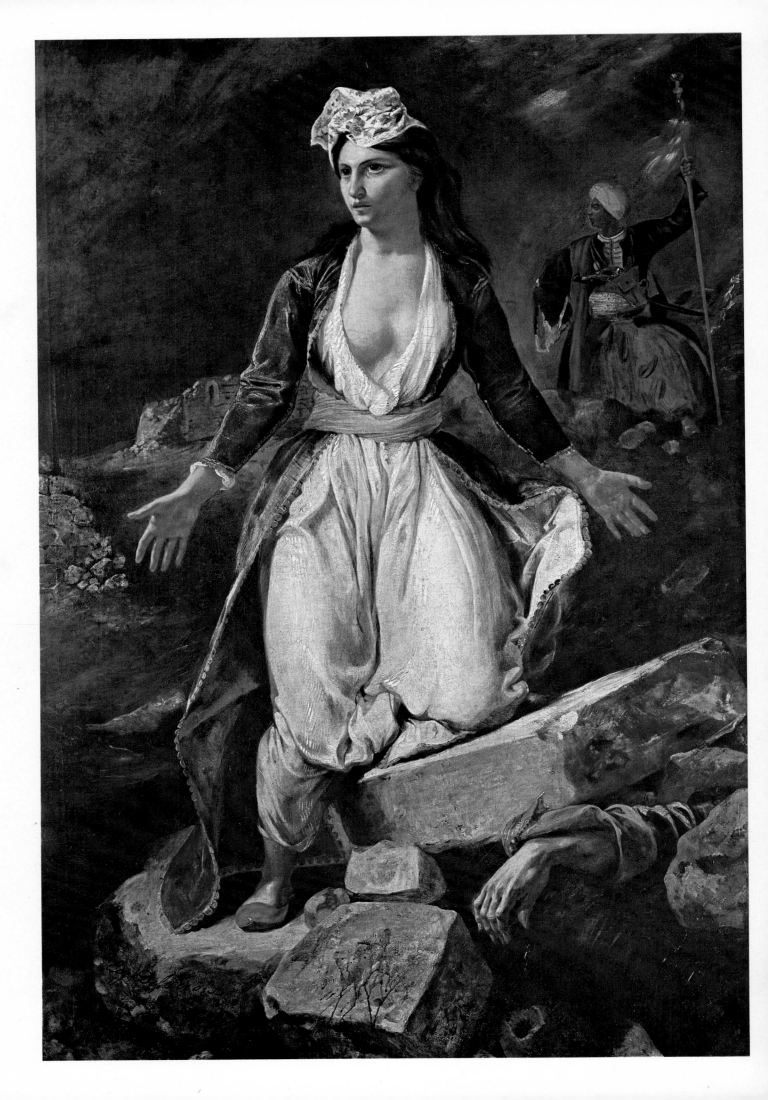

IV

The Literary Bacchanal

The failure of *Sardanapalus* was a double blow to Delacroix. He had been mauled before by critics, but this time their insults were accompanied by a rebuke from the head of the Académie des Beaux-Arts, Sosthène de La Rochefoucauld, who refused to recommend that *Sardanapalus* be purchased by the state. "If you intend to paint this way," warned Sosthène, "don't expect any commissions from us for a long time." Such a pronouncement was enough to alarm any painter in France at this period, for the government-controlled Beaux-Arts, as arbiter of official taste, had the juiciest commissions to dispense. Thus Delacroix's fall from grace threatened both his prestige and his bread and butter.

His failures in Paris, however, were handsomely compensated for by success in London. The *Execution of the Doge Marino Faliero*, which he had sent over after removing it from the Salon show to make room for *Sardanapalus*, was so much admired by Sir Thomas Lawrence that he wanted to buy it. He died before he could do so, and the British government acquired it (it hangs now in London's Wallace Collection). And another epic of the Greco-Turkish War, *Greece Expiring on the Ruins of Missolonghi*, stirred the hearts of Englishmen—Missolonghi, after all, was where their own Lord Byron had died three years earlier while supporting Greek independence. *Greece Expiring*, showing the symbolic figure of the nation standing with outspread arms on the ruins of the town, was first shown at a huge public benefit for Greek relief held in a Paris gallery in 1826, along with 198 other works by almost every noted artist in France: Géricault, Gros, Gérard, Girodet, Devéria, and even the progenitor of neoclassicism, David, who had just died in exile. In all likelihood, this was the first time painters had acted together so solidly for a humanitarian cause.

Both of the Delacroix paintings shown in London were based on the works of Byron, who was by now an established cult among Europe's intelligentsia (no less than 20 complete editions of Byron were published in France in less than 30 years, and even a dull play like his *Marino Faliero* was put on twice in Paris theaters). For Delacroix in par-

The grieving, symbolic figure of Greece, dying with her sons at Missolonghi, foreshadows two later Delacroix heroines— *Liberty Leading the People*, the symbol of the 1830 uprising, and the tragic figure of motherhood, *Medea*.

Greece Expiring on the Ruins of Missolonghi, 1827

ticular, Byron had all the qualifications of a personal hero: he was ardent, brave, elegant, moody, poetic, satanic and freedom-loving—all qualities which led Delacroix to borrow extensively from his works in his constant search for subject matter.

Formal subject matter, particularly that with a strong narrative element, has fallen so out of fashion in contemporary art that it is hard for us to conceive of the importance it once had, or even to respect it. But it should be remembered that not so very long ago hunting down subject matter was a major part of a painter's work, and it was unthinkable that a picture could exist without it. Throughout most of the world's art history, a bad picture of a saint or a king was vastly more important than a good picture of an apple or a pear.

In expressing his whole artistic doctrine, Delacroix states the relation of subject to esthetics with precision and eloquence: "If, to a composition that is already interesting by virtue of the choice of subject, you add an arrangement of lines that reinforces the impression, a chiaroscuro that arrests the imagination, and color that fits the character of the work, you have solved a far more difficult problem and you rise superior: the result is harmony, with all its combinations, adapted to a single song; it is a musical tendency."

For Delacroix, subject matter had an extra strong attraction besides the obvious and exciting one of reconstructing an event or a person. He often wrote longingly about wanting to join souls with somebody else—and in painting he managed to do it. Being in his own way an incorrigible joiner, he was always joining forces with some other mind —Byron's or Scott's or Shakespeare's—or putting himself in tune with some ancient body of myth or legend. And since his mind responded with such eagerness and fire to another's stimulus, almost every work he did was, in some sense, a collaboration.

Of all Byron's works, the one that most attracted Delacroix was *The Giaour*, an exotic, disorderly poem published in 1813, involving a passionate Venetian lover, a slave girl, a pasha and two violent deaths. As a poem *The Giaour* is disorderly because Byron kept adding to it in successive editions, grafting on new sections here and there until it seemed like an old house with too many wings. But if Byron could not leave it alone, neither could Delacroix. He painted 15 different versions of this wild tale. What particularly attracted Delacroix as a painter was a furious combat on horseback, which Byron never actually described. This gave Delacroix a chance to flex his imagination. He also illustrated several other well-known Byron poems, including *The Prisoner of Chillon*, *The Bride of Abydos* and *Lara*, but *The Giaour* kept him busy, off and on, for more than 30 years.

Since Delacroix habitually painted literary themes, it is not surprising that he should also have undertaken the actual illustration of a book. In 1825 he found his inspiration in Goethe's *Faust*. He had seen the play in London, "but," as he wrote to Pierret at the time, "in an arrangement"—perhaps what he saw was Marlowe's version. In any case, the indestructible tale of the medieval scholar who pawns his soul to Satan in return for unlimited knowledge and sensual delights haunted

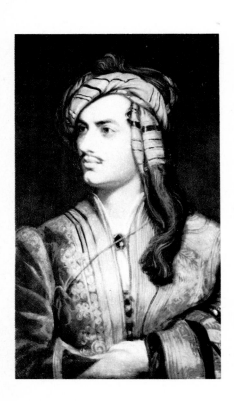

George Gordon, Lord Byron, whose poems were an inspiration to Delacroix, is shown here in Albanian costume in a painting by Thomas Phillips. A poet who backed his convictions with action, Byron sailed for Greece in 1823 to fight in the war for independence against the Turks. He died at Missolonghi of uremic poisoning a few months after his arrival. He was only 36.

him, as it did so many Romantics, and he began experimenting with some drawings.

Faust at that time had been published in France in several translations. Delacroix, contemplating an ambitious series of lithographs, found this new excursion into literature absorbing. The more he worked, the more the subject appealed to him. As his eloquent biographer Huyghe put it: "A different Delacroix was at work, if not revealing himself, at least finding, in his turn, the right to expression: the disillusioned Delacroix, the man who could hear, beyond the fairyland of life which he was so well fitted to enjoy without reserve, the sad voice of Fate. In the inexhaustible theme of Faust he could see, repeated, the mixture of temptations, questionings and moods of despair which he himself felt." And this "different Delacroix" created a special style for *Faust:* impish, exaggerated, prickly as a thornbush, and so shamelessly theatrical as to be almost caricature.

Early in the work, he found encouragement from no less a source than the playwright himself. He sent Goethe several completed samples for his approval, and the poet's first reactions are reported in 1826 in his famous conversations with his friend Eckermann:

"I saw a representation of the wild drinking scene in Auerbach's cellar," said Eckermann, ". . . when the wine sparkles up into flames, and the brutality of the drinkers is shown in the most varied ways. All is passion and movement." "Monsieur Delacroix is a man of great talent," chimed in Goethe, "who found in *Faust* his proper element. The French censure his boldness, but it suits him well here. He will, I hope, go through all *Faust,* and I anticipate a special pleasure from the witches' kitchen. . . . We can see that he has a good knowledge of life, for which a city like Paris has given him the best opportunity. . . . I must confess," said Goethe in a rare access of modesty, "that in some scenes Monsieur Delacroix has surpassed my own notions."

Later, having apparently recovered from his surprise that the imaginative powers of a Frenchman could surpass those of a German, the poet added: "Delacroix seems to have felt at home here and roamed freely, as though on familiar ground, in a strange fusion of heaven and earth, the possible and the impossible, between the coarsest and the most delicate." It was a perceptive comment: Goethe had recognized the paradox-boxer.

By 1827, Delacroix had completed 16 lithographs, plus a portrait of Goethe. The job had now taken on additional importance, for his financial troubles were greater than usual. Upon the death of his sister Henriette in that year, he had taken on full responsibility for her son, Charles de Verninac. Penniless and in debt, Charles had twice pawned the portrait of his mother painted by David, leaving it up to Delacroix to buy it back. So when the new translation of *Faust* with Delacroix's illustrations was readied for publication in 1828, it was for him a doubly welcome occasion.

Unfortunately, it proved to be a double disappointment. Although the Delacroix illustrations now rank among the masterpieces of their kind, they were beyond the understanding of his times. The critics,

with mocking contempt, called him "a ballet dancer in the School of Ugliness"; and his shockingly small total pay was, as he confided to a friend, "something like 100 francs."

Nonetheless, the Romantic turmoil of artistic life in Paris drew him still more deeply into literary circles. Poets, musicians, novelists, as well as artists and sculptors, were all part of the creative uproar. As Raymond Escholier, dean of the Delacroix biographers, reminds us: "These children of the century, conceived during the Napoleonic Wars, were claiming their share of the victory. They must conquer the salons, the theater, the lecture platforms and the public squares."

The young Romantics, all in their twenties, ran in packs. A rallying place for the leaders was the Théâtre de l'Odéon where, on September 6, 1827, a company from London opened a bill including five Shakespeare plays. Just five years earlier another Shakespeare troupe had come over to Paris, only to be hooted off the stage with cries of "Speak French" and sneering accusations that Shakespeare was "a lieutenant of that conqueror at Waterloo." But now the wounds of Waterloo had begun to heal and the climate was propitious for the untrammeled, unclassical dramas of the great Elizabethan. And Shakespeare dazzled the Parisians like a revelation. They did not understand half his words but they understood the spirit. "Imagine," cried the popular new novelist Alexandre Dumas, "a man born blind whose sight was suddenly restored!" On the night when Miss Smithson and Mr. Kemble played *Hamlet*, Delacroix was present with Dumas; with them were the poet Alfred de Vigny, the revolutionary young composer Hector Berlioz and the brilliant firebrand Victor Hugo. For Delacroix, the hit of the evening was Miss Smithson, whose lovely arms he soon painted in his *Death of Ophelia*, reaching vainly upward out of the fatal stream. Berlioz was even more enchanted by Miss Smithson: he married her.

The Shakespeare performances were the beginning of what proved to be a fiery, if equivocal, friendship between Delacroix and Hugo. The two were more and more often mentioned together, for Delacroix in the field of art was in many ways the counterpart of Hugo in the field of literature. In the evening Delacroix used to join Hugo, along with the essayist Sainte-Beuve and others, for long walks and talks in the suburbs of Paris. And after the *Sardanapalus* scandal with the Salon, when Delacroix badly needed support, the ebullient Hugo defended him warmly in a letter to a friend: "Speaking of great paintings, don't believe that Delacroix has failed. His *Sardanapalus* is a magnificent thing. . . . I only regret that he did not set fire to his funeral pyre. This beautiful scene would be still more beautiful if it were based in a basket of flames."

Grateful as Delacroix surely was for Hugo's defense, he must have winced at the "basket of flames," which would have pushed an already melodramatic picture over the edge and into the abyss of roaring bad taste. Hugo was four years younger than the painter, and his gusto and his fits of sensationalism began to rub the more fastidious Delacroix the wrong way. For all their community of interests, the two young giants were temperamentally quite opposite.

During that first year of their friendship, 1827, Delacroix designed costumes for Hugo's play *Amy Robsart*, based on episodes from Sir Walter Scott's *Kenilworth*. In doing so he followed the custom of the times, when men of the arts often pooled their talents, designing scenery or costumes for each other, or providing literary themes. Delacroix's first dip into show business produced the usual exasperations: he complained about the slowness and stupidity of costume-cutters, and he tried to offer advice to an actor. In his sketches for the 16th Century costumes he bent over backwards to be as historically correct as possible, with results that were handsome and dull. But Hugo, who occasionally designed costumes himself, thought they were excellent. The play closed after one performance.

Delacroix was invited to hear Hugo read his next play, *Marion de Lorme*, along with an imposing assemblage of talent that included Dumas, Mérimée, de Vigny, Sainte-Beuve and the rising new genius, Honoré de Balzac. After the reading, Alexandre Dumas, with his mouth full of cake, shouted, "Superb! Superb!" The play was promptly accepted for production, only to be canceled by the King's censor who decreed it to be offensive to royalty. Determined not to stay squelched, Hugo in 28 days wrote another play, *Hernani*, a bloodstained tragedy about a young Spanish bandit who finds himself vying with the king and a nobleman for the hand of the nobleman's ward. It slipped by the King's censor and was produced by the Comédie Française on February 25, 1830, in one of the most uproarious and sensational openings in theater history.

Hugo anticipated, and with good reason, that his enemies—royalists, die-hard classicists and hoodlum members of the press—would stage a riot during the première of *Hernani*. Accordingly, he recruited some 80 young men, Bohemians and freethinkers all, and organized them into platoons seated throughout the theater, ready to heckle any hecklers. Many of them were long-haired and bearded, picked to horrify stodgy playgoers. A leader of the troops was the poet-journalist Théophile Gautier, decked out in an inflammatory rose-colored doublet and green trousers.

Excitement ran high. The Romantic brigade began arriving at three in the afternoon for the 7 o'clock opening. Actors, too, were keyed up. The celebrated Mademoiselle Mars, who was later to be of great service to Delacroix in arranging his Moroccan trip, was worried, not because at 50 she was playing a 17-year-old heroine—that was easy—but because in her opinion Hugo had written some inelegant lines. The word had spread that she had been furious with Hugo during rehearsals: he wanted her to call her lover "my lion"; she preferred "my lord." What would she say tonight?

The curtain went up. The heckling began at the first lines announcing the approach of the Spanish king to a palace bedroom by a secret stairway. Shocking! Throne rooms, not bedrooms, were the proper settings for classical drama. And kings arrived by gates and portals, not by hidden stairways. More serious, of course, was the untraditional way Hugo went on to deal with royalty and religion: he showed respect for

Victor Hugo, the outspoken leader of the Romantic movement, was often a target of caricaturists. An intellectual, he was pictured with a puffed-up head *(above)* by Honoré Daumier, a masterful realistic painter who made a living doing caricatures for the popular press. Daumier followed neither the Romantics nor the classicists. He remained aloof from stylistic allegiances and popped the inflated egos of all persuasions with his barbed wit. Now considered one of the finest painters of the 19th Century, Daumier was little appreciated during his day.

neither. Catcalls and cheers continued all evening. But at the final curtain there was no doubt *Hernani* was a smash hit. Mademoiselle Mars had said "lion," and wanted Victor to kiss her. The notices were mixed, but the play sold out night after night. *Hernani* was a decisive Romantic victory. The audience demonstrations continued at every performance —on cue. Hugo saw to that.

The historic opening has since been commemorated for all time in a painting, the *Battle of Hernani,* by the artist Albert Besnard. Delacroix himself appeared in the picture, standing in the audience near Lamartine and Dumas; but the fact of the matter is that he was conspicuous by his absence. No one knows why. It is not likely that he stayed away because he was shocked by Hugo's innovations, which were tame enough compared to Shakespeare's. But it is altogether possible that he recoiled from Hugo's frenzied press-agentry. From Hugo's point of view the uproar was necessary—for the cause of Romanticism as well as his own success. From Delacroix's, it probably seemed both offensive and boring.

The friendship lasted only about six years. The two men met occasionally at literary salons and public affairs, but they took to sniping at each other. "The young chief . . ." said Hugo, "had not the same boldness in words as he had in pictures. . . . A revolutionary in his studio, he was a conservative in the drawing rooms, disavowed the literary insurrection and preferred tragedy to drama." To a Romantic like Hugo, tragedy had become too stilted and rule-ridden; drama was the thing, with its natural laughter and tears.

Imposing and controversial as he was, Delacroix was a distinctive target for the caricaturist's sallies. A frequent and popular guest at salon evenings, he also wrote intelligent art criticism and stood out in any crowd with his natty style of dress, his traditional high collar and cravat, his distinctive profile and well-barbered moustache and goatee.

As the years passed, the two men were destined to drift further and further apart. Delacroix, who eventually emerged as an astute critic in the Paris journals, was to say of his erstwhile friend: "Hugo . . . has never come within a hundred leagues of truth and *simplicity*." And again, speaking of the eternal laws of taste and logic, he chided the Romantics: "Men like Berlioz and Hugo, and the rest of these so-called reformers, have not yet managed to abolish those laws." And on still another occasion: "The works of Hugo resemble the first draft of a man who has some talent: he says everything that comes into his head."

Hugo, for his part, struck at Delacroix's taste in women. "There is not a single really beautiful woman in his paintings, except that torso in *Chios* and the angel in *Christ in the Garden of Gethsemane.*" He alluded scathingly to "the exquisite ugliness characteristic of Delacroix's women. . . . Be proud . . . you monsters of some Witches' Sabbath art, you cast a spell on our imagination."

After his costume designs for the earlier Hugo play, Delacroix never again got involved in the theater except, briefly, in 1830 with Alexandre Dumas. Dumas invited the painter to do a frontispiece for his drama *Stockholm, Fontainebleau, and Rome,* and paid him a visit at his studio to talk it over. Delacroix happened to be out, and wrote a note of apology. "I am desolated, my good friend. . . . Yesterday I was out carousing with Mérimée and Beyle [Stendhal] and others, and was taken up for the evening."

Mérimée and Stendhal were two others of the literati with whom

Delacroix enjoyed himself often—all three were intellectually compatible. Brilliant and haughty, Prosper Mérimée was the essayist, archeologist and storyteller whose *Carmen* was to make the world's most popular opera. Stendhal, author of *The Red and the Black*, at first put Delacroix off with his boasting of having known Napoleon and Byron. "That Stendhal is rude," Delacroix wrote at the time in his journal, "arrogant when he is right, and often nonsensical." But his opinion soon changed: he learned to evaluate Stendhal shrewdly "as the writer who has perhaps the most distinction, with the best French style it is possible to have in speaking." Stendhal, on his part, recognized the talent of his painter friend. He called him "a pupil of Tintoretto" in recognition of Delacroix's kinship with the great Venetian master in his passionate feeling for opulent color and form.

The three friends met most often at the sociable restaurants of the Palais-Royal, whose *chambres privées* were doubtless conducive to the "carousing" mentioned in Delacroix's note to Dumas; but the artist and Stendhal also found a common affinity for the zoo in the Jardin des Plantes. Delacroix was a serious student of the zoo all his life—he found inspiration there for many of his animal subjects, sketching tigers and attending autopsies to study animal anatomy. And the zoo was handy, too, to the salon of Baron Cuvier, the great naturalist, whose stepdaughter nourished a delightful weakness for the aloof Mérimée. Thus, while Mademoiselle Sophie melted for the third member of the trio, Delacroix and Stendhal conversed among the cages, sharing their admiration for lions, tigers, Mozart and Rossini.

The salon as a meeting place for men and women to exchange ideas continued from the days of Louis XIV. Its character kept changing, but in Delacroix's time it was still enormously influential. Most salons were presided over by a hostess in her own home and were held once a week, usually in the evening. There were salons for every taste. At the house of the Princesse de Liéven, one could talk politics with foreign diplomats. At Baron Gérard's, politics were spiced with art and theater talk. At Madame de Rauzan's one could discuss Berlioz's new *Symphonie fantastique*. At the Princesse de Belgiojoso's, the specialty was exploration of the occult, with perhaps a chance to call up a ghost. Almost every salon had its star guests: At Madame de Girardin's one could find Balzac; at Madame Récamier's, Chateaubriand; and over at Charles Nodier's apartment in the Bibliothèque de l'Arsenal, of which he was curator, one might hit a jackpot that included Hugo, the poets Alphonse Lamartine and de Musset, and the fine animal sculptor, Antoine-Louis Barye—but seldom Delacroix.

Delacroix would turn up at the salon of the Englishwoman, Miss Mary Clarke, where he once dined with Shelley's widow, whose novel, *Frankenstein*, was giving the Parisians goosepimples in the 1830s. Then he had evenings with James Fenimore Cooper and with the mysterious hypnotist Dr. Koreff, who wore an implausible wig of dog-grass and hemp; and Sunday visits to the Devérias, a delightful family of artists with whom he danced the polka under the trees. Delacroix, Mérimée and Stendhal all fell in love with a Madame de Rubempré who held

A typical salon gathering, as shown here by the French caricaturist Grandville, might include writers like Balzac *(left foreground)*, Dumas *(left background)* and Hugo *(right foreground)*. Delacroix *(center)* bends over the composer Franz Liszt, who is dreamily playing the piano, while George Sand peers intently over it. Madame de Girardin *(left center)* was the hostess of this evening, a regular weekly get-together of novelists, poets, painters, historians and scientists.

her salon on the Rue Bleue, and accordingly called herself Madame Azur. This 24-year-old siren studied magic and alchemy, dressed in black velvet with a scarlet shawl and had the painter so bewitched that Mérimée wrote, "Delacroix is up to his ears in love."

France was deeply in debt to its salons. In a period of active intellectual ferment, they provided safety valves for overheated ideas. They also offered scales on which new ideas could be weighed and compared. They stimulated new talent. They brought important minds together to their mutual profit, and by opening their doors to any man of sufficient achievement, they helped democratize the nation. The salons of Paris were an intellectual bazaar where a man like Delacroix could shop for exactly what he wanted.

Two extraordinary studies of a panther show the fascination these big, predatory cats had for Delacroix. Probably made on the spot at the Jardin des Plantes zoo, these sketches show the basic skin and bones which would underlie the fur.

At about this time Delacroix's painting entered a strange and original phase. While most of his works still dealt with historical events—mob violence and mass battles—all were enveloped in a purgatorial gloom as if the smoke from *Sardanapalus* had rolled out and darkened the painter's world. The first to appear, in 1829, was the *Murder of the Bishop of Liège*, based on an episode from Scott's *Quentin Durward*. That Delacroix was working on it two years earlier is attested by a humorous note sent to him in 1827 by Victor Hugo, saying, "Present my compliments to Sardanapalus, to Faliero, to the Bishop of Liège, and to all your retinue."

The event depicted took place in the 15th Century, and Delacroix took great pains, by studying old manuscripts in the Bibliothèque Nationale, to see that all details of costume were correct. Then he took greater pains to ensure that these same details should be virtually lost in the surrounding shadows. What he achieved was significant: here, at last, was a historical painting with no attempt at literal portraiture *(pages 98-99)*. The painter's role had changed: Delacroix was less concerned with being a reporter and more intent on playing the interpreter, telling his audience not so much about this atrocity in particular—the murder of a bishop by a rebel mob—as about mass cruelty in general.

The brightest, and from Delacroix's viewpoint the most crucial, area of the picture is a white tablecloth, casting light upward onto the insurgents just as a witches' bonfire might illumine the furies that encircle it. One night while he was making some preliminary sketches for the tablecloth, Delacroix declared to his friend Frédéric Villot, "Tomorrow I'll attack this damned tablecloth, which will either be my Austerlitz or Waterloo. Drop in late in the day, and see."

When Villot came back, Delacroix was working in a red flannel shirt, and greeted him with a tight-lipped smile. "It's Austerlitz," he announced. The "damned tablecloth" was serving its proper function. It lit up the orgy not too obtrusively, giving off exactly the right quality of illumination. "I'm saved," Delacroix went on. "The rest doesn't bother me."

The *Murder of the Bishop of Liège* has much in common with the kind of sketches a talented film director might create today to show how a movie scene should be designed and lighted. Delacroix's sense of theater had veered this time toward the cinema—a mechanism still

three quarters of a century away. In fact, he claimed the best way to see his picture was at night with a beam of light thrown on the central area, and he went so far as to rig up a lamp and reflector in his studio to present it in this way.

There were several reasons why Delacroix was tending toward this highly dramatic and dimly defined way of painting. For one thing, he had been increasingly impressed by the work and techniques of Rembrandt. In 1827 he had shown great interest in some Rembrandt copies by his friend Poterlet; and he also got in touch with an English specialist in mezzotint engraving to inquire about buying a mezzotint after Rembrandt. Some years later in his journal he uttered what he called a "blasphemy—one that will make almost every schoolman's hair stand on end": that one day the world may discover "that Rembrandt is a far greater painter than Raphael." Rembrandt was, he wrote, "more natively a painter," and achieved a poetic truth in his "mysterious conception of his subjects."

While Rembrandt was partly responsible for the deepening shadows that characterized his work, Delacroix was probably affected as well by his own efforts in lithography, especially the *Faust* series, in which he had discovered how well he could use bold contrasts of dark and light. Also, it was only human, after the *Sardanapalus* rebuff, to turn willfully toward a darker form of art, as if to say, "All right, if you were shocked by my explosion of color, follow me now into my gloom."

Though the critics did not follow him—the picture was virtually ignored in the 1831 Salon—the *Bishop* finally got its message across. Théophile Gautier, some years later, wrote enthusiastically of the actual sound that seems to emanate from the painting. "Who would ever have thought that anyone could paint the clamor of a crowd, could paint *tumult? Movement*, yes; but this not enormously large picture howls, shouts and blasphemes!"

Gautier's comment was the more perceptive since Delacroix, though born into a chaotic period of French history, had himself never witnessed violence, had heard no shouts or blasphemies. His family and friends had passed on to him horrendous tales of the Revolution and Napoleon's conquests, and the same year that he exhibited the *Bishop*, Mérimée wrote an account of a somewhat similar antireligious orgy when a Catholic church was desecrated by ruffians dressed up in church robes, sprinkling holy water from chamber pots while the police held their sides laughing. But Delacroix himself could conjure up such things only in his imagination. It seemed, at this period, as if History had decided not to disturb him.

He seems to have felt this, too. In May 1830, he wrote to his friend Charles Rivet, who was traveling in Italy, complaining that life in Paris was "uneventful." His complaints were destined to be short-lived. By early July there were rumblings of violence. King Charles X, highhanded and reactionary, had managed to antagonize aristocrat and commoner alike in a reign that seemed to ignore all the lessons of the Revolution and Napoleon. For Eugène Delacroix, it was to be a more interesting summer than he expected.

Literary Inspirations

Eugène Delacroix had a lifelong love affair with literature. He read constantly, carrying books on his vacations and discussing them in letters and in his journal. He turned to literature constantly to find subjects for his pictures, using novels, poems, plays, histories and myths. More than 100 of his paintings and drawings derive directly from literary sources. He seemed to be equally inspired by authors of the past—Homer, the Bible, Shakespeare—and by his contemporaries Byron, Scott and Goethe. Like most real book addicts, he had quirkish tastes. He loved the mellow wisdom of Horace and Montaigne, yet "adored" the escapades of Casanova. His schoolboy enthusiasm for Voltaire never waned. He found Victor Hugo prolix, but read the best of Dumas with relish. In poetry he veered from Dante to Robert Burns, and made paintings from both their works.

Such literary inspiration was not at all unique in Delacroix's day. Most painters sought their ideas, at one time or another, in the pages of books. But Delacroix read for pleasure as well as profit, and when he turned another's images to his own purposes he left the original enriched by his interpretation, using his quick understanding, keen visual sense and confident brush to transform it into a new experience—one that was his own.

For the prologue of Goethe's *Faust*, Delacroix invented a fantastic winged devil, as muscular as a man, with hideous talons, flying over medieval towns as he casts evil spells.

Mephistopheles, 1828

In a rare instance when Delacroix illustrated an entire text—his 17 lithographs for a French edition of Goethe's *Faust*—he picked the moments of highest drama with a sure Romantic instinct. Using the deep blacks of the lithographic crayon in a manner influenced by Rembrandt's etchings, he played light against shadow to heighten the mood of doom and violence. The duel scene above takes place near the house of Marguerite, whom Faust has seduced with the devil's help. Valentine, her brother, rushes up to avenge her disgrace with his sword, but the devil drops his mandolin and deftly parries the blow, enabling Faust to run Valentine through.

Emboldened by the devil's sorcery, the formerly shy scholar Faust *(above, right)* accosts the demure Marguerite while his partner keeps a lookout.

Awaiting death for killing the child she conceived with Faust, Marguerite, crazed with grief, resists his remorseful attempt to rescue her from prison.

Delacroix frequently met his fellow artists and writers at the salons, weekly soirées given by wealthy Parisians. There they exchanged gossip, argued esthetics and planned collaborations. A sketch of one such gathering (below) shows Delacroix, top hat in hand, standing haughtily next to his seated cousin, Pierre-Antoine Berryer, who may have been the evening's host. By the mantel is the poet-playwright Alfred de Musset, of whom Delacroix said: "He is a poet who has no color. He handles his pen like an engraver; with it he cuts grooves into the hearts of men. . . . I prefer gaping wounds and the bright color of blood." Such comments were the spice of the salons.

It may have been a salon discussion that
led Delacroix to design costumes for
Victor Hugo's play *Amy Robsart*. His
sketch for the heroine of this story of
intrigue in Elizabethan England is at
right; below is Lord Shrewsbury.

Eugène Lami: *Parisian Salon*, c. 1850

Lord Shrewsbury

Hamlet Reading, c. 1834

Macbeth Consulting the Witches, 1825

Shakespeare's dramas provided Delacroix with many pictorial subjects—the moody Hamlet, the ardent Romeo, the violent Macbeth—which he treated in a variety of mediums: oil paintings, monochrome lithographs, delicate watercolors. They also deeply influenced his attitude toward art. He put Shakespeare in the company of Homer and Dante, and marveled at his "astounding naïveté which made poetry out of commonplace details." Repeatedly, he admired the dramatist's "harmony of opposites," his daring contrasts. He noted, for instance, that "Hamlet, in the midst of his grief and schemes for revenge, indulged in buffoonery with Polonius and the students, and amused himself with the actors." In his painting of the graveyard scene from the play *(right)* Delacroix achieved a truly Shakespearean fusion of opposites: the subtle, lyrical coloring of the sky and the harsh flesh and bone of the gravedigger and the skull.

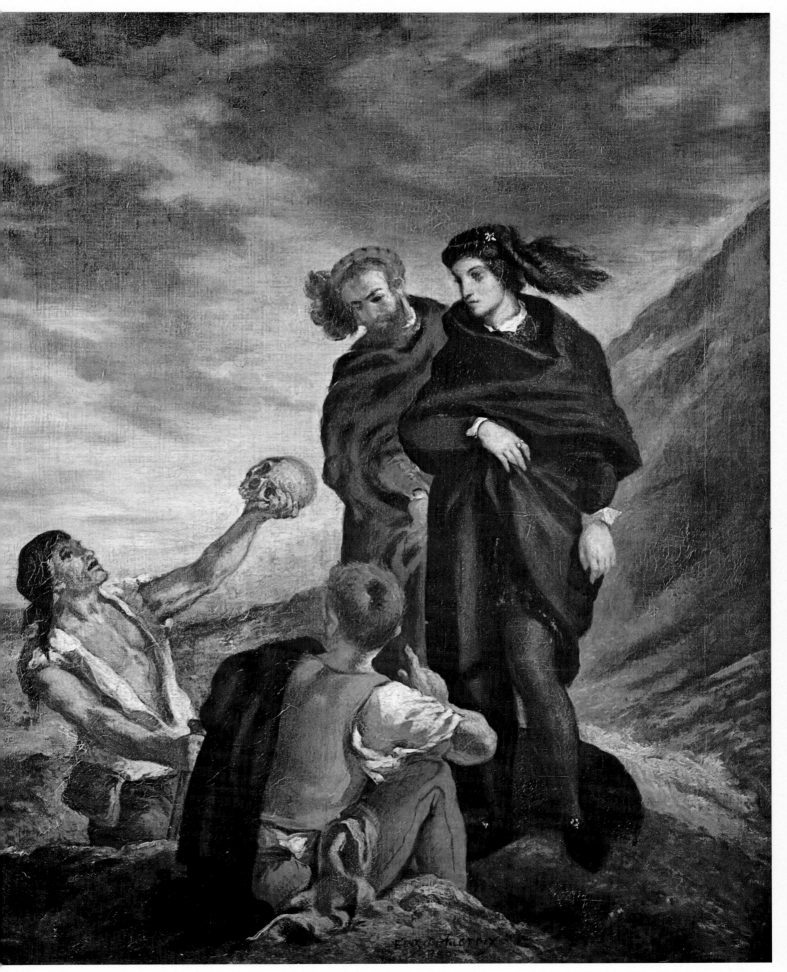

Hamlet and Horatio in the Graveyard, 1839

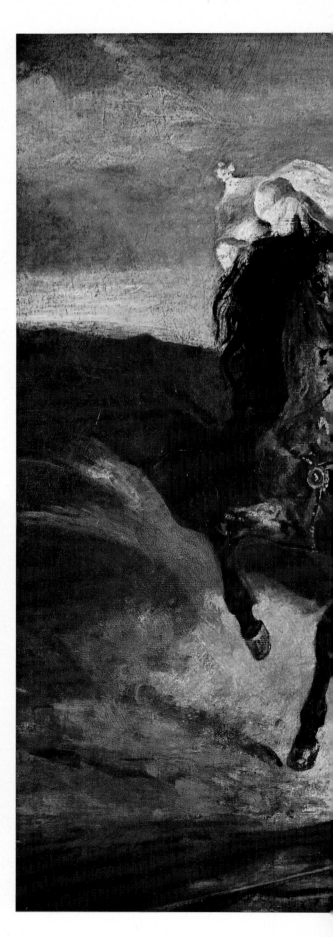

In seeking literary themes, Delacroix found his richest source
—even richer than Shakespeare—in George Gordon, Lord Byron.
He used a dozen of Byron's plays and poems, but especially *The
Giaour*, that rambling poem about a Venetian warrior whom the
Turks called *giaour*, or "the infidel," and his love for a slave
girl who was the Pasha's favorite concubine. Enraged by the
girl's infidelity, the Pasha throws her into the sea; the
giaour, in a fearful combat, then kills the Pasha. In the
painting at right, the white-robed *giaour* is about to slay the
Pasha, whose henchmen are trying to defend him. Below is
Delacroix's scene from that classic Byron poem *Prisoner of
Chillon*, in which a medieval nobleman chained in a dungeon
watches in helpless anguish as his younger brother, also a
prisoner, falls sick and dies. Delacroix painted this work in
grief over the death of his beloved nephew Charles de Verninac.

Prisoner of Chillon, 1834

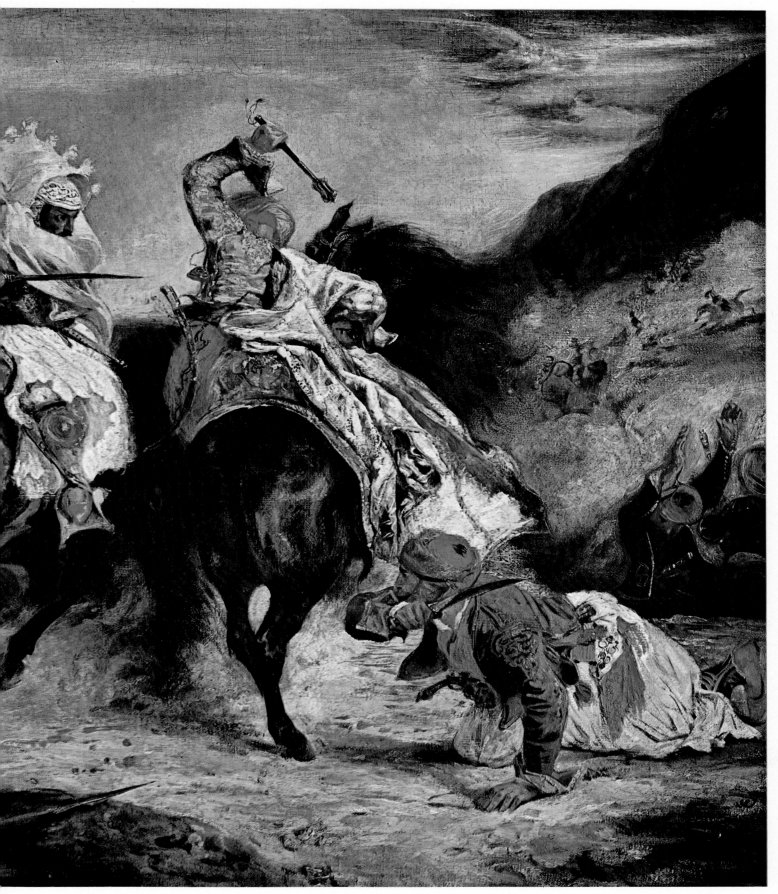

Combat of the Giaour and the Pasha, 1827.

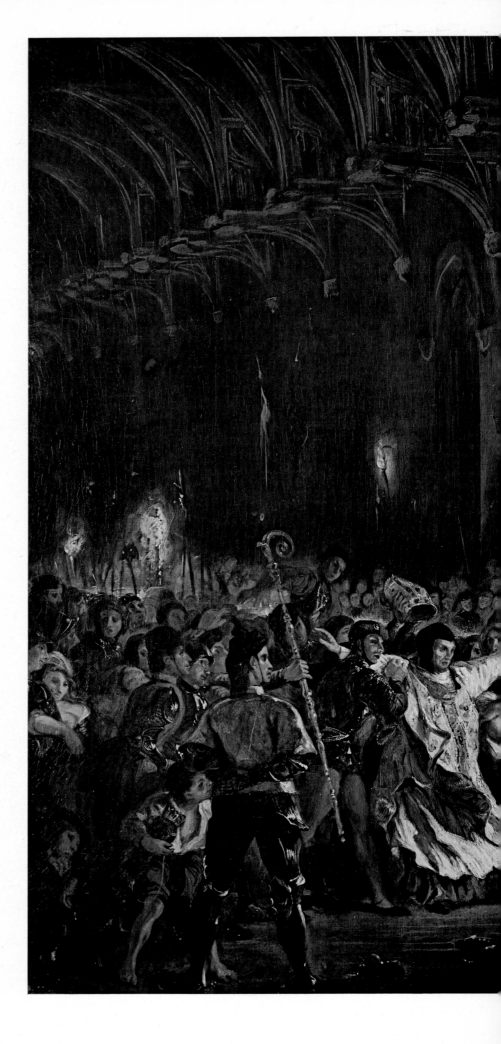

Delacroix's moody painting *Murder of the Bishop of Liège* was a revolutionary departure from the usual literature-inspired paintings of its time. Overloaded with fussy details of costume, weaponry and scenery, these were more often ornate illustrations of a plot than artistic evocations of a theme. But Delacroix's *Bishop* captured the very heart of the bloody episode from Sir Walter Scott's *Quentin Durward* that it depicted. Although he did research for two years, digging up period clothing and selecting a Gothic setting, Delacroix subdued all these details to create an awesome mood of chaos and violence. Illuminating his chief actors with bright flashes of light and color, he forcefully shocks the viewer's eye with a quick recognition of the awful act about to be performed—the murder of a man of God—and then forces him to puzzle out, in the murky background of the scene, how and why such a thing could happen. In this early work, Delacroix pushed his technique almost to the point of abstraction, but stopped short to delineate the thing which interested him most— the high drama of human emotions.

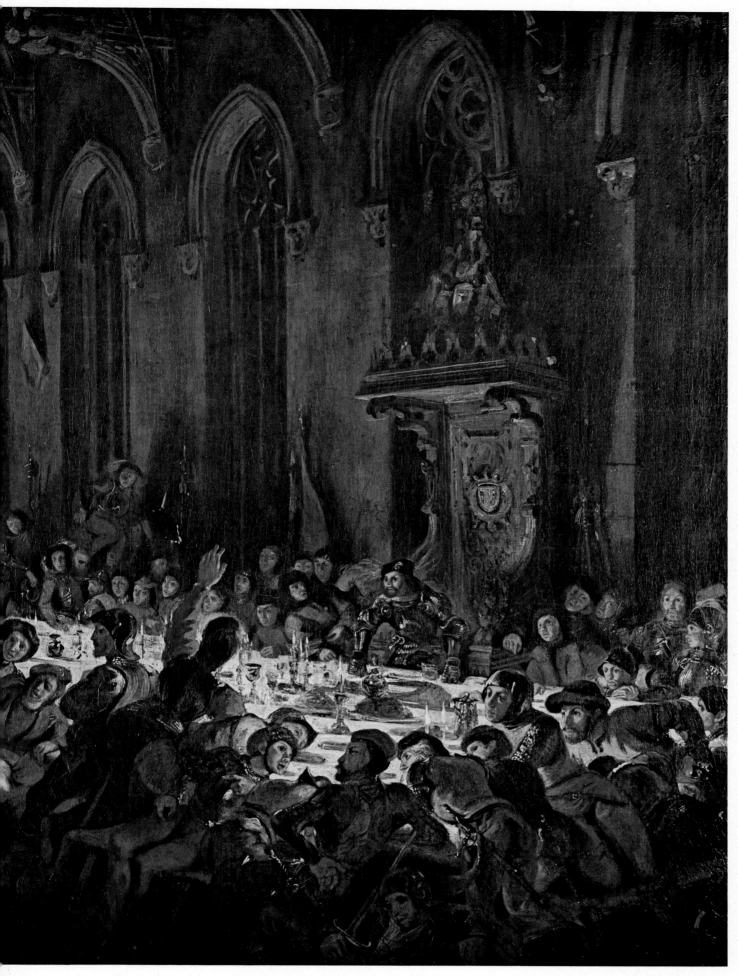

Murder of the Bishop of Liège, c. 1827

V

Morocco: A Fateful Interlude

Delacroix's *Liberty* figure, although clearly a symbol, marks a transition from the fleshier, more realistic women of his early career to the smooth-skinned, straight-nosed and monumental creatures who will be seen, in different dress and settings, in many later paintings.

Liberty Leading the People
(in full above, detail left), 1830

Eugène Delacroix had no affinity for politics. "The moralists and philosophers," he once confided to his journal, "I mean the real ones, like Marcus Aurelius and Jesus, never talked politics. . . . Equal rights, and twenty other chimeras, did not concern them." Nor did they concern Delacroix: his attitude toward social reform was inherently detached and *laissez-faire,* and conversations with politicians, by his own confession, bored him.

Nevertheless, by July 1830, the political crisis in France compelled his attention. Politics had become everyone's concern; unfinished battles for liberty, left over from the Revolution, were to be fought again —and this time almost under Delacroix's windows.

The troubles stemmed directly from the restored Bourbon kings, who tended to regress to the monarchy's old habits of thinking and ruling. Louis XVI, executed in 1793, was survived by two brothers, one of whom was called home in 1814 from his exile in England to rule as Louis XVIII. Moderate and prudent—at least, as Bourbon kings went—this Louis pursued a policy described by the brilliant liberal of his day, Alexis de Tocqueville, as "joining the principle of modern liberty to that of the *ancien régime.*" But by the time Louis XVIII died in 1824, ultra-royalist elements in the government had come back in force. When his younger brother, Charles X, was crowned with traditional medieval pageantry at Reims Cathedral, the *ancien régime* appeared to have the upper hand.

At 67, Charles, a true son of his forefathers, was both reactionary and rash. He revived the titles of the old days, with a strong implication that he planned to revive the old privileges too. He proposed to pay the ousted aristocrats a billion francs to indemnify them for property lost during the Revolution. In a royal huff, he disbanded the National Guard, a citizens' militia that was fundamentally loyal to him. He denounced the Charter of 1814 as a curtailment of his powers. And on July 25, 1830, he signed four ordinances that suspended freedom of the press, dissolved the Chamber of Deputies, and wrought

These two lithographs, the *Besieged (top)* and the *Besiegers (below)*, celebrate the "three glorious days" when the people of Paris threw everything, almost literally, into the fight against Charles X and his mercenaries. In that brief war, washtubs, tool chests, benches, roof tiles and antique muskets became weapons and the rooftops of Paris became a battlefield.

such basic changes in balloting procedures that many merchants and rising industrialists were denied their voting rights.

Within three days, public wrath had risen to fighting pitch. When police broke into the offices of several newspapers which had protested the King's highhanded actions, outraged citizens rallied to fight them off. Overnight barricades were piled up; Paris streets took on the look of the Revolution all over again. The National Guard took up arms against the King who had disbanded them. Delacroix and his painter friend, Eugène Lami, went out to watch the fighting, which erupted on both banks of the river not far from his studio on the Quai Voltaire. Alexandre Dumas was there, brandishing a double-barreled shotgun. Young Honoré Daumier, soon to become the great satirist and painter of the Paris populace, suffered a saber slash in his face. Only a few of the literati failed to appear: Stendhal stayed indoors with a lady friend, Victor Hugo stayed home with his wife, who on July 24 had given birth to a baby girl. But students, shopkeepers, actors, laborers of all kinds joined the July Revolution. For the first time, the frock coat was rubbing elbows in battle with the worker's smock.

As the fighting raged, the whole uprising took on more and more the flavor of Dumas-inspired Romantic drama. When the King's troops tried to shoot their way through the narrow streets, the insurgents dropped furniture on them from their windows, dug up paving stones and even commandeered a wagonful of melons to re-enforce the barricades. The director of the vaudeville playhouse supplied guns from his theater prop room. When a passing medical student dug a bullet from the wound of a little shopkeeper, the dying man kissed the lead that killed him and said, "Take it to my wife." A 12-year-old boy who had dispatched a king's officer and was himself seriously wounded brushed off his comrades' praise with the words: "Loving your country can quickly make a man out of a boy."

King Charles X at first took the uprising lightly; but by August 3 he had abdicated his throne and taken the exile's trek to England. His successor, maneuvered into office by Adolphe Thiers and the Marquis de Lafayette—the onetime benefactor of the young American republic, now a venerable 73—was the Citizen King, Louis-Philippe. A modest and unassuming scion of the royal house of Orléans, he displayed such bourgeois virtues as carrying an umbrella, getting up early and walking through the muddy streets. He was the first French king to have visited the United States, having spent four years there. His five sons were educated at an ordinary school, and during his exile in England he had known the strictures of privation.

Soon after Louis-Philippe became king, Delacroix set out to commemorate the July Revolution in an extraordinary work to be called *Liberty Leading the People*. By September he had decided what were to be its dominating colors and had put in an order with his paint dealer, Haro. They were to be, with seeming banality, the colors of the French flag: red, white and blue. But Delacroix handled them with the utmost restraint and subtlety *(page 101)*; his picture achieved a kind of apocalyptic luminosity in which the tricolor theme is virtually subliminal.

In October he wrote his brother, the retired general: "I have undertaken a modern subject, a barricade. . . . If I did not fight for our country, at least I will paint for her."

After making a number of sketches of street fighters, individually and in groups, he began to construct his picture around an allegorical female representing Liberty. It was a daring concept: setting a high-flown symbolic figure amid the dirt and the bloodstained victims of an actual battle. But Delacroix could never resist the temptation to bring contradictory elements into harmonious juxtaposition; had not Goethe credited him with achieving his "strange fusion of heaven and earth"?

The foreground is a graveyard. The dead and dying are sprawled in pitiful attitudes. Higher up is the smoky battlefield. On either side, insurgents rush forward dressed in the civilian clothes of a pickup army, ranging from a street youth in a beret, waving two pistols like a youngster playing cops and robbers, to a respectable student in a top hat. On this gentleman, Delacroix is said to have painted his own face, and it does indeed resemble one of his self-portraits.

In the center a wounded man lifts himself on his arms to gaze raptly at the figure of Liberty, who towers above the mortal strife, holding the flag of France. Here, Delacroix dared to crop the top of the flag, which adds greatly to the feeling of spontaneous action, as if Liberty had just strode upward and were breaking out of the picture's formal frame.

Delacroix's concept of Liberty as half goddess and half woman of the people seems to have been derived from many sources. A popular ode in the summer of 1830 described Liberty as "this strong woman with powerful breasts, rough voice and robust charm." And Delacroix had also seen a similar figure in an illustration for Byron's poem *Childe Harold*. And, too, doubtless lively in his memory was the story of a young seamstress who avenged the shooting of her brother at the barricades by killing nine Swiss Guards.

A beautiful touch in the picture, easily missed in the general uproar which dominates it, is a glimpse of old Paris through the gun smoke, with a tiny tricolor flying from the Cathedral of Notre Dame, and a row of ancient houses that stand like an old sea wall, washed and weathered by history. In their somber simplicity they anticipate the paintings of Daumier, and in their sinister melancholy the poems of Baudelaire.

Liberty Leading the People was shown at the 1831 Salon, eliciting the usual mixed reception, with a preponderance of brickbats. Critics complained that the picture was "a slander" of those five glorious days, that Liberty was "ignoble," and that the insurgents represented a rude class of people—urchins and workmen. Slander or not, the government bought the painting for 3,000 francs; the intention was to hang it in the throne room of the Palais du Luxembourg as a reminder to the new King of how he came to be sitting there. Instead, it was hung for a few months in the palace museum. As times grew more difficult, however, its inflammatory message burned too brightly for official liking, and it was taken down. Delacroix was permitted to send it to his Aunt Félicité for safekeeping. It was exhibited again, briefly, after the Revolution of

1848, and during the *Exposition Universelle* of 1855. Today it hangs in the Louvre in a room with four other Delacroix paintings, including *Sardanapalus* and *Women of Algiers;* no special place of honor is accorded the work which so roused the French a century ago.

In 1831 the painter's mood was predominantly dark. The city around him was rebellious. The Citizen King was being treated with hostility and ridicule. Delacroix now was past 30, and his successes had been fitful. He had no compelling interest in any one woman. He often felt tired and listless. He talked of travel—to Venice, perhaps. Then he received a crucial invitation.

It came from the Count Charles de Mornay, a young diplomat and dandy who was going to Morocco and wished to take along an artist to record some of the events of the trip. De Mornay had first invited a fashionable painter, Eugène Isabey, who turned the offer down because he had already visited Morocco. Then, through his mistress, the actress Mademoiselle Mars, de Mornay learned of Eugène Delacroix. In December the painter wrote to a friend, "I shall probably be off to Morocco next week. You may laugh, but it is quite true, and I am in a whirl."

The whirl was well justified, for the trip was ideally suited to Delacroix. The count, cultured and pleasure-loving, was being sent by the King as a good-will ambassador to Morocco. France having recently conquered nearby Algiers, the Sultan of Morocco had now to be courted as a friendly neighbor. This gave Delacroix a perfect opportunity to see the country with as much comfort and protection as were then possible.

On the night before they left Paris, Mademoiselle Mars gave a party that included the count and Delacroix. She wrote about the count's departure in a letter: "He left on 1 January at three in the morning. . . . We had had our usual New Year's Eve gathering, joined by his traveling companion, Eugène La Croix, a young painter who has talent, wit, social graces and, they say, an excellent character—which is not to be despised when people have to spend four or five months together."

At Toulon on January 11, 1832, along with a *valet de chambre* and an interpreter, Delacroix and the count boarded *La Perle,* a naval vessel outfitted for the mission and equipped with 18 cannon. On January 23, *La Perle* put in briefly at Algeciras in the Straits of Gibraltar, where Delacroix saw "all Goya pulsating around me," and on the next morning at eight the party arrived in the harbor of Tangiers, where the painter began to put his first notes and sketches down in his travel diary.

The delegation was allowed to disembark on January 24, and the next day Delacroix explored the town and began writing home to his friends. "I am quite overwhelmed by what I have seen . . ." he reported. "I am like a man dreaming, who sees things he is afraid to see escape him." His trip was to be both a voyage of discovery and a homecoming. He had been there before—in his imagination. His battles of the *giaour,* his odalisques, his *favorites,* and Oriental ambassadors were previews, so to speak, of what he now saw, and he had the double excitement of watching his dreams materialize and meeting new and unexpected realities.

What surprised him most was that the Moroccans in their flowing

While the July Revolution was taking place in Paris, French troops were opening the way for colonization in Algeria. This 1830 cartoon by Auvray satirizes the first group of artists and colonials to reach Algiers. Their Romantic dreams apparently turned to nightmares when they found not a cool, green paradise but a hot, dry desert. The serpent and the lion, well-known Romantic symbols, are used by the cartoonist to symbolize the real dangers and discomforts which the adventuresome pioneers faced.

robes were far closer to ancient Rome and Greece than were the frozen images of the academicians. "Imagine, my friend," he wrote, "what it is to see, lying in the sun, walking the streets or mending shoes, men of consular type, each one a Cato or a Brutus . . . all in white like the senators of Rome and the Panathenaic procession of Athens.

"Romans and Greeks are at my doors . . ." he went on ecstatically. "The heroes of David and company would cut a poor figure here with their pink limbs."

Putting David and company in their place continued to amuse him. "I have had a good laugh at the expense of David's Greeks," he wrote again, "apart, of course, from his sublime technique. . . . The marbles are the truth itself, but one must know how to read what they have to say, and our poor moderns have seen in them no more than hieroglyphs." Striking out at the classical training of young art students in Paris, he wrote, "It would be infinitely better for them to be sent as cabin boys to Barbary on the first ship."

If Islam's world was strange to Delacroix, the Occident was an equally unknown—and suspicious—element to the Moroccans. Delacroix and the count had to wait six weeks in Tangiers before all arrangements were made to visit Sultan Muley Abd-er-Rahman at Meknes, far in the interior. But Delacroix had plenty to do, and he sketched continuously. On January 29, the artist and the count rode outside the city. "Enchanting view while descending the length of the ramparts," Delacroix noted. "After that the sea. Cactus and enormous aloes." They watched a fight between two stallions: "They stood up and fought with a fierceness that made me tremble for those gentlemen [their riders], but it was really admirable for a painting. I witnessed, I am certain, the most fantastic and graceful movements that Gros and Rubens could have imagined." Again, Delacroix might have felt he was seeing his own dreams take form. He had already painted horsemen fighting in medieval style. Now, after this firsthand encounter, he would go on painting variations on the theme as long as he lived.

Delacroix also was impressed by the beauty of the Jewish women in Tangiers. "They are pearls of Eden," he wrote. On February 21 he attended a Jewish wedding, which later was pictured in his famous 1841 Salon painting, *Jewish Wedding in Morocco (page 114)*.

But as he and the count waited in Tangiers to hear from the Sultan, the city began to pall on Delacroix. His senses were bruised by light, color, endless movement. The teeming streets, he complained, "assassinate you with reality," and he was assaulted by the picturesque, until he feared he was growing insensitive to it. At first he gloried in the sun. "I am experiencing sensations like those I had in childhood. Perhaps a confused memory of the southern sunshine, which I saw when I was a small child, is awakening in me." But then he wrote home, "I am rather worried about my eyes. . . . Although the sun has not reached its full strength, its brightness and the reflections from the houses which are all of them whitewashed, tire me excessively." It was, he decided, "the devil's own sunshine."

On February 16 the Sultan's invitation to Meknes arrived. But it

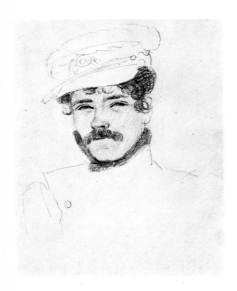

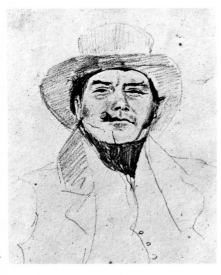

Two travelers Morocco-bound, Delacroix *(top)* and the Count de Mornay, are pictured thus in the first pages of the artist's record of the journey. While still aboard the naval vessel *La Perle*, Delacroix was already sketching furiously.

took almost three weeks to get the expedition into the interior started. Finally, on March 5, under the command of Ben Abou, Military Governor of Tangiers, Delacroix and the Count de Mornay set forth with a 120-man cavalry escort, 30 serving men and 42 mules. The distance to Meknes was about 200 miles, over mountains and across rivers.

On March 15 the mission arrived at the gates of Meknes and paraded into the city, accompanied by more soldiers, jostling crowds and wild pistol shots that almost unnerved the honored guests. They were lodged, doubtless to their relief, in a sumptuous palace.

The visit lasted 20 days, and ended with an exchange of lavish gifts. From the French King, the Sultan accepted a velvet saddle ornamented with gold; he, in turn, sent the King a lioness, a tiger, two gazelles, an ostrich, and four Arabian steeds from his own stables. He also provided extra mules to haul the caged animals.

Back in Tangiers, while the count busied himself for seven weeks getting a treaty signed, Delacroix worked intensely. On a back street he discovered a crowd of religious zealots, writhing and wailing in a frenzy: he recorded this primitive pandemonium in several versions of the *Fanatics of Tangier*. He embarked on *La Perle* for a short trip to Spain, there to absorb the glitter of the bull ring, bloody crucifixes in dim cathedrals, veiled smiles, the paintings of Velázquez, Zurbarán, Murillo, and his great Goya. Back again in what he was beginning to call "my Morocco," he picked up the count and at last started homeward. On the way they made a three-day stopover at Algiers which turned out to be the most thrilling event of the trip.

Delacroix wanted to visit a harem. This had proved impossible to arrange in Morocco, where religious rules were stricter, but in Algiers he enlisted the aid of the harbor engineer, who persuaded one of his Moslem colleagues to allow the Frenchman to visit his own personal harem—under oath of strictest secrecy. Never was a secret less likely to be kept.

From what friend told friend, and even from the words of the Count de Mornay, we know that when Delacroix stepped from a dark corridor into the golden light of the harem quarters and saw "in the midst of that heap of silk and gold . . . the lovely human gazelles . . . now tame," he became "exalted to the point of fever, which was calmed with difficulty by sherbets and fruit."

Delacroix spent hours with the gazelles, recording his sensations in watercolors and words. There were "moments of fascination and strange happiness." Again, he was transported back to ancient times: seeing some of the women caring for their children and working at a loom, he cried, "It's like the days of Homer!"

The contrast inspired him to a characteristically Romantic synthesis. "This is woman as I understand her," he exclaimed, "not thrown into the life of the world, but withdrawn at its heart as its most secret, delicious and moving fulfillment."

If the synthesis was false, he may be forgiven. In the harem Delacroix simply thought he had found his ideal: a happy relationship with women that made minimum demands on his time and emotions.

True to himself, Delacroix took so many notes and drew so many sketches that two years later he was able to create a masterpiece of enchantment, the *Women of Algiers*. Compared to most harem scenes, which look as if they were meant to decorate the lid of a gaudy cigar box, Delacroix's painting is a triumph of sensual delicacy *(page 119)*. His three seated women, dressed in light veils and heavy velvets of jewel-like colors, are studies in tranquillity. They appear to exist timelessly, freed of the frantic coquetry of Western women who always fear they will be late for love. To set off this Eastern dream of motionless peace, a Negro servant walks through the room, her head and hips turned fleetingly to create a typical Delacroix contrast between stillness and action. When shown at the 1834 Salon, the *Women of Algiers* was dismissed by an important critic as an example of the painter's "extreme negligence" in technical execution. But in later years artists gave it the reverence it deserves: Renoir, for example, once remarked that when he approached the picture he felt he could actually smell the incense in the room.

Delacroix and the Count de Mornay returned to Paris on July 20. Before long Delacroix was complaining that Paris "bores me profoundly: men and things appear to me in a quite different light since my journey." After the free-flowing simplicity of Moroccan garb, he felt, "we in our corsets, tight shoes and ridiculous casings are pitiable."

But beyond any doubt, the painter was fortified, and would be for the rest of his life, by what he had seen. The ramparts of Meknes would turn up, slightly modified, as the walls of a Scottish castle in the *Abduction of Rebecca*, Delacroix's rendering of Scott's *Ivanhoe*. The mountains of Morocco would loom again in his paintings of Palestine and Greece. The fighting horses, tigers, lions, careless attitudes of merchants and warriors, would all return in future works. Often they would not be recognizable. They would merge with the creatures of Delacroix's own imagination, just as his women of Algiers surrendered part of their identity to the models and mistresses he had known.

Along with specific data, Delacroix also brought home a new feeling for color. His exposure to "the devil's sunshine" extended his palette, and led him to experiment with more sparkling light effects. Lessons he learned from Veronese became second nature after he saw them confirmed in the streets of Tangiers: colored objects cast shadows that were tinged with their own complementary colors; pure colors put on side by side vibrated like a plucked harp string. His compositions also grew stronger, influenced by the solid masses and straight lines of Moorish architecture. Morocco cast its light far into the future. For Delacroix's adventure suggested a way for many modern painters to stimulate their art with foreign and exotic influences.

But of all the treasures Delacroix brought back, his most important acquisition had no tangible shape or form. In Morocco he had seen how a passionate Romanticism could unite harmoniously with the natural dignity and control that constituted pure classicism. The opposites could be reconciled, even in his own nature. Morocco gave him many gifts. But, most to be valued, it gave him a more complete self.

Delacroix spent only four months in Morocco, but in his mind the journey lasted a lifetime. Although his commission as painter to the diplomatic party of Count de Mornay was hastily arranged, he prepared carefully, gathering supplies of pens, ink, watercolor paints and brushes, blank notebooks and quantities of paper and pencils. In a frenzy of anticipation, he began to sketch even while on shipboard crossing the Mediterranean. His lively pen and brush never stopped thereafter; letters to friends at home in the dank Paris winter were brightened with little pen scribbles, note pages were covered quickly with scrawly handwriting and active line sketches, and loose pages of watercolor paper flickered with light and color. He took the time to complete only a few of his numerous drawings, but near the end of the trip, while waiting in quarantine at Toulon before returning to Paris, he made an album of 18 watercolors as a gift to his host and new friend, de Mornay. Later, he visited the count's home and made a painting of his Moroccan-decorated bedroom (*right*). Using his sketchbooks, Delacroix relived his southern adventure again and again. The natural beauty of the people and their way of life provided him with a lifetime of subjects. Paintings he did later, whatever their subject, show how vivid this brief experience was. The African sun, it seemed, had burned into his memory, radiating energy and inspiration.

A Burst of Color

Delacroix's study of the Count de Mornay's bedroom (*right*) was made in preparation for the double portrait he did of the count with his friend Prince Demidoff, a Russian aristocrat (*above*). It was destroyed during the First World War.

Count de Mornay's Room, 1831-1832

Delacroix's artistic record of his Moroccan adventure filled seven fat notebooks with drawings and watercolor sketches, but four of the books were lost in later years. He painted no oils and finished only a few of the watercolors, but he made daily records of costumes, faces, animals, countryside, and architecture. Even while riding, he would sketch with his notebook propped up on his saddle. Often there was only time to write on the margin of his sketches what colors he was seeing. The books he filled with these artist's shorthand notes are one of the treasures of art history. Although created in the excitement of the moment, they are notably tidy and specific. Delacroix once said that an artist should consult nature as he would a dictionary, master her vocabulary, then use her "words" in whatever way he chose. His sketchbooks are indeed a kind of Moroccan vocabulary, neatly spelled out and organized to serve him later. He was filled with an acute sense of urgency: he knew this was his only chance to seize

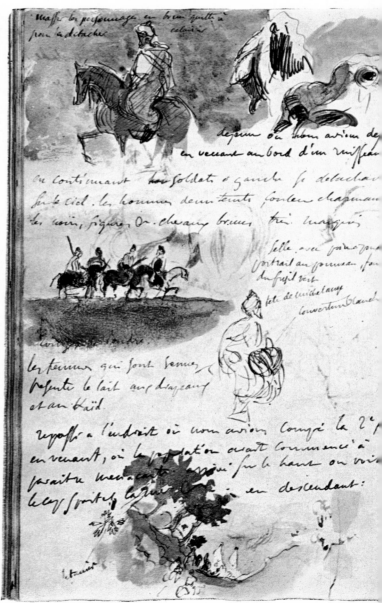

Walls of Meknes, painted between April 1 and April 5, 1832

this material, and he must set it down factually and primer-clear with key visual definitions.

Below are pages from one notebook now in the Louvre, recording his long ride from Meknes to Tangiers. On the page at left, he noted details of Moorish architecture and Arabs standing guard, and on the double page in the middle he dashed off impressions of Arab horsemen and the scrubby Moroccan landscape. The three watercolors at the right were done on a separate sketchpad.

The Bay of Tangiers in Morocco

Desert and mountains near Tangiers

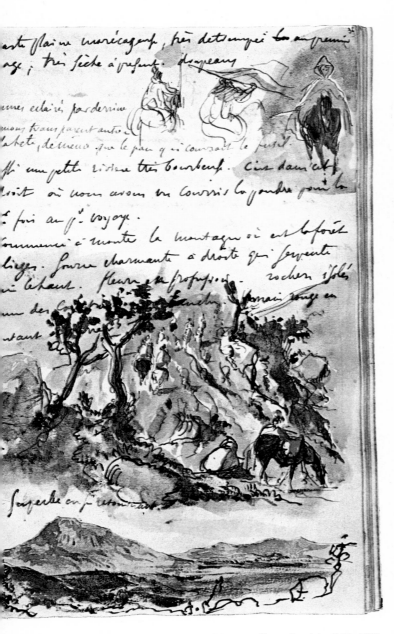

Pages dated April 11, 1832

Room in the Sultan's Palace at Meknes

Seated Arab in Tangiers, 1832

Watching the Arabs as they sat in a crowded street or in a shaded doorway *(above)*, Delacroix admired their repose and perfect dignity, and he constantly sketched both men and women as they walked, rode or stood, gracefully gathering their robes about them.

But he was less appreciative of the opposite side of their nature, which moved them to fly into frenzies. On the long ride to Meknes, bands of Arab warriors often swooped down on the visiting Frenchmen, treating them to exhibitions of fancy shooting called "powder plays," which Delacroix sourly described as "disorder, dust, din . . . thousands of shots fired in our faces." When the diplomatic party finally reached the gates of Meknes and prepared to parade into the city, the Sultan's personal soldiers gave them just such a noisy display as a welcome. Though unnerved at the time, Delacroix later recalled this jamboree with relish, and he painted the "powder play" *(right)* for the album of watercolors which he presented to the Count de Mornay as a memento of their journey. Wild-eyed and bursting with energy, the horses and riders satisfied his Romantic appetite for violent action and formed a perfect antidote to the civilized restraints of Paris society.

112

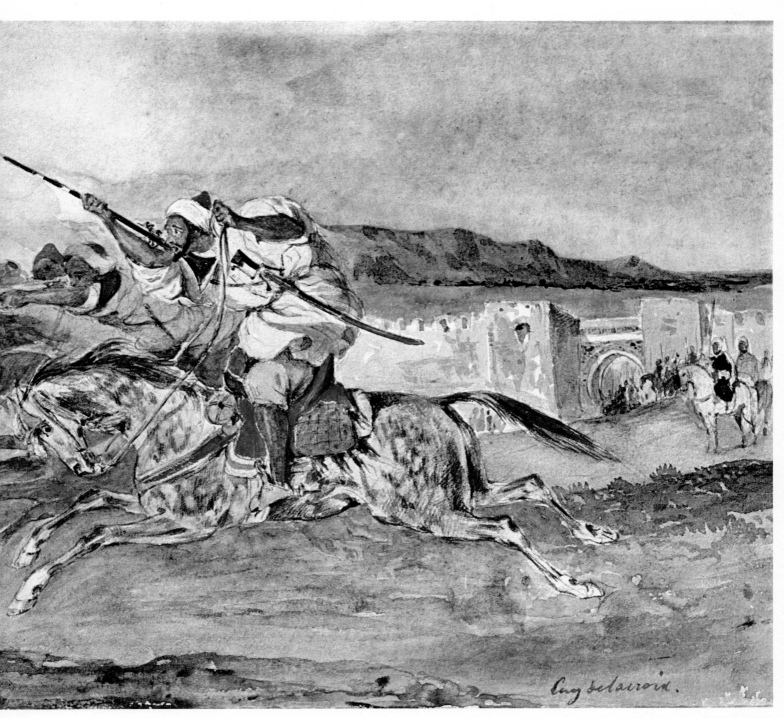

"Powder play" at the gates of Meknes, 1832

Watercolor sketch of the courtyard

Delacroix's *Jewish Wedding* is the souvenir of a rare privilege: to be invited, through a Jewish interpreter friend, to a wedding in a Moroccan home. With his host's permission he was free to sketch what he saw. One watercolor he made was of the courtyard *(left)*, cool and empty save for a seated figure. Struck by the interplay of light and shadow, Delacroix kept the same tone and pleasing proportions when he painted the scene *(below)* in oils seven years later. With bold brushstrokes, he deftly worked in the numerous guests, musicians and the dancing bride herself *(right)*, whose rich brocaded bodice and headdress are suggested in his thickly applied, glowing colors.

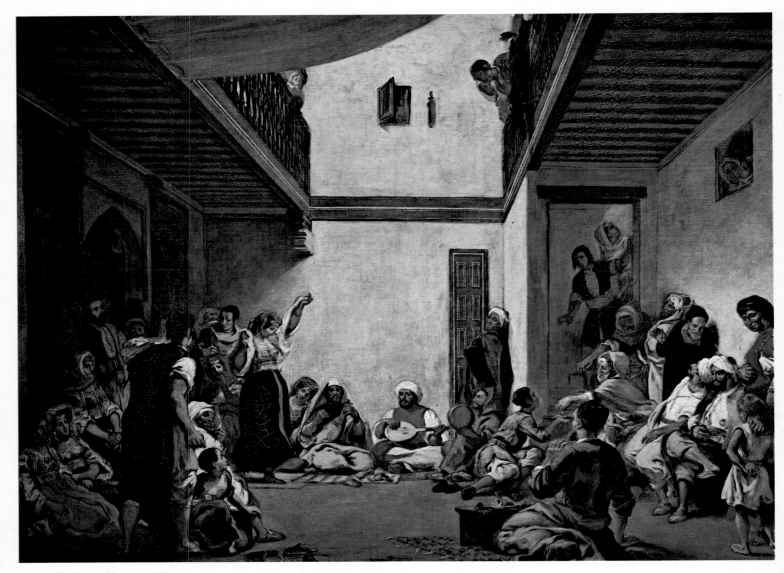

Jewish Wedding in Morocco, 1839

114

Jewish Wedding in Morocco, detail

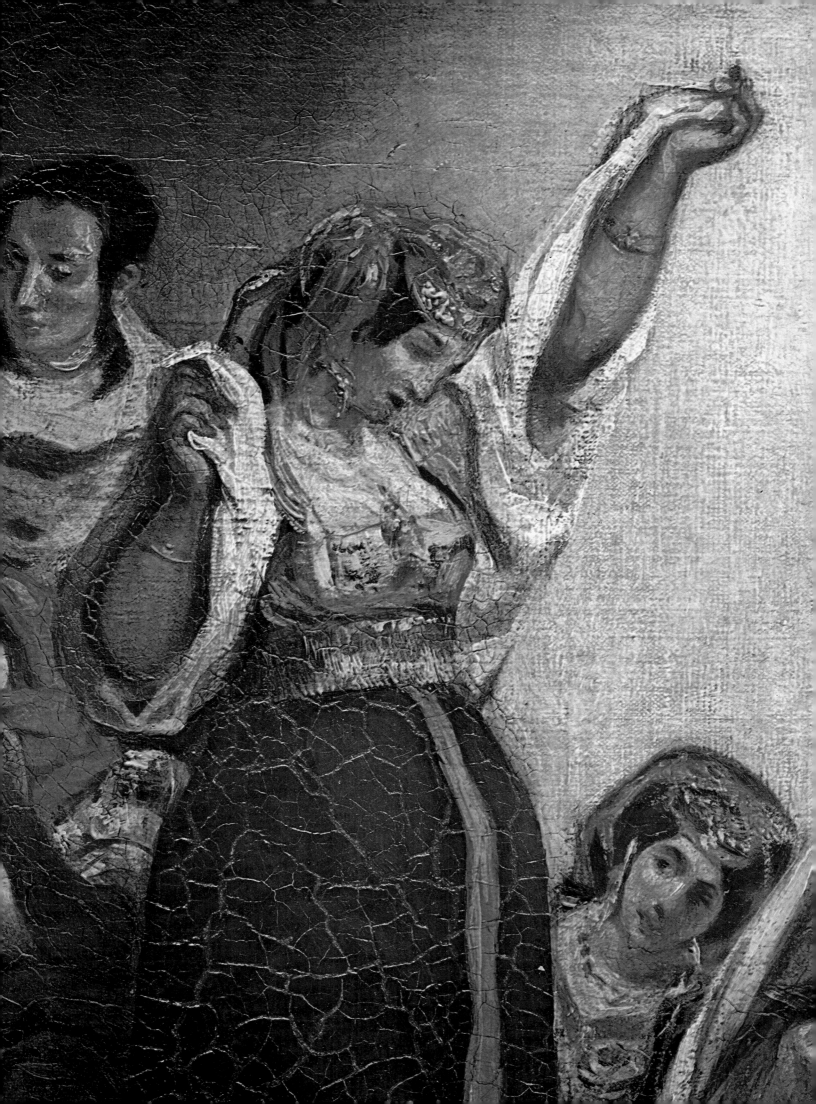

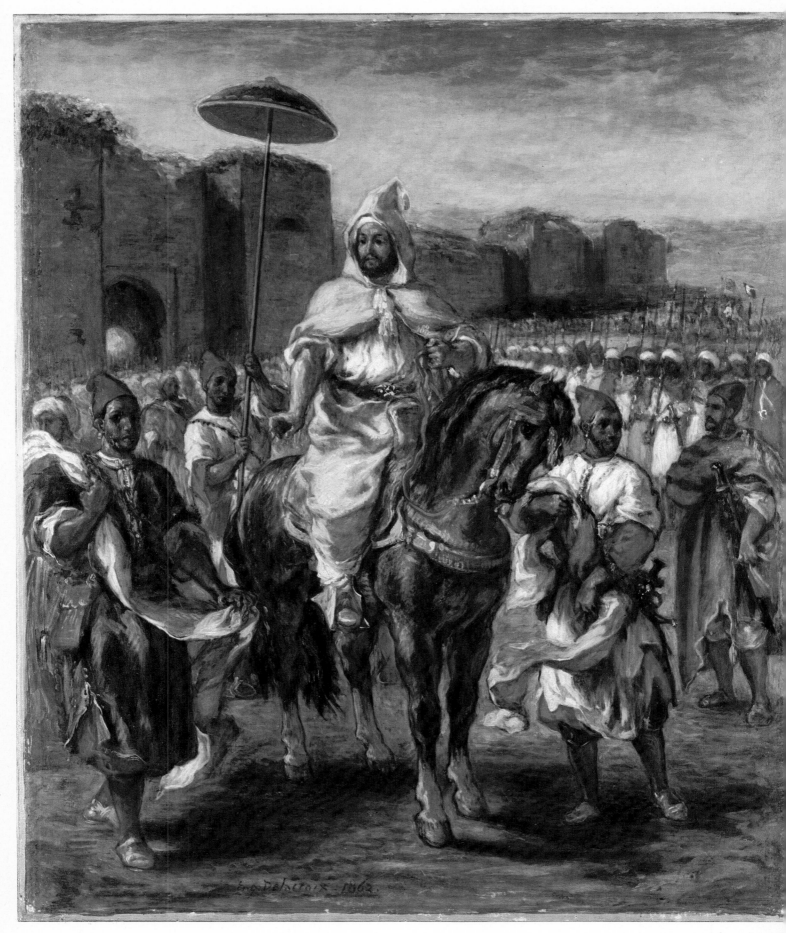

Sultan of Morocco, 1862

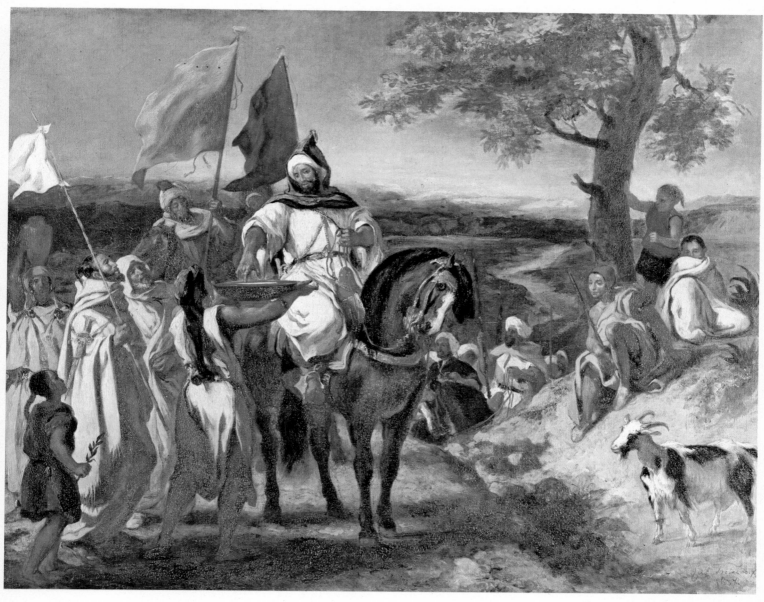

Moroccan Caid Visiting His Tribe, 1837

Meeting the Sultan of Morocco was the climax of Delacroix's journey, but he did not make a painting of the event for years. First he did a scene that he had witnessed on his return from Meknes: a minor chief *(above)* greeting his tribesmen and accepting a gift of milk, into which he symbolically dips his fingers.

The simple ceremony and the imposing power of the leader on horseback must have impressed Delacroix deeply, for he retained this attitude when he painted the meeting with the Sultan outside the gates of Meknes *(right)*. He also changed the composition to a vertical one in order to emphasize the mounted figure, who, with his imperial gesture, now has the strength of an equestrian statue. In a final version *(left)* made only a year before he died, Delacroix brought the central figure into even greater dominance.

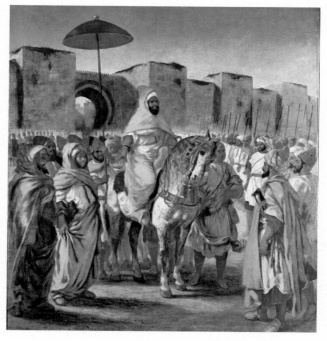

Sultan of Morocco, 1845

117

Watercolor and pencil sketches of harem women

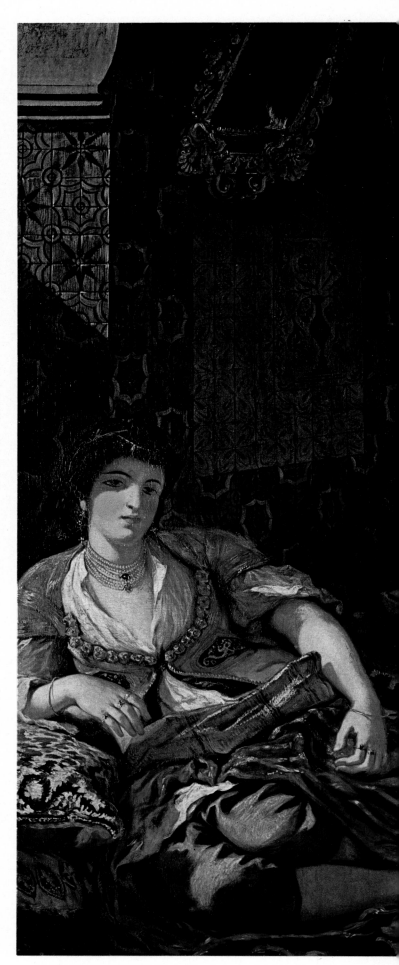

Working from sketches *(above)* made during his eagerly awaited visit to an Algerian harem, Delacroix created an enchanting masterpiece for the 1834 Salon. Though painters and critics of the time derided the painting as a daub, artists since then have marveled at its subtle weaving of shapes and colors, its gaudy golds and luminous whites, its delectable reds, ranging from faint pinks to deep madder— all enveloped in seductive shadows that evoke peace and pleasure. "The color of the red slippers," said Cézanne, "goes into one's eyes like a glass of wine down one's throat." Renoir remarked that when he got close to it he imagined he could smell the incense. And Picasso, working over its details like a composer doing variations on a theme, painted 15 different versions of it in 1954 and 1955.

Women of Algiers, 1834

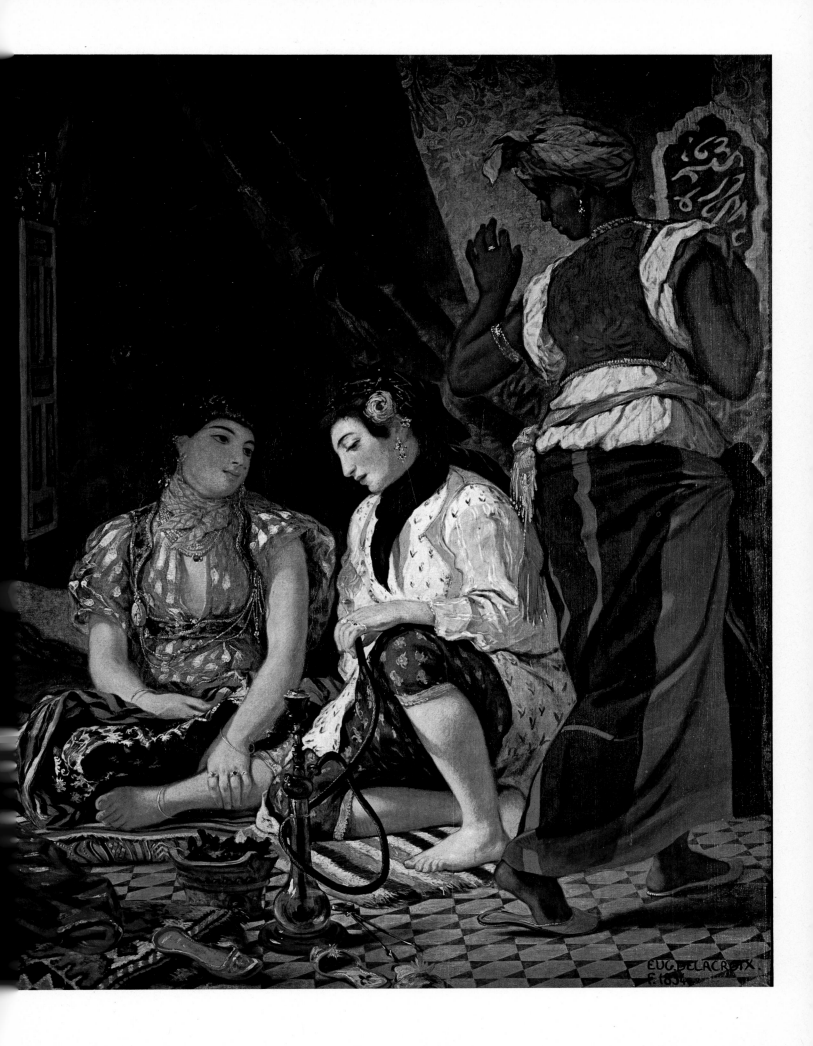

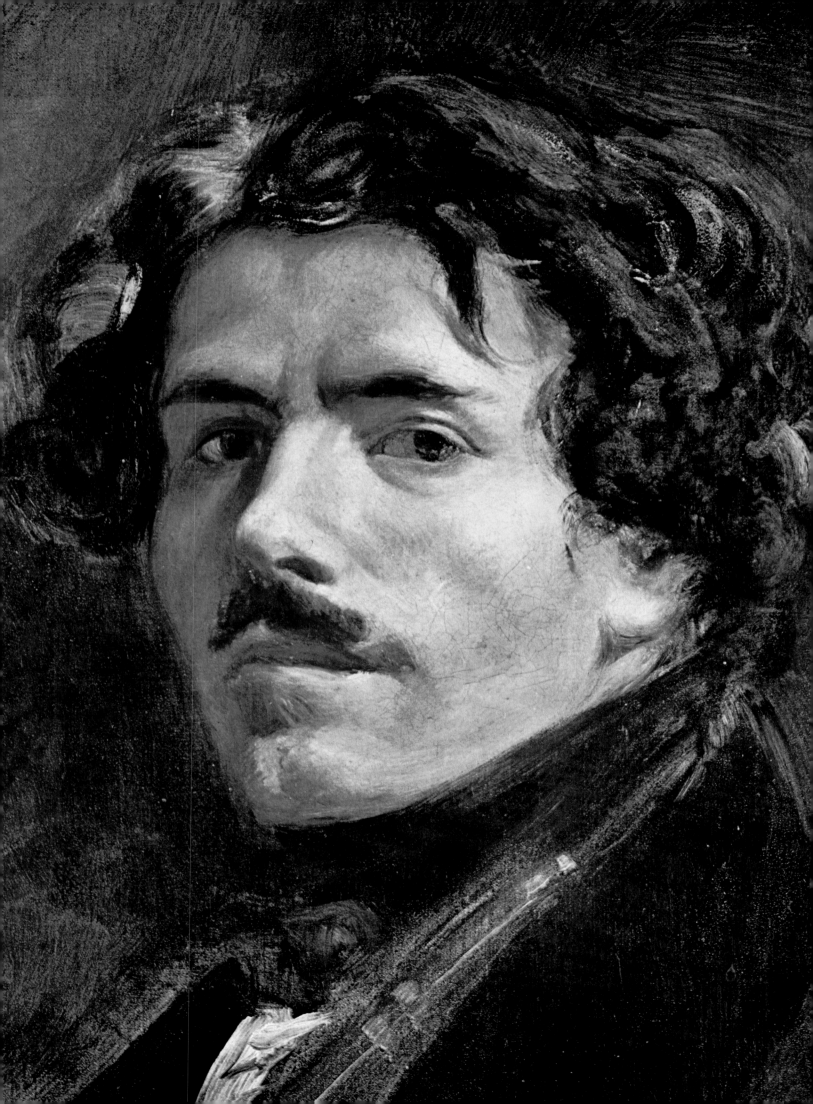

VI

The Painter Comes of Age

The Delacroix who looked back on Morocco was a different man, in vital respects, from the Delacroix who had looked forward to it. He had come joltingly face to face with a world beyond the books that had nourished his imagination. He had been "assaulted"—as he put it—by the savage realities of Moroccan manners and mores; yet in the end the experience provided a kind of shock therapy. Like a green recruit seasoned in battle, Delacroix took on a new assurance: he was on more solid ground, more in command of his own resources both in his private life and in his art.

The change was discernible in an incident that took place some months after Delacroix's return home. For pre-Lenten carnival time in March 1833, Alexandre Dumas decided to give a costume ball. Since his own quarters were not large enough for the 400 invited guests, he rented an adjacent empty apartment for the occasion and then invited Delacroix and all the other artists he knew—in effect, most of the Romantic painters in Paris—to decorate the place with works produced specifically for the celebration.

Delacroix was fond of Dumas, although he considered him a chattering nuisance and his highly popular novels "very superficial." In his account of the events leading up to the ball, however, Dumas offered some shrewd insights into Delacroix's new-found self-confidence. As he later recalled in his memoirs, his artist friends, one by one, installed their works on the premises; only Delacroix failed to appear. On the morning of the ball, after Dumas had about given up hope, Delacroix walked in and proceeded serenely to inspect all the other paintings, with a kind word for each. Then he got down to his own work. At Dumas' request, he had agreed to depict a Visigoth hero, King Rodrigo, who had fought his way through the folk *romanceros* of old Spain and had been killed in battle.

As Dumas remembered it: "Without taking off [his] little black coat . . . without turning up his sleeves . . . or putting on a blouse or cotton jacket, Delacroix took some charcoal and, in three or four swift strokes, had drawn the horse; in five or six, the cavalier; in seven or

Delacroix was once described as "thin, delicate, with a rather cold and reserved countenance, but with a simplicity that did not exclude elegance." Whether or not he agreed, he seems to have seen some of these qualities when he looked at himself.

Self-portrait, detail, 1835-1837

eight, the battlefield, dead, dying and fugitives included. Then he began to paint.

"In a flash, one saw appear a cavalier, bleeding, injured . . . and half-dragged by his horse, holding on by the mere support of his stirrups, and leaning on his long lance. . . . As far as the eye could see, away toward the horizon, stretched the battlefield, over which a sun was setting like a red buckler in a forge. It was all wonderful to watch. A circle gathered round the master, and each of the artists left his task to admire, without jealousy or envy, this new Rubens who improvised both composition and execution as he went along. It was finished in two or three hours."

Dumas' description of the artist, calm and unruffled, secure in his position and in his control of his brush, memorialized the new Delacroix. The ball itself epitomized the Romantic era. Half of literary and artistic Paris was there—the livelier half, plus a few of its more sedate admirers, including the septuagenarian Marquis de Lafayette. "He who had pressed the hand of Washington," as Dumas emotionally put it in his memoirs, "smiling at all this youthful folly, had without demur dressed in a Venetian costume." The Italian composer Gioacchino Rossini came as Figaro, the 23-year-old Alfred de Musset as Pagliaccio, the animal sculptor Barye as a Bengal tiger, Dumas himself as a Titianesque type. The girls—among them an 18-year-old beauty on whom Delacroix cast a questing eye—came as shepherdesses, odalisques, slaves, dolls, Dumas heroines, Neapolitan peasants, Madame du Barry and assorted queens of France.

Supper was served at 3 a.m. To feed his army of guests, Dumas had conducted a hunting expedition to a nearby forest that netted nine plump stags, some of which were traded for a 50-pound sturgeon. The food was washed down with hundreds of bottles of Burgundy, Bordeaux and champagne. Two orchestras—one in each apartment—synchronized their *galops* so the dancers could move from room to room without missing a beat. The party broke up, or at least left the premises, about nine in the morning, and paraded down into the Square d'Orléans and out into the Boulevard des Italiens with bursts of song and dance. Cutting an oddly somber figure among the revelers was Delacroix—as Dante.

The entire procession, as it poured exuberantly into the new day, was a reflection of the Romantic movement itself. Historically, French Romanticism was at its zenith, and it still had some years to go before it was to succumb to the cold winds of realism. There were, to be sure, portents of change. King Louis-Philippe was actually courting the bourgeoisie, trying to popularize the image of himself as a businessman. France already had its first railroad, servicing a coal mine; steam engines were powering textile factories; new machines were beginning to modernize the iron industry; an expanded network of roads and canals was encouraging the growth of commerce. Though it was moving more slowly than in England, the Industrial Revolution was on its way, bringing with it the materials and mass conformity that were anathema to the Romantic spirit. But meanwhile Romanticism stood its ground,

When Delacroix made his last-minute appearance to paint a mural for Dumas' fancy-dress ball on March 15, 1833, he chose to show the Visigoth King Rodrigo valiantly wielding his lance in the moment of his defeat in battle. This tour de force, done in only a few hours, was later removed from the wall and is now in the Kunsthalle Museum in Bremen, Germany.

and it was still seemly for a Dante, an Oriental slave girl and a man in a tiger suit to dance in the streets.

A few weeks after the Dumas ball, Delacroix won his first commission to decorate a government building. He was asked to execute a group of murals for the Salon du Roi—the King's Chamber—at the Palais Bourbon, where Louis-Philippe received his ministers and deputies when he opened his legislative sessions. The Citizen King, it seemed, was still enough of a monarch to hanker for visual grandeur. The fee was to be 30,000 francs; it was increased by 5,000 francs as the work progressed.

Artistic Paris was considerably irked at the news of Delacroix's assignment. In the field of monumental painting, the Salon du Roi project was one of the biggest in recent French history; Delacroix's detractors felt that the plum should have fallen to an older painter, and one experienced in the special techniques required. But the award had been arranged by Adolphe Thiers, who had risen from journalism to become Minister of Commerce and Public Works, and who, in the decade since he had acclaimed Delacroix's *Bark of Dante* and urged him to "devote himself to immense tasks," had seen no reason to change his opinion. Nor would he change it in the future: virtually all of Delacroix's many subsequent government commissions had Thiers' overt or behind-the-scenes backing.

There is no record that Delacroix—with all his new aplomb and certainty of his gifts—was either disturbed at the critical outcry or doubtful of his ability to measure up to the totally different challenge posed by the Salon du Roi. Here was no simple two-dimensional canvas but an entire 36-foot-square room to be decorated, and one with built-in architectural problems. Each of the four walls was broken by three arched doorways and real or false windows; the ceiling, instead of presenting an uninterrupted sweep, was divided into four parts by a central cupola, or dome, itself unpaintable because of the huge chandelier suspended from it. Altogether the space for painting was cramped and poorly disposed; obviously the room had not been designed with murals in mind.

There were other problems as well. The ceiling leaked, and Delacroix had to write the Chief of the Division of Belles-Lettres, Sciences and Arts at the Ministry of the Interior to arrange that it be fortified against dampness before he began work. The waterproofing went slowly, and meanwhile Delacroix was laid low by a fever—never accurately diagnosed—which had intermittently dogged him since boyhood. "Delacroix's health is up and down," Pierret wrote Félix Guillemardet in July, "he hasn't put a hand yet to his grand work, the scaffolds are being set up, and in a few days he will be perched on his ladder."

Three weeks later the painter wrote Guillemardet, "I've started . . . but not without pain. I had to resort to intrigue to get my scaffold built right. But now it suits me. I'm doing charcoal sketches on the walls, and the beginnings are beautiful." He was no less pleased by his entire grand plan. On the walls, to fit the tall spaces between the 12 arched openings, he proposed to place figures personifying the rivers

Napoleon I

Louis XVIII

Charles X

Louis-Philippe I

Napoleon III

These silver five-franc pieces trace
the rulers of France during Delacroix's
lifetime. At the top is Napoleon Bonaparte,
who in 1804 had himself declared
Emperor. When he abdicated 10 years
later, Louis XVIII, a Bourbon, took over,
but he died in 1824 and was succeeded
by his brother Charles X. The regime fell
in 1830 when Louis-Philippe came
to power. Finally, in 1848, Napoleon I's
nephew was elected Prince-President
of the Republic. In 1852 he became
Emperor Napoleon III, his title until 1870.

and oceans of France, painted to look like gray marble carvings. On the four long, rectangular ceiling panels he proposed to place female allegorical figures representing Justice, Agriculture, Industry and War. Justice was to hover just above the part of the room where the King customarily sat enthroned. War was to be as remote as possible—on the opposite ceiling panel.

As the work developed, it became apparent to Delacroix that the wall and ceiling decorations did not hold together. They were too scattered, too isolated. At a high cost in extra toil, he decided to add a border of figures around the top of the walls to unify the disparate elements. The space for this frieze could hardly have been worse. It was bitten into by the tops of the 12 arched openings, with the result that the figures had to be squeezed, stretched and twisted around them.

Still, Delacroix managed to fit some 60 figures into this tortuous jigsaw puzzle. In his first sketches for the border, which was to repeat the allegorical themes on the ceiling, Delacroix leaned heavily on his Moroccan memories. He draped his figures in Arab robes and set them in the casual attitudes he had seen on the streets of Tangiers. The Arab faces and costumes do not appear in the final painting, but the easy fluidity remains, imparting a freshness and movement seldom to be found in classical allegory.

For all its fascination, the Salon du Roi project was an ordeal for Delacroix; grueling self-punishment had been the lot of ceiling painters since Michelangelo. Delacroix's friend Charles Rivet wrote of the "efforts of will" that were entailed, and added: "To conceive of what such labor was like, you had to have seen him at the end of each day, leaving the scaffolding on which he was condemned to remain, often in a painful position—pale, tired out, hardly able to talk, dragging himself along as if he had just escaped from torture."

To distract and refresh himself, Delacroix turned to three spirited women who were to remain his friends for life. One was Elisabeth Boulanger, the smiling-eyed young beauty who had caught his fancy at the Dumas costume ball. She was a relative of the Bonapartes, married, and an artist who exhibited at the Salon. When she wrote Delacroix asking to borrow his painting of *Romeo and Juliet* so that she could make a pastel copy, they began an exchange of pictures, letters and presents—including, from him, a whole hamper of *pâté*. Their affection survived a curious episode—much gossiped about in Paris—in which Elisabeth left Delacroix abruptly in mid-journey after two weeks together in Bruges and Antwerp. Whether this jaunt was intended to test the strength of their attachment can only be conjectured; despite its apparent failure and Elisabeth's subsequent second marriage, they were still seeing and writing each other years later.

The second woman in Delacroix's life—more important to him than any other—was his distant cousin Joséphine de Forget. Their relationship thrived for more than 30 years, sometimes with passion, always with affection. Joséphine had had a heroic girlhood. In 1815—when she was 13—her father, a general, was sentenced to be executed for helping Napoleon. On the day before sentence was to be carried out, Joséphine

and her mother paid him a farewell visit in his prison cell; by pre-arranged plan the general dressed in his wife's clothes and was led out to freedom by Joséphine under the noses of the guards. Her mother, who remained behind in his place, was held captive for years, and was so tormented that she lost her mind. Joséphine married at 17, and had one child. She and her cousin Eugène had enjoyed a secret rendezvous near Valmont as far back as 1829, but their liaison became known only after her husband's death during the Salon du Roi period. At Delacroix's own death, Joséphine was made one of his heirs. Among her treasures was a stack of letters he had written her, most of which have been destroyed.

Delacroix's third lasting friendship was with the greatest woman writer of the day, George Sand. They met when she climbed the 117 steps to his studio on the Quai Voltaire, with a request from a magazine editor that Delacroix paint her portrait so it could be published in his journal. Madame Sand had just returned from Venice, where her stormy affair with her fellow-writer Alfred de Musset had come to a quarrel-some halt; she had cut off her hair and sent it to him as a rebuke, and she badly needed cheering up. Delacroix offered her cigarettes, which she found delicious, let her look at his Goya prints, which she vastly admired, and counseled her not to repress her anguish, but to give vent to it, let it pour out to clear the air. He did not offer her, it appears, any more personal consolation. Delacroix was rightly wary of George Sand, a dominating personality, given to dressing herself in male attire; moreover, she lived, in frightening proximity, almost next door.

She did not like Delacroix's portrait of her; the painter's eye had probed deep, and the result was to make her look too grieving, too un-glamorous. The magazine hired an Italian engraver to do a prettier job. Delacroix was understandably annoyed, but the incident did not seri-ously impair his relations with his temperamental sitter. Indeed they improved a good bit when she moved farther away.

The perceptivity of the George Sand portrait was characteristic of the intimate paintings with which Delacroix spelled himself to offset the grandiose murals of the Salon du Roi. Working at his easel in the privacy of his studio, he painted like a man humming to himself, easily, almost unconsciously, tossing off sketches to please friends, to capture a mood, to satisfy a whim.

Delacroix showered portraits on the family of his old friend, Pierret, including a half-dozen of Pierret's beautiful wife, one of his sister, and several of the four Pierret children. He sketched the wife of his friend Frédéric Villot, in one of the Moroccan costumes he had brought back among his souvenirs. He also painted a portrait of her husband, with whom he was later to quarrel. Delacroix caught enough of Villot's sharp intelligence—he peers out of the picture with impudent curiosity—to suggest that whatever the precise cause of their falling-out, it in-volved the clash of two strong personalities.

Significantly, some of his finest portraits were of members of his own family. He had already painted his brother Charles, the general, as he appeared in the years after his Army retirement. Stretched out on a

hillside, sloppily dressed, Charles has the look of a brave, warmhearted man gone to seed *(page 134)*. It is a penetrating portrait for any time, but by the accepted standards of Delacroix's day an unflattering one. Yet for this man so unlike himself, Delacroix makes clear his affection and his sympathy.

Of his first cousin, Léon Riesener, who was a talented minor painter, Delacroix produced another appealing portrait, catching the young man's handsome, sturdy earnestness, and the shy diffidence that made him something of a recluse. An even more engaging portrait is the one of Léon's mother—Delacroix's beloved Aunt Félicité, with whom he used to translate Byron. With her lacey cap and collar, her party curls all in place, there is no doubt she is proud of Eugène—doing murals for the King and everything—but she also wants to laugh and knows that he will laugh with her.

Rarely did Delacroix do a portrait of anybody who was not a friend. "I can't ever be a fashionable painter," he once said. As far as his abilities went, this was certainly untrue. His refusal to pursue this lucrative occupation, it seems, stemmed from the proud vein in his nature that prevented him from making the necessary concessions to a haughty patron. Many other painters have faced up to this unpleasant requirement, but for Delacroix it would have been peculiarly hard to take the headaches along with the high fees.

Delacroix brought back a trunkful of costumes from Morocco which he put to use at once. He dressed up Pauline Villot, wife of his friend Frédéric Villot (later to become Keeper of the Paintings at the Louvre), in Moroccan robes; and while she sketched him *(below)*, he sketched her.

Delacroix poured a new kind of personal expressiveness into his portraits at this time, and into a number of other works which he executed away from the spotlight of the Salon du Roi. Sometime during the summer of 1834 he learned that Charles de Verninac had contracted yellow fever on a consular mission to Mexico and had died in New York City. The artist's grief, and his feeling of helplessness at being so far from his favorite nephew, took form in a painting based on Byron's poem *The Prisoner of Chillon (page 96)*. He saw himself as the prisoner chained in a dungeon, obliged to watch his younger brother—chained only a few feet away—dying slowly before his eyes. In agony, he reaches out to help the boy until the chains almost cut through him, but all in vain; the distance is too great.

In the same year, perhaps less than coincidentally, Delacroix began a series of 16 lithographs illustrating *Hamlet*. The Melancholy Dane had haunted the painter for years; he had done a self-portrait in dark Hamletlike garb as far back as 1821. For the lithographs, Delacroix used a technique similar to the one he had used for *Faust*. But while this style had exactly the right diabolic crackle and verve for *Faust*, it somehow struck the wrong note for *Hamlet*. Palette and brush proved better interpreters; through the poetic use of color, Delacroix's later paintings of Hamlet were far more evocative. As for the lithographs, some of them were published—in part at Delacroix's own expense—in 1843; the full set was not issued until a year after his death.

One of the smallest of the works Delacroix painted—a canvas only about 10 by 16 inches in size—provided an astonishing signpost to the future, pointing to a new direction, a new emphasis in art. This was an oil sketch of the Genoese violinist Niccolò Paganini *(page 137)*, in

which Delacroix ventured to create not a likeness but the total impression of a Paganini performance. Both a composer and superb fiddler, Paganini had for years been causing a furor in the concert halls of Europe. His programs, which included such showpieces as *Perpetual Motion* and the *Witches' Dance*, had something of the same arcane appeal as the boulevard hits of the novelist Charles Nodier, whose *La Vampire* and *Trilby* led to a spate of plays about human bats and weird hypnotists preying on delicate girls. When Paganini stepped out on the stage, seeking a spot behind the glare of the gas footlights in order to protect his eyes—or was it because demons of darkness feared the light?—a chill fell on the audience. Superstitious people had long suspected that the violin was the devil's music box; now it was obviously true.

When Paganini clamped the violin under his chin and lifted the bow in his long, bony hand, when his cadaverous face stiffened into a trance and his right foot began tapping, his listeners were even more transfixed; one woman claimed she saw the devil himself peering over Paganini's shoulder. The notes skittered off the strings like imps. The long *legatos* beckoned slowly, caressingly, like Lucifer's temptresses. When the music was over and Paganini stepped forward to bow, he moved with such skeletonlike looseness that one expected him to collapse in a clatter of bones.

Delacroix admired this showmanship. He was still more impressed by Paganini's technique, developed from endless hours of practice. Paganini was a prime example of the Delacroix tenet that technique must be perfected until it never obtrudes on the final effect of spontaneity; it is thus appropriate that the little portrait seems to have been dashed off while the fiddling still echoed in the painter's ears.

In later decades, both Daumier and Manet would avail themselves of the lessons of Delacroix's *Paganini*. Outside of art circles scant attention has been paid to it. Had it been 10 times larger—somewhat nearer, say, the size of Manet's celebrated *Fifer*—it might perhaps have become a popular work. Nevertheless, Delacroix must be admired for not yielding to the temptation to make the work pretentious and puffed up, for letting it exist as a quick little picture totally true to his own feelings.

Paganini held an interest beyond its merits as a painting. It marked another round in a battle Delacroix had waged since almost the start of his artistic career, and would wage until almost its end. This was his recurrent rivalry with another major figure in the history of French painting, Jean-Auguste-Dominique Ingres.

If Delacroix, with his penchant for antitheses, had tried to conjure up a directly opposed adversary in art, he could hardly have invented a better one. Some years back Ingres, too, had done a portrait of Paganini, and in the contrast between his treatment and Delacroix's the gulf between the two painters' esthetic philosophies is clearly discernible. The Ingres version—a sketch—is a thoroughly attractive work that tells us precisely what the violinist looked like *(page 136)*. The picture is tidy and civilized, suitable to be seen in polite society, reflecting credit on both the artist and his subject—and on whoever owned the drawing.

But it stirs no excitement, reveals little of Paganini's personality, and, above all, generates none of the ambience of his performance. Ambience concerned Ingres little. His acknowledged goal was to create polished representations, and it was a goal which he almost invariably achieved, and with brilliance.

In actual fact, Delacroix and Ingres had much in common. Both had cut their teeth on neoclassicism—Ingres as a star pupil of David's, Delacroix of Guérin's—and both retained an immense respect for the principles of traditional art. It was in putting these principles into practice that the two men parted company; Delacroix could not be constrained within their limits. While both men believed firmly in the absolute value of the use of line in painting, they differed radically over its value relative to color. "Drawing is the first of the virtues for a painter," Ingres once remarked to a pupil. "It is everything; a thing well drawn is always well enough painted." Delacroix, on the other hand, felt that color was at least as important as line—color "varied, lovingly united to thought, and completely transformed according to the nature of the subject treated." Such ideas were quite outside Ingres' ken. It was as if he feared that color, by its very freedom and spontaneity, could overrun a canvas and play havoc with all orderliness and precision. Indeed, he forbade his students, on their trips to the Louvre, to look at the works of Rubens lest they be corrupted by his color and flamboyance.

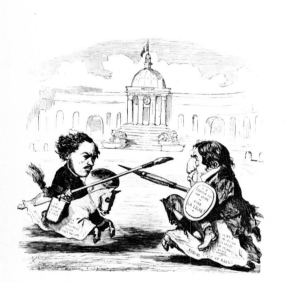

This burlesque duel between the neoclassicist Ingres and the Romantic Delacroix takes place before the Institut de France, parent body of the Académie des Beaux-Arts, to which Delacroix had been denied admission for 20 years. He brandishes a paintbrush here against Ingres' pen and shield, on which is written "Color is a Utopia, Long Live Line!" On Ingres' horse's skirts is the taunt "Rubens is a Red." Delacroix parries with the slogan "Line is a Color," written on his paint pot, and "Only at night are all cats gray." A caption said: "No hope of quarter being given, if M. Ingres wins, color will be proscribed all down the line."

The historic feud between Ingres and Delacroix had begun with the 1824 Salon. Ingres, a Prix de Rome winner, had returned home with a painting, the *Vow of Louis XIII*, which promptly won him membership in the Académie des Beaux-Arts, a much-coveted honor that was to elude Delacroix until near the end of his life. Since Ingres' entry was certainly not one of his better paintings, it has been suggested that he was voted into the Academy less as a reward for merit than for political reasons and as a snub to Delacroix, whose Salon entry that same year, the *Massacre at Chios*, seemed to flout all that French conservatives held dear.

Three years later the two painters were Salon rivals again. Delacroix had his *Sardanapalus*. Ingres had his *Apotheosis of Homer*, in which the Greek poet was enthroned on the steps of a temple, flanked by famous men of both recent and ancient times, looking as if they were posing for a graduation photograph. Ingres' painting was not all bad, any more than Delacroix's was all good. But the contrast between them points up how easy it was for Ingres to become identified as the champion of academic standards and for Delacroix to become suspect as a purveyor of radical notions.

As usual in notorious feuds, stories about the combatants received wide circulation. One day, it was said, just after Delacroix had left the Louvre, Ingres ordered the windows opened to clear the air of the smell of sulphur. At another time, a Parisian banker invited both men to a dinner party. Assuming that he alone was the guest of honor, Ingres held forth happily until he became aware that Delacroix was present. He scowled, then grew silent. Finally, after dinner, he took coffee cup in hand and strode up to Delacroix, who was standing by a fireplace.

Without preamble, he went to the heart of the matter: their running dispute over the merits of line versus color. "Monsieur," sputtered Ingres, "drawing is honesty." Delacroix made no response. Infuriated, Ingres shook so much that he slopped coffee over his shirt and coat. "This is too much," he shouted. "I will not stay here any longer and be insulted." He seized his hat and made for the door, calling back, "Yes, Monsieur, drawing is honesty! Yes, Monsieur, it is honor!"

Beyond question, Ingres was one of the great masters of French art, more uniquely individual and gifted than was, perhaps, apparent to his conservative admirers. Sometimes his perfection in painting was almost supernatural; at all times his drawing was superb. His line was unerring and firm, with a tender, living quality. His textural skill was unsurpassed; he had a miraculous ability to convey the feel of expensive velvets and ruffled lace, and the gleam of satin as it was drawn tightly across a bodice. If occasionally he could be pompous—especially in his depictions of large groups of important people—his individual portraits were wonderfully shrewd and exquisitely rendered.

Ingres instinctively mistrusted and fought the rising tide of artistic freedom; he could not hold it back. The concessions he made to it were rare; a few of them, curiously, were directed at Delacroix. A student once had the temerity to ask him what he really thought of Delacroix. "He is a man of genius," was the reply, "but don't speak about him." (By a curious coincidence Delacroix, when asked about Ingres, said: "He is a man of talent, but don't speak about him.") The two archenemies seldom met; only in later years did the bitterness seem to wane.

By 1835 Delacroix had pushed his murals at the Salon du Roi near enough to completion so that Louis-Philippe inspected them—without comment—at his opening legislative session that year. But the work stretched on, with Delacroix retouching and artisans working on decorative borders. The room was finally revealed to the public, after many delays, in 1838. Before the last paint was dry Delacroix accepted another government commission: a huge canvas, the *Battle of Taillebourg*, for the new Hall of Battles at Versailles, in which he depicted the din, blood and pageantry of medieval combat, with King Saint-Louis, like an avenging angel on a white horse, repulsing the English invaders as they attempted to take a small bridge—another monumental work of unabashed grandeur.

It would be wrong to assume, however, that Delacroix had surrendered to the pressures of conservatism. Eclecticism was his personal climate, and he felt equally at home in Homer's Greece, Virgil's Rome, and Raphael's Renaissance—not to mention Muley Abd-er-Rahman's Morocco. In these first grand-scale decorations, he pooled his enthusiasms and achieved another Delacroix synthesis.

The critics were more cordial to Delacroix than ever before. They were happy to see that he could be "sober and severe." They granted that he had stamped the walls with his own personality and his own color harmonies, but they were reassured to note that he was directly inspired by Michelangelo, Raphael, Veronese and others no less esteemed. His credentials were now impeccable.

Daumier pokes fun at the Académie Française in his cartoon *Academic Reception* showing two members showering each other with rhubarb and senna tea —illustrating a French saying, "*Passez-moi la rhubarbe et je vous passerai le séné*" or —roughly—"You scratch my back and I'll scratch yours." The gibe is directed at the greedy control exercised by members of the Academy over Salon juries, official commissions and art instruction.

A City
for the Artist

In Delacroix's day, Paris had already acquired its reputation as a salutary place for the arts. Its beauty, charm and easygoing ways drew artists not only from all France, but from all the world. For Delacroix, who never married and had few family ties, the city was home. He lived and worked all over it, moving from studio to studio as a man might move from room to room in a large family house. And although he had traveled to England and North Africa, had seen something of the Continent and spent time in the countryside near Paris, he remained essentially a homebody. His working quarters were usually separate from his lodgings, but he finally found, in 1829, a combination of both in an apartment that had a lovely view across the Seine to the Louvre. Here he could rejoice that "I can walk in my house slippers from my bedroom to my studio."

A child of the Left Bank, Delacroix in the first half of his life preferred to live and work there. But in 1845 he moved across the Seine in order to be near his mistress, Madame de Forget. Nearby lived his friends Chopin and George Sand, and the writer Alexandre Dumas. His studio, shown here, was large, well lighted and, because of his frail health, always well heated. On the walls hung many paintings—some his own, some by others he admired; among these were sketches for the murals he was then working on. Delacroix lived there for 12 years before moving to the Left Bank for the last time.

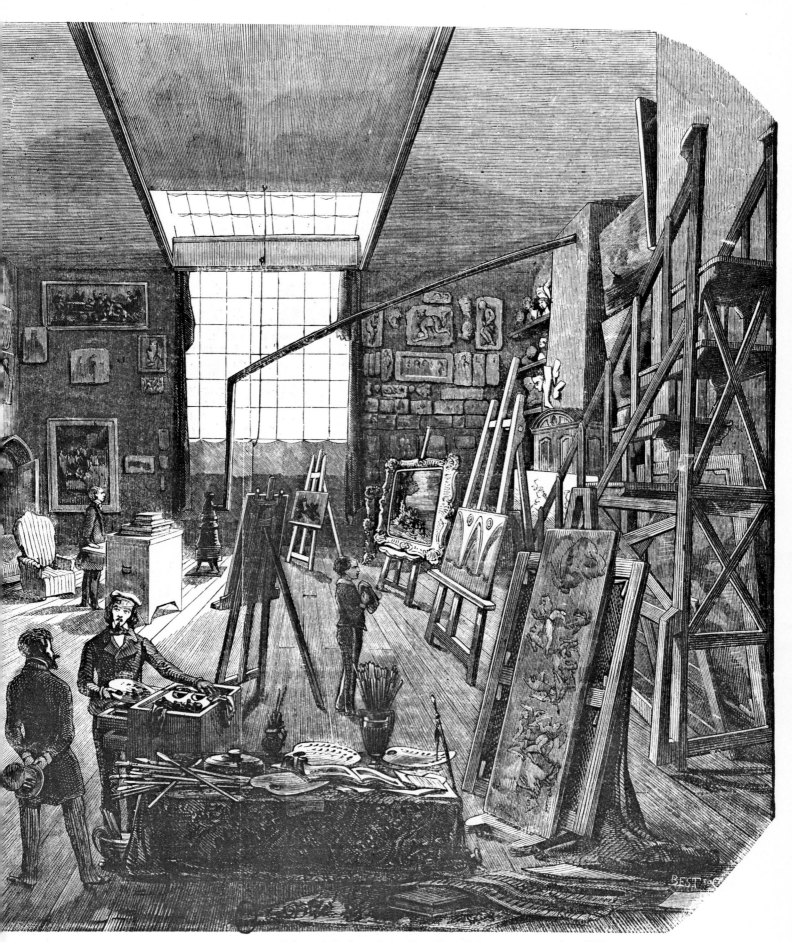

Delacroix's Studio in the Rue Notre-Dame de Lorette, engraving from *L'Illustration*, 1852

Delacroix's Paris

This map shows the public and private places in Paris which meant the most to Delacroix throughout his life. On the Left Bank of the Seine *(lower portion)* he spent most of his childhood, getting his early art training at the Ecole des Beaux-Arts and his education at the Lycée Impérial. There, too, are the zoo he loved to visit in the Jardin des Plantes and three of the buildings for which he did murals: the Palais Bourbon, Palais du Luxembourg and Saint-Sulpice, as well as the Institut de France, which denied him membership for so long. Across the Seine are his beloved museum-teacher, the Louvre, some of his favorite theaters and the city hall (Hôtel de Ville) where his murals were destroyed by fire. At the top of the map are a cluster of Delacroix's own residences and studios and those of many friends. The nostalgic walk Delacroix took in 1859, from the ball at the Hôtel de Ville to Rue Notre-Dame de Lorette and back to the Left Bank, is marked in dotted lines.

132

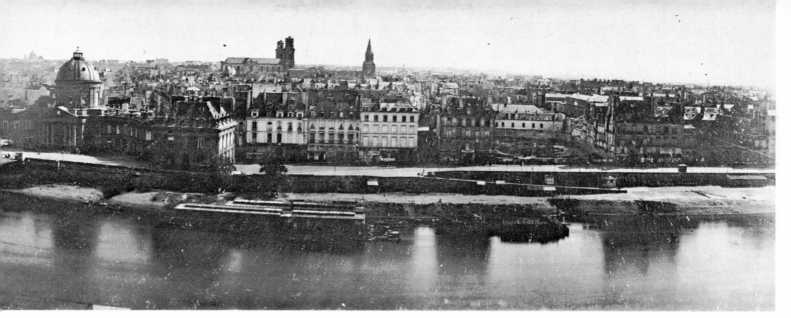

A panoramic daguerreotype (its image reversed to read naturally) made in 1846 shows the Left Bank as seen from the roof of the Louvre.

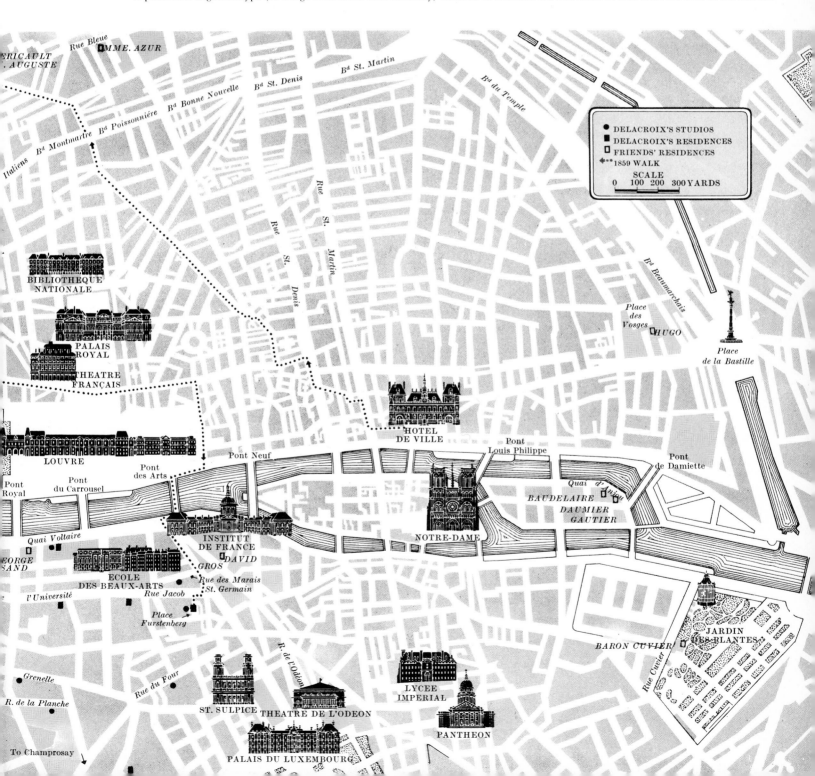

Family, Friends, and the Ladies

Although Delacroix had no interest in becoming a professional portrait painter, when he painted his friends and close relatives he showed a skillful hand and a marked ability to catch a living presence. And though both his parents died when he was young, there were several family members to whom he remained faithfully attached. His favorite was the wife of his mother's half-brother Henri, Félicité Riesener (she had been a mistress of Napoleon in 1805). He studied English with her, visited her home in Rouen often and was deeply grieved when she died. He was friendly with Aunt Félicité's son, Léon, who was a fine painter himself, though he remained aloof from Paris art circles. For his sister's nephew Henri he had no particular attachment, but he was a close companion to her son, Charles, whom he treated like a brother, especially after the boy's father died in 1822. His own older brother Charles was perhaps closest of all to him; he visited him often and enjoyed hunting with him on his modest country estate.

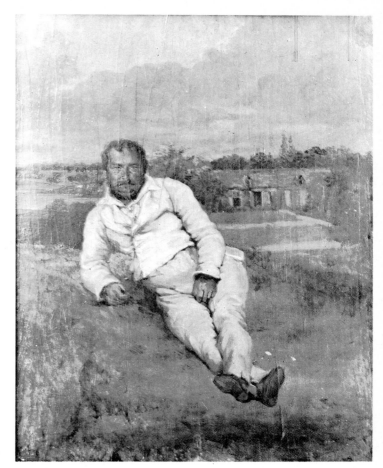

Delacroix's older brother, Charles

Jenny Le Guillou

He adored women," a friend wrote of Delacroix. "As early as 1836 when I saw him at the house of the Princess Belgiojoso he could not keep his eyes away from the ladies' corner." But adore them though he might, Delacroix usually kept women at a distance. His first and last loves were servants: his sister's English maid Elizabeth Salter, and his housekeeper Jenny Le Guillou. In between, he dallied with models, but had lasting relationships with Eugénie Dalton and Elisabeth Boulanger, a talented painter who married Edmond Cavé. His most important attachment, lasting nearly 30 years, was for his cousin, Joséphine de Forget.

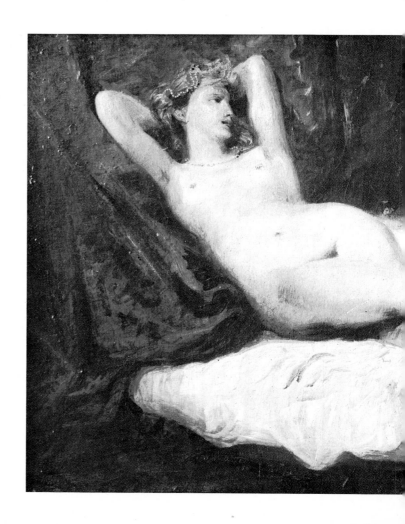

His aunt, Félicité Riesener

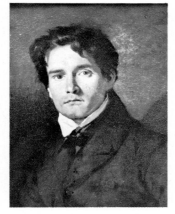

His cousin, Léon Riesener

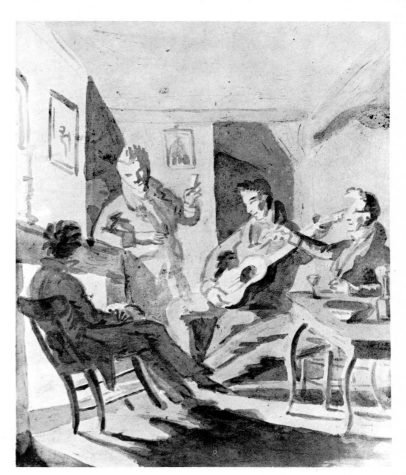

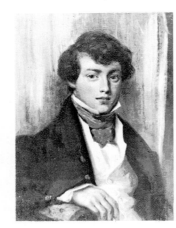

His nephew, Charles de Verninac

His nephew, Henri de Verninac

His New Year's Eve cronies

Lady in White Stockings

Elizabeth Salter

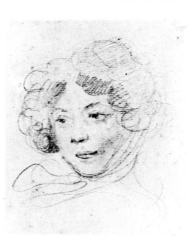

Joséphine de Forget

Madame Cavé (J.A.D. Ingres)

Eugénie Aimée Dalton (R. P. Bonington)

135

Jean-Auguste-Dominique Ingres: *Niccolò Paganini*, 1819

A spurious photograph of Paganini

In the world of music in Delacroix's time, no man caused a greater sensation than Niccolò Paganini, the composer-violinist whose brilliant playing and eccentric manner thrilled listeners all across the Continent. Paganini's almost diabolical genius inspired a cult of worshipers that persisted after his death in 1840: a trumped-up photograph of a man impersonating the maestro was circulated for years *(above)*. Delacroix, an amateur fiddler and ardent concert-goer, also fell under the Paganini spell, and his attempt to capture the elusive personality of the violinist resulted in a striking painting *(right)*— hardly a likeness, but a vivid evocation of what Paganini must have seemed like while playing. The painter's rival, Ingres, true to his neoclassical training, had earlier drawn Paganini in an elegant pose *(left)*, seen from the front to de-emphasize the musician's large nose. The portraits reveal as much about the men who made them as they do about their subject.

Portrait of Paganini, 1832

George Sand, 1838

Sketch for the double portrait, 1838

By the time Delacroix was 45, most of his family had died and he turned more to the companionship of composer Frédéric Chopin and his mistress, the novelist George Sand. For three summers he visited their country home and felt like a member of the family. He took particular delight in discussing music with Chopin because he felt that the esthetic problems of the painter and the composer were similar. Both arts, he declared, must make a direct appeal to the emotions.

Delacroix painted a double portrait of Sand and Chopin in 1838, but the picture was subsequently cut in two, possibly so that the owner would profit more by selling the parts. The only evidence of what the original looked like is an early pencil sketch *(left)* showing Chopin playing while Madame Sand sits lost in the music's spell.

Frédéric Chopin, 1838

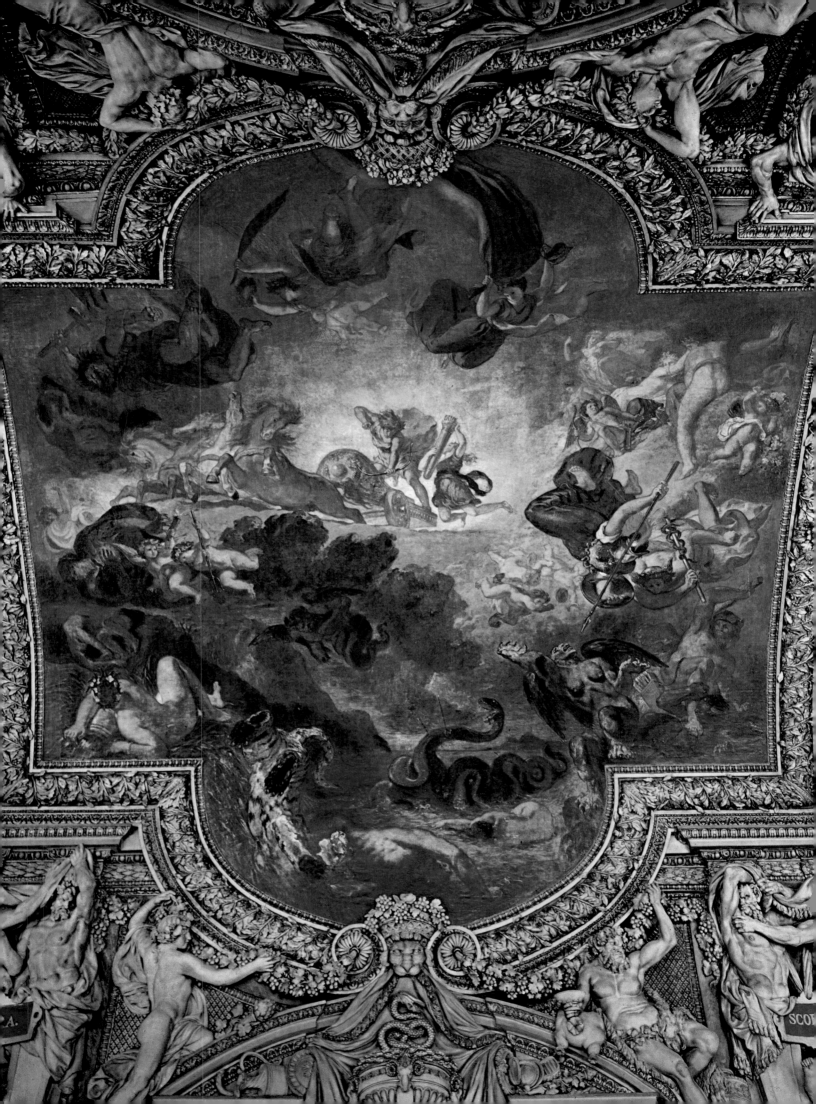

VII

A Time
for Masterworks

With his murals, Delacroix crowned his achievements as an artist, proving that he could breathe new life into a dying art form. By his day, mural painting in Europe was well past its prime, surviving mainly as a static, stereotyped, overblown kind of decoration that conformed to official tastes. Yet Delacroix's murals—despite such handicaps as poor placement and lighting—are masterpieces of verve and nobility. They belong among the glories of French art.

In these works Delacroix demonstrated his unique ability to straddle the centuries. He had long felt an affinity for the ancient world, though he quarreled with some of the neoclassic simulations of that world; now, in the Greek and Biblical allegories of the Salon du Roi and subsequent projects, he turned to the past not as a tourist but as a spiritual homecomer. At the same time he continued to live in the present, with a warm commitment to the Romantic ideas of his own era. And, to stretch himself still further, he continued to pioneer the future, not only in his techniques and use of color but in his insistence on the importance of the artist's personal vision. By advocating that art be more than merely representational, that it combine recognizable images with indefinable feelings, that it be more of a love letter than an itemized bill of sale, he loosened the soil for modern art and helped create a climate propitious for its growth.

No other artist in history matched Delacroix's genius for orchestrating the old and the new; none more brilliantly practiced the preachment that art was a continuum in which there was room for both the tried and the untried. Not until later generations would painters reap the full benefits of this remarkable open-mindedness, but it began to be appreciated even during Delacroix's lifetime, particularly as he reached the maturity of his forties. There was something in his esthetic philosophy for everyone, the younger and more venturesome as well as the older and more decorous.

Certainly Delacroix's persistent and spirited defense of the experimental held no fears for his government sponsors. In 1838—shortly after the Salon du Roi murals were unveiled—he was visiting at Valmont

when he picked up a Paris newspaper and read that he was to do another set of murals, also in the Palais Bourbon, but for the library of the Chamber of Deputies. This commission had been in the wind for a year, and Delacroix had given up hope of winning it. He was overjoyed: the room was even more of a challenge to his ingenuity than the Salon du Roi. It was not quite as wide, but it was more than three times as long— 137½ feet in all (page 156).

Moreover, the ceiling he now had to contend with had not just one dome, as in the Salon du Roi, but five, each with four pendentives. All 20 of these spherical triangles—a difficult shape to work with at best —had to be fitted with different paintings of sufficient inventiveness and variety to avoid monotony. In addition, he had to paint two large hemicycles—semicircular panels—one at each end of the room, just below the ceiling. All in all, the tasks were heavy and would require help. Delacroix recruited some 30 apprentices and set up a studio where he could train them to do various preparatory chores. In the end he depended mainly on three of the more experienced men to transfer his sketches onto canvas, and to complete 15 of the pendentives subject to his retouching. But the hemicycles and the other pendentives were done by his own hand.

In the hemicycle at the south end of the library Delacroix depicted Orpheus with his lyre, exerting his civilizing influence on a group of primitive Thracians. In the other hemicycle Attila the Hun rides like a demented savage across the land, leaving death and terror in the smoking ruins behind him. Between these opposite poles of war and peace, the 20 pendentives present a panorama of human achievement, divided into five groups: poetry, religion, law, philosophy and science. Delacroix drew incidents from the Bible as well as from Greco-Roman history and mythology; his subjects ranged from Salome holding a platter to receive the head of John the Baptist to Demosthenes outroaring the ocean.

Such sweeping surveys of human activity were very popular in the Romantic era. One painter friend of Delacroix's, Paul Chenavard, projected a *History of Humanity* from the Creation to the French Revolution; others devised grandiose schemes to draw diagrams of all extant knowledge. These high-flown ideas were by-products of the new discoveries in archeology and science, which encouraged people to believe they had plumbed all the secrets of the earth and could now safely sum up the whole human adventure. In principle Delacroix opposed such over-ambitious pictorial surveys. But when the occasion called for him to enter this field, he was able to keep his work free of stiff pedantry. What impresses the beholder in the murals of the Chamber of Deputies library is not the grandness of the themes, but the bounding, pulsing life they reflect.

Like the Salon du Roi, the library project produced its special technical headaches. Originally Delacroix had planned to put all his paintings on canvas and mount them in the allotted spaces. He followed through on this plan for the pendentives, but was compelled to alter it in the case of the hemicycles when heat created a crack in the Orpheus panel. Delacroix had to take down the canvas and paint directly

on the walls, mixing his paint with a virgin wax, free of fatty elements, designed to withstand the humidity of the building.

He had another major problem as well—a psychological one. Delacroix could not fail to be aware of the fact that the library commission —indeed all the massive endeavors of this type—had been born not of any strong desire for epic art, but simply of Louis-Philippe's urge to show that he had a decent interest in culture. Although in his pursuit of prestige the King had dutifully recruited many painters to add murals to the buildings of France, there was no hiding the fact that now, at the start of the Industrial Revolution, nobody really wanted the things.

But however lukewarm the French public may have felt toward mural art, Delacroix applied himself zestfully. The Chamber of Deputies murals reflect his enthusiasm. Arching over the long reading room, they shed a warm and noble aura of intelligence suited perfectly to a library. As one singles out, picture by picture, Adam and Eve being expelled from Eden, Achilles riding on the Centaur, Aristotle cataloguing the animals, it is like perusing a family album of the human race.

The project earned Delacroix the handsome sum of 60,000 francs, and took him nearly 10 years to complete. But the pace required of him was not inordinate, and between the start and finish of the work he was able to accept and complete two other government commissions. One was the decoration of the large central dome of the library of the Palais du Luxembourg, along with a hemicycle adjoining the dome; for these he again harked back to the past, depicting such figures as Dante, Homer, Virgil and Alexander the Great. In the second commission, a huge painting for the historical galleries at Versailles, he chose as his subject the *Entry of the Crusaders into Constantinople (page 163)*. As in the *Massacre at Chios*, Delacroix filled the foreground with the wounded and dying, and his invaders—this time Christians instead of Turks— display no mercy to their helpless captives. Also as in *Chios*, he delivered no obvious sermon against war; nevertheless he put across a telling message of the horror it inflicts on its innocent victims.

An increasingly meditative Delacroix, a man who had reached the stage of life where one tends to pause and ponder, also appeared in the smaller easel paintings to which he turned during this same period. Two of his most searching portraits of women—a far cry from the odalisques, the captive *houris* and harem girls who had graced his earlier works—were executed at this time. One was *Medea*, exhibited at the 1838 Salon. Borrowing from the tragedy by Euripides, Delacroix showed the sorceress of Greek myth at her most awesome, as she gripped her dagger and frenziedly prepared to slay her two children as revenge upon her faithless husband, Jason. The second study, exhibited at the Salon the next year, was of Cleopatra, divested of her customary headdress and ornaments, depicted simply as a courageous queen confronting death; a robust peasant presents her with a basket of figs in which the death-dealing asp lies in wait.

Medea won the critics' plaudits; *Cleopatra and the Countryman* their insults. It was impossible, said one carper, that the Queen would have

permitted the asp to be delivered by such a crude bumpkin; that Delacroix had intended precisely this dramatic contrast between the smiling peasant and the tragic purpose of his visit was overlooked. George Sand, who had better judgment in art than in her human relations, was so taken with the work that she persuaded Delacroix to give her a sketch of it.

Even as his portraits became more penetrating, so his paintings of sacred themes took on a deeper meaning, a more powerful sense of personal involvement. Delacroix was never religious in an orthodox way. He believed that "God is within us," but his spiritual feelings were much closer to the ethical philosophy of Marcus Aurelius than to Church dogma. And yet in 1844 he painted a *Pietà* which is an intensely moving statement of Christian faith *(page 162)*.

This work, one of his least-known masterpieces, was a mural for the church of Saint-Denys-du-Saint-Sacrement in Paris. Placed in a high, dim corner—an adjacent building erected in 1880 cuts out most of the natural light—the picture virtually glows in the darkness, its streaks of scarlet crying out like heart's blood, the faces of its huddled figures white with grief. The Holy Mother bears her Son's broken body on her knees, but her arms do not hold Him; instead, they are outflung in an agony of despair, as if she, too, had been crucified. The symmetrical grouping of the figures and the rich coloring suggest the art of the Renaissance; but there is a directness of feeling that would be echoed a century later in the paintings of Rouault.

There could be no tepid response to Delacroix's *Pietà:* the critics were passionate either in their censure or praise. An anonymous writer for the *Journal des Artistes* cried: "Kneel down before these repulsive figures, before that Magdalene with the bloodshot eyes, before that crucified Virgin, inanimated, plastered, and disfigured; before that hideous body, putrefied and frightful, that one dares to present as the image of the Son of God! . . . The behavior of Delacroix is that of a monkey. . . . We are not saying this man is a charlatan, but this man is the equivalent of a charlatan."

There was, however, a strongly dissenting opinion from another quarter: "He alone, perhaps, in our unbelieving age has conceived religious paintings which are neither empty and cold, like competition works, nor pedantic, mystical or neo-Christian, like the works of those philosophers of art who make religion into an archaistic science. . . . Look at his *Pietà* . . . the majestic Queen of Sorrows . . . a mother's paroxysm of grief. . . . This masterpiece leaves a deep furrow of melancholy upon the mind."

The author of this comment was Charles Baudelaire, and at the time of writing he was a mere 25, a newcomer to the intellectual rough-and-tumble of Paris who would soon prove that he could more than hold his own in it. Baudelaire, who was to become one of the greatest French poets, had decided to launch his literary career as a critic. He had an amazing ability for detecting talent which, like his own, he felt was insufficiently appreciated. He introduced Edgar Allan Poe's works to Europe; he was among the first Frenchmen to champion the music of

Richard Wagner. He took up his cudgels not only for older artists whom he regarded as inadequately acclaimed, such as Brueghel and Goya, but for newcomers like Daumier and Manet.

Delacroix, however, was his great hero—and one who never seemed to fail him. Baudelaire's fervor for the artist manifested itself with his very first review of a Salon—the 1845 exhibit—in which he pronounced Delacroix "decidedly the most original painter of ancient or modern times," and he was still holding to this belief in his obituary of Delacroix 18 years later. Among the many thousands of words Baudelaire lavished upon his subject, perhaps the most memorable—and perceptive—are these:

"Heir to the great tradition—that is, to breadth, nobility and magnificence in composition—and a worthy successor to the old masters, he has even surpassed them in his command of anguish, passion and gesture! . . . Suppose, indeed, that the baggage of one of the illustrious departed were to go astray; he will almost always have his counterpart. . . . But take away Delacroix, and the great chain of history is broken and slips to the ground." In this last extraordinary sentence Baudelaire paid prophetic tribute to Delacroix's vital role as a link between past and future.

How Delacroix reacted to this cascade of acclaim is not known; it began during the years when, for no apparent reason, he had suspended his journal. Even in his later writing there is little mention of Baudelaire except the comment: "He tires me out." Possibly the pale young poet not only tired but alarmed him. In his private life Baudelaire was given to debauchery and to hashish and other bizarre extravagances. Then, too, his notorious book of poems, *Flowers of Evil*, which got him arrested for obscenity, might have put off the older man, who was getting more sedate as time went on. In the judgment of hindsight, however, Delacroix had no cause to feel any embarrassment over his youthful admirer. Baudelaire was destined to join him, in equal glory, on the Gallic Olympus.

Delacroix enjoyed a more comfortable relationship—indeed, one of the deepest friendships of his life—with another young luminary of Paris, the Polish-born composer Frédéric Chopin. They met at the home of Heinrich Heine, the German poet, who was living in Paris at the time; Delacroix's friend and Chopin's mistress, George Sand, may have made the actual introduction. Delacroix, 13 years older than Chopin, recognized in this slender, intense foreigner, with his bright, birdlike eyes and beak, an authentic genius. The painter at once felt drawn to the composer, and proceeded to treat him with big-brotherly affection, even playfulness.

One of their common bonds was music—but not art. Delacroix admired Chopin's compositions and wrote about them with the appreciation of a connoisseur. Chopin, on the other hand, had little use for Delacroix's art. Looking on, George Sand sized up the dilemma with womanly candor: "Delacroix appreciates music, his taste is sure and exquisite, and he never gets tired of listening to Chopin, he savors him. Chopin accepts this adoration and is touched by it, but when he looks

Delacroix came to painting flowers rather late in his life. This study was probably done while visiting George Sand's home at Nohant, where his hostess wrote of Delacroix at work: "I came upon him in an ecstasy of enchantment before a yellow lily, of which he had just understood the beautiful 'architecture'—that was the felicitous word he used."

at a picture by his friend he is miserable, and can find nothing to say to him." Then, analyzing her lover's failings in the field of art appreciation, she noted: "He is a musician, only a musician. His thoughts can come out only in music. He has infinite delicacy and spirit, but he can understand neither painting nor sculpture. He fears Michelangelo, and Rubens gives him goose-flesh. Anything that appears eccentric scandalizes him."

Fortunately, the lack of a complete cultural entente did not sour the conviviality of the two men. Delacroix so enjoyed hearing Chopin play that he had a Pleyel piano—the finest made in France—moved up to his studio so that Chopin could drop in and play whenever he felt inclined. That Delacroix, who usually detested visitors, would encourage such a thing was another measure of his regard for his friend.

George Sand, who saw in Chopin a man to mother as well as love, decided to have the piano moved to her own home on the Rue Pigalle. Before then, however, Delacroix persuaded them to pose for a double portrait, with Chopin at the keyboard and his mistress worshipfully watching him. The picture was to suffer a curious fate: some years later it was cut in two, possibly to settle a dispute among the heirs of the friend to whom Delacroix bequeathed it. The Chopin half now hangs in the Louvre; the Sand half is privately owned.

The Chopin portrait is one of Delacroix's masterpieces *(page 139)*. In spirit it is close to his Paganini portrait, conveying the essence of both man and music. But Chopin's likeness is stronger, and there is an almost palpable sense of the composer's total involvement with his muse. Almost incandescent from the heat of his inner fires, he appears the prototype of all inspired artists. Lesser Romantic painters, to evoke Chopin's spirit, would have dreamed up misty gardens all aswirl with moonlit dancers and trysting lovers; Delacroix's interpretation of his subject is almost austere, suggesting the basic process of creation rather than its prettified trappings.

Chopin and George Sand lived together for nearly nine years, often at Nohant, her family estate in central France. There Delacroix visited during three summers, for several weeks at a time. Nohant served him in his middle years in much the same way Valmont did in his youth. It was an island of repose, providing a taste of affectionate family life that he lacked in Paris. In his pursuit of equilibrium, Nohant was a necessary counterweight.

Arriving by coach from Paris, he would be greeted by the household, which included young Maurice and Solange, Madame Sand's children from an early and short-lived marriage. Delacroix had, in addition to his own room, a little studio in the yard which the writer had fixed up for him. These were easy, festive days, with no formal dressing. The children would give marionette shows. Often the family would go walking in the forest—all except Chopin, who preferred riding on a donkey. One night they had a picnic on the lawn for the villagers, with a bagpiper to supply the music for dancing. For the most part there was talk and books and music. Madame Sand was busy at what was to be her best novel, *Consuelo.* Chopin worked at the piano. Delacroix recalled read-

ing alone in his room at night and hearing, through the open window, Chopin improvising on a theme. The music, mixing with the notes of a nightingale and the damp fragrance of the roses, made him feel that all this beauty was not inherent in the outside world, but existed only in one's own responses.

Occasionally Delacroix felt the need to "do something" at Nohant. During one visit he decided to paint for the village church a picture of St. Anne reading to the Virgin. Since he had brought no canvas with him, Madame Sand poked into an old wardrobe and found some white duck used for making corsets, which Delacroix nailed to a frame. He recruited one of the household maids to pose for St. Anne, and Madame Sand's god-daughter for the child. While he worked on his *Education of the Virgin*, Madame Sand read aloud to him, and her son, Maurice, sketched along with the painter. The Salon later rejected the Delacroix painting; it is now in a private collection. Maurice, who was soon to be recruited as one of the apprentice helpers on Delacroix's murals, ultimately painted the copy of the Delacroix work which now hangs in the church at Nohant.

Also at Nohant Delacroix for the first time tried some flower painting. "He asked to see my dried plants," Madame Sand wrote, "and fell in love with their delicate, charming silhouettes, that still kept the shape of their species. . . . 'This is grace,' he said, 'in death.' "

Delacroix made this quiet sketch of his dear friend Chopin on the evening after the composer's funeral in October 1849. In deep grief over the loss of a man he regarded as a genius, Delacroix clothed the musician in the wreath and mantle of Dante, the immortal Italian poet he had pictured in several important works.

The paradise of Nohant, in a few years, was less graceful in its death. Madame Sand and Chopin—she called him Chopinsky, or Chip—fought and sulked. The children sided violently with one combatant or another, and began to have tempestuous love affairs of their own. Madame Sand filled the house with more of her uncouth, socialist young men. Chopin scorned them, and constantly washed himself. "We laugh ourselves sick," wrote his beloved, "to see that ethereal being refusing to perspire like everybody else." In the summer of 1846 Delacroix saw Nohant for the last time.

Back in Paris, Madame Sand and her Chip went on living together. Delacroix visited them often—and with increasing sadness. Chopin had become tubercular; now the illness was beginning to take its full toll of him, and he was growing weaker. One spring evening in 1847 Madame Sand invited Delacroix and other friends to hear her read her new novel. The hero was a thinly disguised caricature of Chopin himself, revealing, as one listener later commented, "every kind of unsavory domestic detail." Delacroix was horrified. "I was in agonies all the time the reading was going on," he reported, "but I don't know which surprised me most, the executioner or the victim. Madame Sand appeared to be completely at ease, while Chopin expressed the warmest admiration of the story. At midnight we left together. Chopin wanted to walk home with me, and I took the opportunity to find out, if I could, what he really felt. Was he playing a part for my benefit? No, the truth was that he had just not understood."

Gossip and indignation followed the Sand reading. Delacroix sided with Chopin, although he did not sever his long friendship with the author. One night early in 1849 he visited Chopin and found him too

ill to work. A few months later, on a warm April day, the two men rode in a carriage up the Champs-Elysées, past the Arc de Triomphe, for a bottle of wine at a garden café. They met again during the summer. On October 20 of that year, while Delacroix was at Valmont, he learned that Chopin had died.

He came back to Paris for the funeral, which was held in the Church of the Madeleine. There, for the first time in its history, women's voices were heard in a commemorative performance of Mozart's *Requiem.* Delacroix attended the burial at which, according to Chopin's wishes, a small vial of Polish earth was sprinkled on his grave. Alone that night in his studio, the painter made a sketch of Chopin in the costume of Dante. He started to write an inscription on the sketch, beginning "Dear Chopin"—but his eyes were too blurred, and he could not go on.

Nearing his fifties, Delacroix showed no signs of wanting to slow the pace of his work; his way of life, however, underwent considerable change. More and more he preferred the peace and quiet of his studio; he felt a growing distaste for the frivolities of former years. His diversions were apt to be solitary, and often an extension of his ceaseless explorations in art.

On one memorable occasion in 1846 he went to a Paris exhibition hall to watch, in fascination, as a troupe of Ojibwa Indians danced with war whoops and drums. The Ojibwas had been brought from Iowa to Europe, on tour, by the American painter and ethnologist George Catlin; they had captivated London, and were now exerting the same effect on sophisticated Parisian audiences that included King Louis-Philippe himself. Delacroix sketched the event as it occurred, seeing in these primitive Americans the same classical dignity that excited him so much in the natives of Morocco. "They are the true sons of Ajax," he enthused. Later he even designed a poster, since lost, to help Catlin publicize his Ojibwas on their European venture.

Delacroix's delight in these unlikely visitors tempts us to imagine how much he would have enjoyed the American Wild West. In a sense, he had already come close to it; with a change of costume, the Arab horsemen in many of his paintings could be taken for the Indian and cowboy riders of the great prairies. The thrill he found in the blazing sunlight and open country of Morocco he would have tasted again in Arizona, and in the "powder plays" of the Arab cavalry he was close to the more deadly gunplay of galloping cowboys and Indian raiders. The painter surely would have liked meeting the "pashas" of Montana. But history, unfortunately, never set up a confrontation between Eugène Delacroix and Kit Carson.

The Ojibwas were a rarity; another favored diversion of Delacroix's was more accessible. Not surprisingly, when he resumed his journal in 1847, it began with an entry about a visit to the zoo and the natural history museum at the Jardin des Plantes:

"Elephants, rhinoceros, hippopotamus, strange animals. . . . I had a feeling of happiness. . . . What a prodigious variety of species, of forms, and of destinations! At every moment, what seems to us deformity,

George Catlin, the American artist who brought his troupe of 11 Ojibwa Indians to Paris in 1845, was the first conscientious chronicler of Indian ways, detailing their activities in some 500 paintings. This troupe made a tremendous hit with the French public and had an audience with King Louis-Philippe *(above),* which Catlin sketched. Delacroix was as struck with the simple beauty of these natural people as he had been with the Arabs, and sketched them during their stay in Paris *(below).*

side by side with what seems to us grace. Here are the herds of Neptune, the seals, the walruses, the whales, the immensity of the fishes with their insensitive eyes, and their mouths stupidly open; the crabs, the turtles; then the hideous family of the serpents. The enormous body of the boa, with his small head. The elegance of his coils wound around a tree. . . . "

He was viewing the world with the fresh excitement of a young Adam naming the animals. "How necessary it is to give oneself a shaking up . . . to try to read in the book of creation, which has nothing in common with our cities and with the works of men! Certainly, seeing such things renders one better and calmer. When I came out of the museum, even the trees got their share of my admiration."

Inevitably, with such thoughts, Delacroix was to reassess his own relation to the city in which he lived and worked. Paris would never relinquish its hold on him; but increasingly he felt the need to be relieved of its pressures. In 1844, at the urgings of his friends, the Villots, he had rented a retreat near them in the wooded suburb of Champrosay. He and his faithful Jenny began to spend more time in the modest little house; it offered not total isolation, but an escape hatch.

It was an escape, sometimes, from Joséphine de Forget, whom he still loved and admired, but whose need for attention clashed with his need for peace. Delacroix was not trying to abandon the lady. In fact he had moved his city studio to the Right Bank to be closer to her quarters in the same neighborhood. But from Joséphine's point of view, the Champrosay set-up was just too much. Delacroix forgot to write. He asked her to postpone her visit until the "damned workmen" got out of the house. He wrote about the help he was getting with his dust-covers. Help from whom? Dust-covers were a woman's business. Joséphine heard from a friend that he had been in town for a day; he hadn't called on her. "It would have been kind of you to have written sooner . . . but then, you have so many other things to think about!!!" Yes, she was well entitled to three exclamation marks.

And when he did spend some time with her in Paris, he could be distinctly hateful. "When I think at this hour," he wrote her in the middle of the night, "how surly I was last night, how I spoke foolishly and flippantly of things just to torment and contradict you, I can't forgive myself. You are perhaps the only person in this world whom I sincerely love, and I mistreat you. . . . Last night when I left, I had scarcely put my foot on the stairs when I wanted to run back and embrace you. . . . Accept, dear and only loved one, all the embraces that I could not give you last night. I detest myself and I love you more than I can ever say."

Nevertheless, life in the country held a number of joys which he did not care to share. One of the most important was the opportunity to turn his attention, at last, to a long-dreamed-of plan for a *Dictionnaire des Beaux-Arts*—a dictionary that would define the terms of art as he had known and experienced them. Whatever wisdom he had acquired he wanted to put down. He wanted to tidy his mind and put his house in order.

The Great Murals

The period when Delacroix emerged as the greatest muralist of his age began in 1833, when he was 35 years old. In the next three decades he painted murals for important public buildings in Paris, mostly as government commissions. His aim, above all, was to make these works blend harmoniously both in theme and treatment with existing architecture and other decorations—and he succeeded well. Entering a hall decorated by Delacroix, today one is first struck not by the painter's individual handiwork but by the pleasing atmosphere of the whole room. Instead of working like a virtuoso soloist, Delacroix painted as a member of the orchestra of other artistic craftsmen and the designers of the building.

But even in this subordinate role, he showed his originality, starting with his first assignment in 1833, which was to decorate the King's throne room in the Palais Bourbon in Paris *(right)*. He had a genius for taking the stereotypes of official art and suffusing them with the warmth and vitality of his own vision. To achieve the final effect of elegance and unified color, he studied and restudied his palette, making changes to suit the particular work at hand, and express his feelings better. He cleaned his palette of blacks and earth pigments and used, instead, brighter mixtures of the primary colors to achieve pure, clean tones. And he achieved a final mastery of drawing by using the thickness of pigments and their relative color values to determine shape, line and form.

The Salon du Roi of the Palais Bourbon, now the National Assembly, serves as a writing and reception area for members of the legislature. Delacroix's murals decorate panels between the glass doors, above the arches and on the ceiling, warming the cool, marble-floored interior.

Truth and the Law-Maker

Each of the four friezes above the doorways in the Salon du Roi represents an allegory of civil government: Justice, Agriculture, Industry and War. For the Justice wall, above, Delacroix assembled a group of heroic figures resembling the muscular, big-limbed people of Michelangelo's sculpture. On the left, a female figure representing Truth carries a mirror, suggesting the kinship between truth and self-knowledge. Beside her, a handmaiden holds an oil lamp to illuminate the parchment on which a patriarch has inscribed the laws; he now awaits Truth's judgment.

Force and the Judges

In the right-hand portion of the Justice frieze, three venerable judges pass
sentence while Force, depicted in feminine form, stands by to carry out their
verdicts. To assist Force, Delacroix added a sturdy lion which the critic
Théophile Gautier described as "an admirable lion, a monstrous lion . . .
more handsome than all the lions of Atlas, the ideal lion; an enormous head,
a streaming, fawn-colored mane, and clear, metallic yellow eyes, like suns,
with an inexpressible character of strength . . . and imposing persuasiveness,
befitting the attributes of orderly, constitutional force."

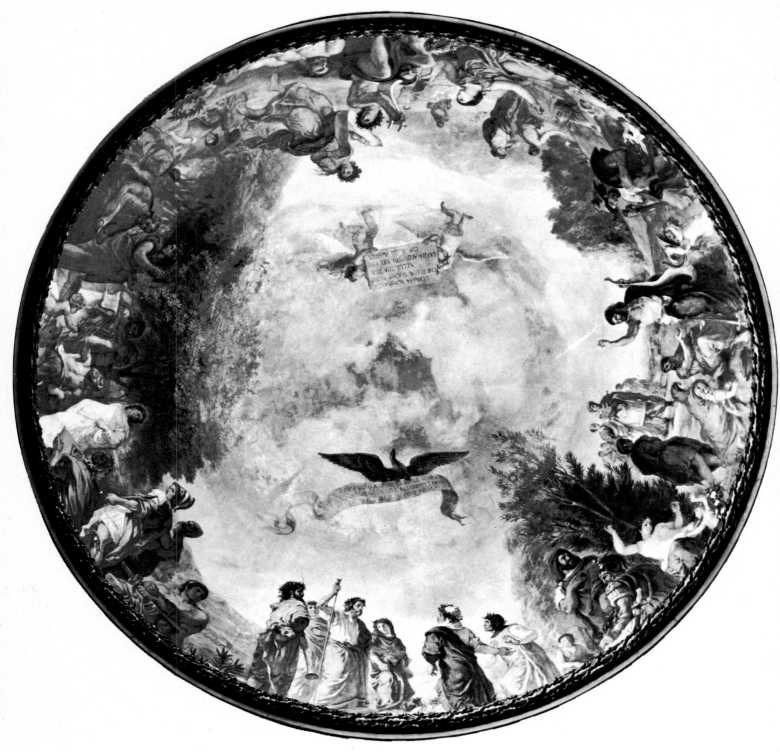

The Palais du Luxembourg cupola, 1845-1846

For buoyant, lyrical beauty, Delacroix painted nothing to compare with this cupola in the library of the Palais du Luxembourg, finished in 1846. Appropriately selecting the arts and literature as his themes, he divided his circular composition into four main parts. Clockwise from the bottom are: Virgil introducing Dante to Homer and other poets; a group of illustrious Greeks, including Alexander, Socrates, Aristotle and Demosthenes; Orpheus and poets of the heroic age, along with Hesiod and Sappho; and, finally, a group of illustrious Romans,

among whom are Caesar, Trajan and Cicero. In the radiant center of the cupola, which seems to float over the room like a bubble, cherubs carry a banner announcing the subject of the scene while an eagle proclaims: "I see the illustrious company of the supreme poet, who soars like an eagle over all poets." The grace and elegance with which Delacroix portrayed the figures in this remarkable ceiling are perfectly seen in the person of Aspasia, consort of Pericles, who in the detail at right is shown having her portrait painted by the Greek artist Apelles.

Apelles Painting the Portrait of Aspasia

The library of the Palais Bourbon

A muralist's nightmare faced Delacroix when he was commissioned to decorate the ceiling of the long, narrow library in the Palais Bourbon *(above)*. The space was divided into two hemicycles at each end of the room and five cupolas down the length of it, each with four pendentives. Save for the fairly large hemicycles, therefore, Delacroix's creation had to be subdivided into 20 awkwardly shaped curved areas.

As the basic element in his plan, he determined to show the achievements of the human spirit. Each cupola was devoted to a specific area of endeavor: Poetry, Theology, Legislation, Philosophy and the Natural Sciences. In deciding how to illustrate each subject, he consulted his friend Frédéric Villot, a scholar who later became a Keeper of Paintings at the Louvre, and did considerable historical research. But he was torn between the need to be instructive and his instinctive wish to inspire. He explained this feeling best, perhaps, in an article on Prud'hon, which he wrote at the time he was planning the library murals. "One finds," he stated, "a mysterious pleasure, I was going to say pure pleasure . . . in scenes whose subjects have no explanation."

In the end, Delacroix both instructed and inspired, as is evident in the pendentive from the Poetry cupola *(opposite)* where the Greek poet Hesiod lies asleep on a hillside while his airborne muse inspires him.

Hesiod and the Mus

HÉSIODE
ET
LA MUSE.

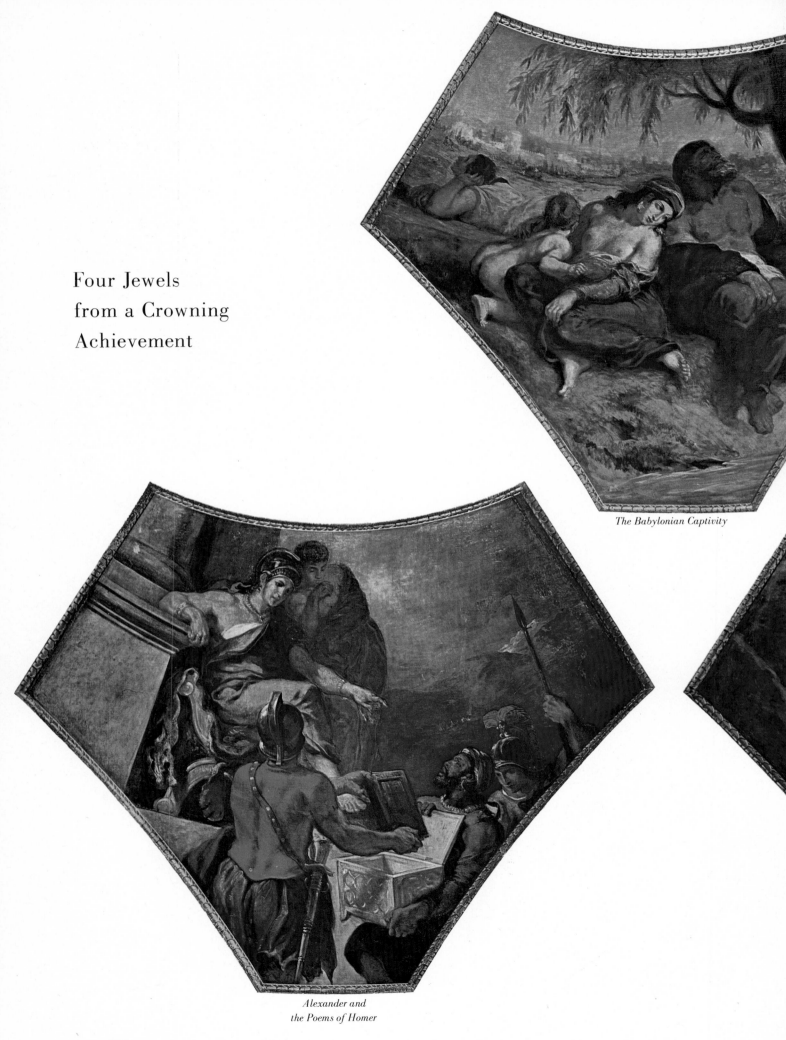

Four Jewels
from a Crowning
Achievement

The Babylonian Captivity

*Alexander and
the Poems of Homer*

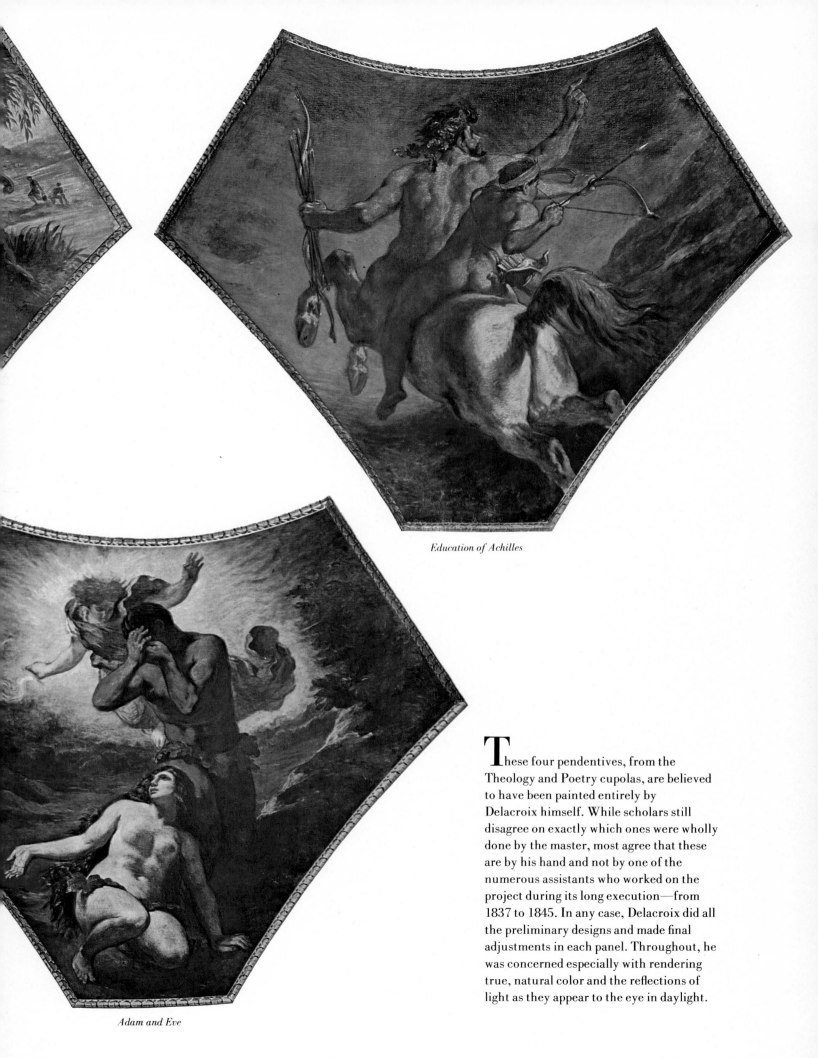

Education of Achilles

Adam and Eve

These four pendentives, from the Theology and Poetry cupolas, are believed to have been painted entirely by Delacroix himself. While scholars still disagree on exactly which ones were wholly done by the master, most agree that these are by his hand and not by one of the numerous assistants who worked on the project during its long execution—from 1837 to 1845. In any case, Delacroix did all the preliminary designs and made final adjustments in each panel. Throughout, he was concerned especially with rendering true, natural color and the reflections of light as they appear to the eye in daylight.

159

For the hemicycles in the library, Delacroix designed two great contrapuntal works which, in spatial arrangement, thematic development and color are separated by, yet united with, the pendentives between them. At the north end, shown here, he depicted Attila the Hun, spreading havoc and destruction before him. In 1847, Delacroix described this work in a newspaper article: "Attila, followed by his barbarous hordes, tramples Italy.... The Arts flee before the Hun's ferocious war horse and Eloquence is in tears."

Contrasting strongly with that savage theme are the peaceful tones and soft lines of the south hemicycle (not shown), in which Orpheus brings the blessings of Civilization to a ravaged world. In between, human achievements in religion, poetry, lawmaking, philosophy and science are represented in the pendentives which connect the two hemicycles.

But despite the beauties, both visual and intellectual,

Attila Tramples Italy and the Arts, 1838-1847

of the peaceful passages in Delacroix's composition,
it is Attila (also shown in the sketch at right) and the
hateful Huns who strike the eye. The painting has
a cyclonic, frenzied quality, like a *furioso* passage
in music. Attila, riding his ghostly white steed,
is a figure of death. The bold, almost uncontrolled
lines of force in this work—the woman's flailing
gesture, the streaming banners, Attila's upraised arm
and the downward pull of his horse—add to the turmoil.

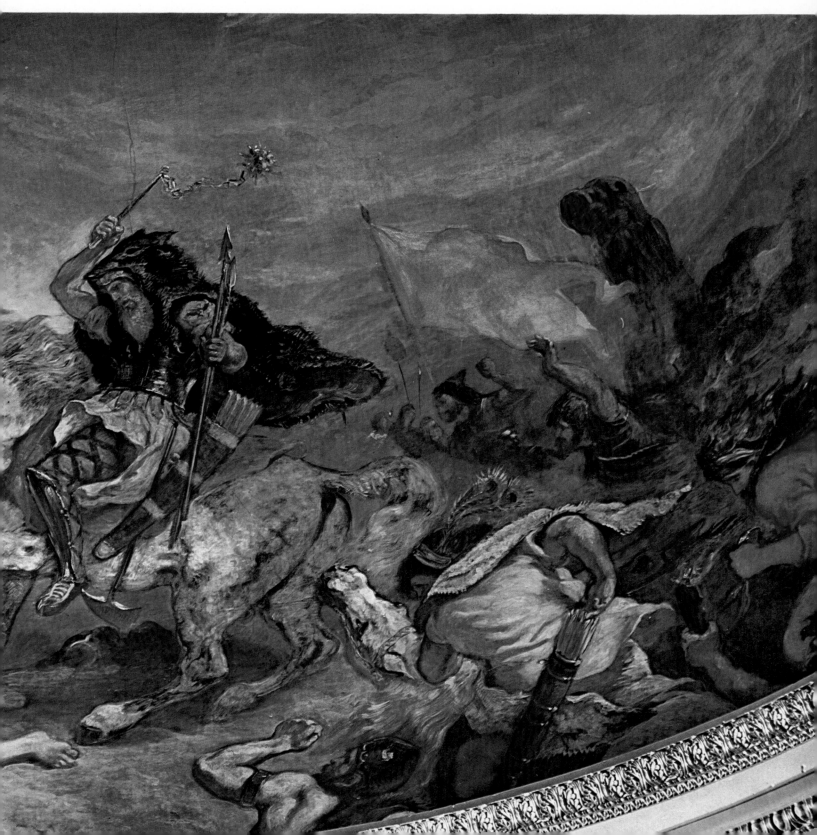

Sketch for the *Pietà* in Saint-Denys-du-Saint-Sacrement

One of the key works in Delacroix's artistic development is the
Entry of the Crusaders into Constantinople (right), a mural-sized canvas
which was commissioned by the government for the Palace at Versailles.
Here Delacroix's mastery of form, line and color is complete. The lessons
he learned from Rubens and Veronese, which he had tried earlier
in *Massacre at Chios*, are now fully absorbed and he can subordinate
technique to final effect. There is, however, a subtle change of mood.
In the *Massacre at Chios* the invading Turks appear joyous as they
triumph over their Greek victims. In the *Crusaders*, the invading
Europeans appear depressed by their conquest over the anguished
Byzantines, and the hollowness of war is suggested. Delacroix's color
harmonies support this melancholy mood; everything deepens;
reds tend toward garnet; cold violet-blues creep in and gray smoke
hangs in a chilling sky. Although individual colors are brilliant
when seen in isolation from one another, in the composition they
blend and harmonize, letting light penetrate the shadows. This
gives the heightened impression of true colors seen in the open air.

In their colors, the works which followed the *Crusaders* bear
the same superb stamp. One such is the *Pietà* Delacroix painted for
the church of Saint-Denys-du-Saint-Sacrement in Paris. Although
the mural is almost 186 square feet, he completed it in only 17 days.
But in preparation for this speedily executed masterpiece, Delacroix
painted a sketch *(above)*, showing that he knew exactly how he meant
to use composition and color in establishing a mood.

162

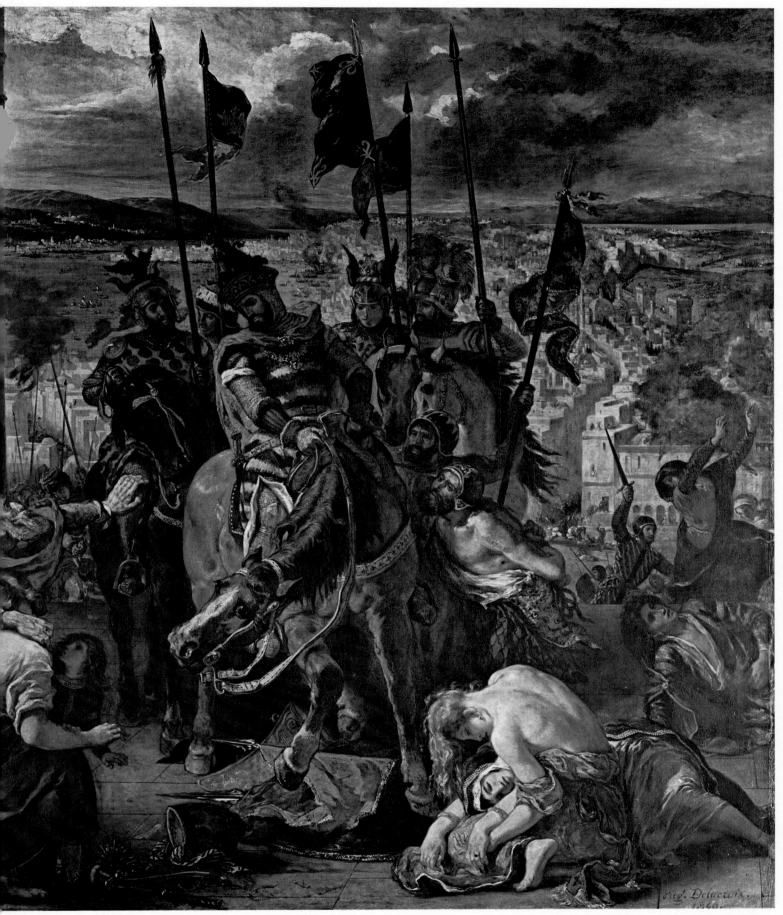

Entry of the Crusaders into Constantinople, 1840

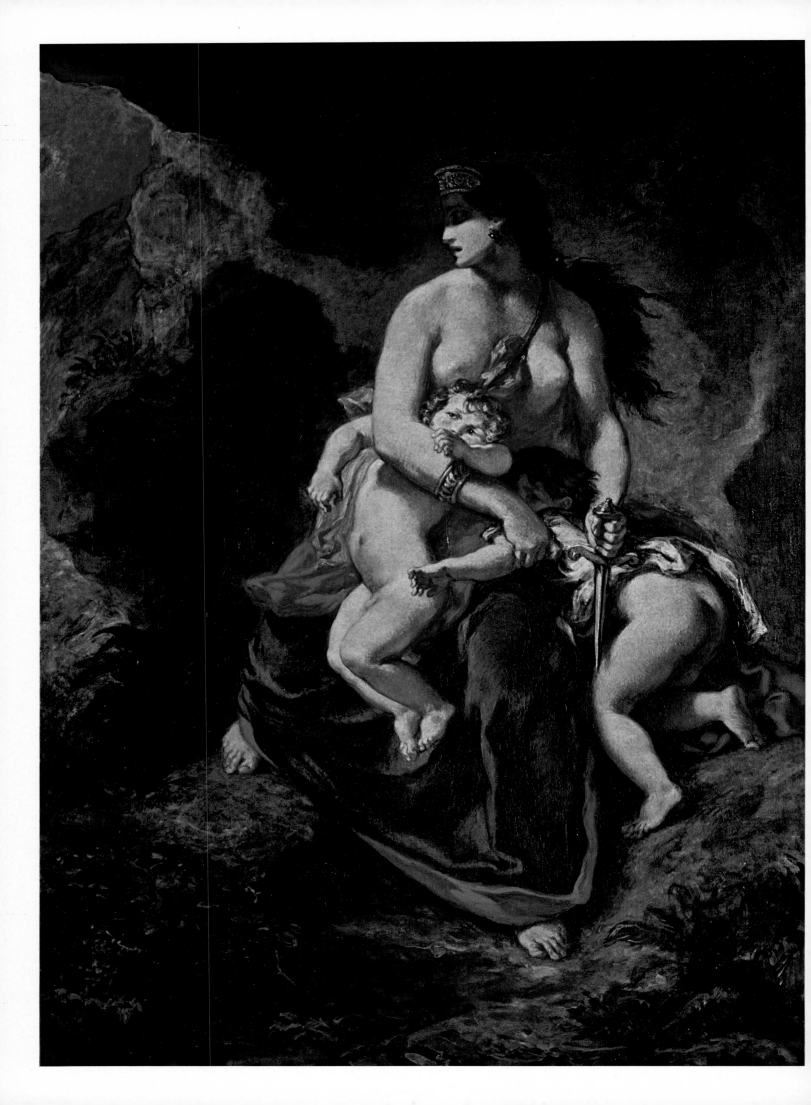

VIII

The Final Encounter

In the works of Eugène Delacroix the most common theme is encounter. Virgil and Dante encounter the doomed souls of hell. Sardanapalus and his seraglio encounter savagery and death. The victors of Chios and Constantinople beset their victims, tigers attack horses, horses fight each other. Faust meets the devil, and Hamlet meets himself.

It may be argued that this is hardly remarkable, since all life is a series of encounters. What is remarkable in Delacroix's art, however, is the intensity of these meetings. People and forces clash headlong. They change each other, sometimes through love or compassion, more often through conflict or combat. But one way or another there is continual confrontation.

To Delacroix, the creation of art itself was an encounter. He faced up to the primal, raw energies of life, wrestled with them, tamed them, transmitted them to canvas and finally hung them on walls like any other trophies of battle.

As a private individual, paradoxically, he shied from any such degree of embroilment; encounter had to be offset by periodic withdrawal. He freely admitted this ambivalence. "I consider all people my friends," he once wrote. "I want to be liked by the man who delivers a piece of furniture; I want any man I meet, whether peasant or great lord, to go away happy." And yet, he confessed, "in direct opposition to my friendliness . . . I have a singular passion for solitude." On a visit to the Count de Mornay and his wife, Delacroix wrote Madame de Forget describing the château at which he was staying, with its 20 servants, rare furniture, paintings and tapestries, and all the devoted attention he was getting from his host and hostess. It was lovely, but—"I would rather be a little more alone. . . . I am a bit fatigued and sigh for the tranquillity and simple roast and beef stew of my own home. . . . I declare myself decidedly to be a bourgeois, a grocer. . . . The simple machinery of life is preferable to pomp with 20 servants." Five days later he was happily back in the quiet of his retreat at Champrosay.

Delacroix's disinclination to keep his personal relationships at a sustained pitch may have been born of the very ferocity of his commit-

In its simplicity of form, tragic sentiment and harmonic colors, *Medea* is the perfect expression of a vision Delacroix had already tentatively suggested in *Greece Expiring*, *Liberty*, and two earlier versions of this painting.

Medea, 1862

ment to his art. No mistress, no friend, no family could have elicited so fervent a response. The pursuit of art drained him, yet he suffered its demands gladly. Fortunately, he never had to make a clear-cut choice between the world inside his studio and the world outside his door, but there is no question as to what the choice would have been. Perhaps the strongest proof was his reaction to the most momentous public event of his lifetime, one that shook the social foundations of all Europe: the Revolution of 1848.

The lower classes had ample cause for unrest. Disastrous floods and two bad harvests in a row had brought France to the brink of a wheat famine. Another staple crop, potatoes, had been hit by blight. Along with soaring food prices there was far-flung unemployment; great hordes of laborers and craftsmen were jobless as a result of a collapse in the railway-building boom and its echoing shudders in industry. Added to the economic stress was the disclosure of corruption in high places: a former government minister, since promoted to a judgeship on France's supreme court of appeal, was convicted of taking a bribe from a general in return for a mining concession. An outbreak of personal scandals—among them, a jealous husband's discovery of his spouse in a hideaway with Victor Hugo—convinced the man in the street that the morals of the dominant bourgeoisie were no better than those of the decadent aristocrats they had supplanted.

All these troubles were, however, merely symptomatic. Fundamentally, what sparked the Revolution of 1848 in France—and the same year in Italy, Germany, Austria and elsewhere—was the desperation of an ever-expanding force in society, the proletariat. Industrialization had spawned these great working masses but kept them enmeshed, subject to its vagaries and those of its masters. The average laborer earned less than two francs a day for 13 hours' work; he had neither the right to strike nor other means of airing grievances. As the economic depression deepened so did the distance between haves and have-nots; Victor Hugo was not too busy with the embarrassments of his private life to observe that the bourgeoisie, having themselves climbed to power, had pulled up the ladder to keep the common people from following after them.

Like Hugo, many other leading Romantics made plain where their sympathies lay. Delacroix was conspicuously absent from their ranks. He was suspicious of high-flown talk about the need for reforms, and blind to the issues at stake. True, he wanted the furniture mover's good will, and professed a democratic taste for simple beef stew. But he had no real conception of what social justice involved, and how it could be achieved. When his friend George Sand, who had become one of the more impassioned champions of the poor, cried out, "Great and good people, thou art heroic by thy nature. . . . Thou wilt rule, O People, rule in brotherhood," Delacroix was politely patient but skeptical.

He was no more won over when the first blood of the Revolution was shed on February 23, 1848. Government troops fired into a crowd howling outside the residence of King Louis-Philippe's premier; about 80 people were killed, and the battle was joined in earnest. To Delacroix,

however, it seemed that Parisians had merely reverted to the same old in-surrection routine, building barricades in the streets and shooting from attic windows. He could feel no fellowship with mobs that broke into the royal family's apartments at the Tuileries, slashed priceless tapestries and paintings, smashed furniture, carted off five tons of *objets d'art* and other items to second-hand dealers, and axed open so many kegs in the wine cellars that several men were drowned in the flood.

Delacroix did not even go out into the streets to watch the fighting —as he had 18 years earlier during the July Revolution—but ironi-cally he had, in a sense, painted a backdrop for it. When Louis-Philippe concluded that he would have to abdicate, his 10-year-old grandson and heir was rushed to the Chamber of Deputies to be crowned. In the nearby library was Delacroix's mural of Attila the Hun, leaving his wake of panic and war. Outside in the street angry insurgents roared so vehemently against the would-be boy king that he remained crownless. A provisional republic took over, and the royal family hastily departed for England. For a moment, however, it seemed as if Delacroix's paint-ing of Attila had come to life with full, blood-chilling sound effects.

During the February crisis and the ensuing months, Delacroix divid-ed most of his time between Paris and Champrosay, too upset to do much work. He complained about newsboys shouting all day. He hated all the scare talk and the ceaseless political maneuvering. He spoke sar-donically of a victory parade put on by the new provisional regime which included a so-called sacred cow—presumably as a symbol of agricul-tural prosperity—and triumphal chariots filled with 500 virgins. He concluded sourly that revolutions were for young people: "Me, I am cold as marble, and will probably end up insensible."

To George Sand he quoted an old Latin saying, "I prefer freedom sur-rounded by danger to a peaceful servitude," and proceeded to tear it down. "I have come, alas, to the opposite opinion," he wrote her, "con-sidering that this liberty achieved by war is not the real liberty, which consists of going and coming in peace, of thinking, of having dinner on time, and of many other advantages which political agitators do not respect. Pardon my retrograde reflections, dear friend, and love me de-spite my incorrigible misanthropy."

Late in the summer of 1848, unrest in Paris was still rampant, and Delacroix was still fuming about it: "Would that I were an Austrian, but an Austrian of the old regime when it was forbidden, under the most severe penalties, to be concerned with politics." And in a tender letter to Madame de Forget he avowed that he much preferred to con-cern himself with her than with the state of the nation: "You are my Republic and I give you my vote."

As much as he could, Delacroix avoided encounter with the Revolu-tion. But he made one rather curious gesture to it as the upheaval died down. In December 1848 the new Second Republic elected a president —Prince Louis Napoleon, the exiled nephew of Napoleon Bonaparte. The Prince had much to commend him: he was self-educated, a serious student of affairs, an author of sorts who had even written a tract on *The Extinction of Pauperism,* and an avowed devotee of the cause of

One of the unique documents of art history is Delacroix's *Journal,* begun in 1822 and continued intermittently until his death. In it the artist recorded his activities, his observations on life and art, and made occasional sketches. On this page, dated Monday, October 19, 1849, during a visit to Angerville where he stayed with his cousin Berryer, he noted the contrast between the pale inner bark of trees ripped by a storm and their darker dead leaves.

republicanism. Under these circumstances it occurred to Delacroix that his famous old flag-waving picture of the Revolution of 1830, *Liberty Leading the People*, was right back in style. Accordingly, he exhumed it from the obscurity of his Aunt Félicité's home, where it had been stored during Louis-Philippe's reign, and offered it to the Louvre. It was put on exhibit for a short time, then again taken down. In a *coup d'état* of December 1851, Prince Louis Napoleon declared himself Emperor and was henceforth known as Napoleon III. *Liberty* had once more become a tactless reminder of republican sentiments.

Delacroix remained on good enough terms with the new regime—his two brothers, after all, had fought for Napoleon Bonaparte—and before long he received several major mural commissions. Moreover, he was appointed a municipal councillor and given the authority to make recommendations for restoring old churches. Madame de Forget likewise stood well at court, for she was related to the immense Bonaparte clan. She and Delacroix enjoyed such pleasant fringe benefits as getting seats in an official box when they went to a concert or to the opera.

In 1853, Napoleon III appointed Baron Haussmann as Chief Administrator of Paris, with the assignment of beautifying the city by widening the boulevards and cleaning up old slum areas. Napoleon's ulterior motive was to make it much more difficult for Parisians, should they become rebellious, to barricade narrow streets and bombard the King's troops from the rooftops. As the contemporary engraving above shows, Haussmann took his work seriously, and soon after he took office Parisians were choking on plaster dust and tripping over building blocks, fully convinced that their beautiful, historic city was being ruthlessly destroyed.

The Revolution of 1848 had come and gone, and Delacroix could not help but feel relief. He seemed, nevertheless, to be haunted by it. A number of entries in his journal over the next few years indicate that the issues raised by the Revolutionists had set him thinking. These observations make plain that he had found his own villain for the troubles that had wracked France: the machine. Increasingly, he brooded, the machine's "great arms" would drive people from the land and consign its yield "to the impure and godless hands of speculators." Thus disinherited, more and more people would flock to the cities where it would be necessary "to construct for them immense barracks where they will lodge pell-mell." Under the pretext of saving men labor, the machine would turn them into "human cattle."

"Man makes progress in all directions," Delacroix wryly observed. ". . . he takes command over matter . . . but he does not learn how to command himself. Build your railroads and your telegraph lines, cross lands and seas in the twinkling of an eye, but let us see you direct the passions as you direct gas balloons! Above all, let us see you abolish the evil passions, which have not lost their detestable power over men's hearts despite the liberal and fraternal maxims of the period! Therein lies the problem of progress."

At Dieppe, where Delacroix and his ever-present Jenny shared a small apartment during occasional summer visits, he saw some English steamboats in the harbor and bristled with contempt: "They know no more than a single thing: *to go fast*. Let them go to the devil then, and faster yet, with their machines that make of man just another machine." The next day he was still muttering. At noon a big ship called a "clipper" was to be launched. "Here is another American invention," he wrote, "that will let people go faster, always faster. When they have got travelers comfortably lodged in a cannon, so that the cannon can make them travel as fast as bullets . . . civilization will doubtless have taken a long step. . . . it will have conquered space but not boredom."

Among the new marvels of science, the only one that he approved

was photography. He watched with fascination the devices of Louis Daguerre, posed for a dozen daguerreotypes and took at least one photograph himself, a back view of a seminude model, composed with the same care he put into a painting *(page 172)*. The camera, he felt, could be a great boon to the artist, giving him detailed studies of nudes, scenes and all manner of objects which he could incorporate into his canvases. It did not occur to him that photography would be a factor in driving later generations away from representational art. For to Delacroix the artist's personal stamp was so necessary in good painting that it could never be threatened or superseded by a mechanical device. Instead, photography and art could go hand in hand—another Delacroix synthesis. In 1854 he wrote a fellow enthusiast: "How sorry I am that so admirable an invention comes so late, I mean as far as I am concerned. . . . It is the palpable demonstration of nature's real design."

So late, I mean as far as I am concerned. . . . In these words Delacroix revealed his increasing preoccupation with the passing of the years. Revolutions could be disdained and machines despised; but time was an enemy to be fought.

The battle was more easily waged on canvas than on the calendar. One of the great satisfactions Delacroix derived from art was its ability to capture the transient, to preserve a sense of immediacy. Comparing painting with the other arts, he noted that while music and literature are obliged to unroll note by note and word by word, and require one's attention over a span of many minutes or even hours, painting could deliver its message instantaneously, like the view seen outside a door suddenly flung open. The highest compliment people could pay Delacroix was to tell him that they saw his works "all at once." To him it meant not only that he had created a unified total effect, with no single detail obtruding, but that he had successfully flouted time.

Painting also permitted him to circle round and round the entire field of his experience. No painter was more addicted to the "retake" or "return engagement." The *Women of Algiers,* the *Entry of the Crusaders into Constantinople* and the *Education of the Virgin* are but three of a long list of his works which he did in successive versions. To be sure, he was trying in each new version to solve new problems, just as a composer reworks a basic theme into many variations, but the essence remained the same. Delacroix seldom discarded an artistic idea: it was as if he were loath to let a good thing go.

His one-man war against time also took the form of an almost obsessive reluctance to stay away from his palette. Hymns to hard work sprinkled his journal and his letters. "I have gone without rest for seven, eight, and nearly nine hours working on my pictures," he wrote Madame de Forget in 1852. "I believe that my custom of just one meal a day decidedly suits me best." Eight years later—when he was 62—he was sounding much the same note: "I have been at work all day; what a happy life. What a divine compensation for my isolated state, as they call it! . . . I hasten to this enchanting work as to the feet of the most cherished mistress."

The pace of his production during these years of his fifties and early

The changing face of Paris added to Delacroix's growing feeling of discontent with the city. In the 1850s many Parisians protested Baron Haussmann's scheme for lining the boulevards with regularly spaced five-story apartment houses having similar façades. They argued that the look-alike buildings gave a drab, conforming aspect to the city. But Haussmann prevailed and hundreds of these dwellings were erected. The cartoon above shows the interior of one, with shops on the ground-floor, rich people with high-ceilinged flats on the second floor and, on the floors above, tenants of decreasing wealth—right up to the artists in their airless garrets.

sixties would have staggered many a younger man. Three of his works, moreover, involved long, arduous hours on the scaffoldings and amid the chill drafts of Parisian public buildings.

The first was the decoration of the central ceiling of the Galerie d'Apollon at the Louvre. The rest of this huge room had been decorated almost two centuries earlier by the illustrious Charles Le Brun, court painter to Louis XIV. Delacroix thus had a problem of harmonizing his style with Le Brun's—a feat he achieved so well that, in the words of Réné Huyghe, his work managed "to blaze out with its full force in the center of the other's total scheme without blowing it to pieces." Delacroix again used the theme of encounter. Apollo, god of the sun and all enlightened powers, meets and slays the serpent Python, who symbolizes darkness, ignorance and evil. Roaring across the sky in his golden chariot, Apollo rains arrows down upon the hideous Python, who arches his slimy coils in a smoky tarn, oozing blood, spitting fire and getting what help he can from his attendant monsters.

Delacroix followed this opus with another, equally gigantic in scope. For the Salon de la Paix at the Hôtel de Ville, he assembled another classical galaxy of gods, with Cybele, the earth, enthroned high on a circular ceiling, summoning Venus, Bacchus and Neptune to help her restore order after the ravages of human conflict. All around the hall, just below the ceiling, Delacroix depicted Hercules performing eight of his famous labors. These allegorical themes were hardly unfamiliar by now, but Delacroix's vigorous and imaginative treatment gave them a singular freshness. Today only his preliminary drawings and color sketches of this work survive. It was destroyed by fire—along with the venerable Hôtel de Ville itself—during a new proletarian uprising in 1871.

Delacroix's last public commission, begun in 1856 and completed in 1861, was the decoration of the walls and ceiling of the Chapel of the Holy Angels of the church of Saint-Sulpice. The project was one of the most taxing he had ever undertaken, partly because of recurring bouts of illness and partly because of the sheer size of the surfaces to be covered; each wall alone measured about 16 by 23 feet. Yet Delacroix tackled the job eagerly, even commuting to it by train from Champrosay to Paris. The work, he noted in his journal, was "a happy compensation for the things that the good years of youth have taken away with them; a noble use of the moments of the old age which is besieging me."

It was, indeed, a noble use, resulting in a monumental commentary on the good and evil in man *(pages 184-185)*. On one wall the Emperor Heliodorus, thwarted in his attempt to rob the Temple in Jerusalem of its holy treasures, is being driven off by three avenging angels. On the opposite wall, an angel on quite another mission wrestles with the youthful Jacob in an effort to bring him spiritual grace. Overhead, on the ceiling, the archangel Michael defeats the devil and, with his outstretched wings, signals the final triumph of good. All the more powerful because of its simplicity, Delacroix's achievement at Saint-Sulpice reflects the thinking of a man who has come to grips—and to terms—with himself.

The Saint-Sulpice murals were not particularly well-received; the

170

tastes of sophisticated Parisians had turned to other subjects. When the work was to be unveiled, Delacroix sent out a number of invitations to the ceremony. Many artists came, but no important officials, no one from the court of Napoleon III. In his earlier years, such indifference would have stung Delacroix. Now he seemed to take it with a shrug.

He no longer needed reassurance as to his stature as an artist. French officialdom had long since given him high honor and recognition. For the *Exposition Universelle* of 1855—an international fair intended by Napoleon III to show the world his Empire's progress in industry, commerce and art—Delacroix and Ingres were invited to assemble retrospective exhibits of their own works. Each was given a special gallery; Delacroix's show of 40 of his paintings dominated the central hall. Artists from 28 nations submitted more than 5,000 canvases; when a special Salon jury—expanded to include judges from other countries—made its awards, Ingres, Delacroix and seven others were given Grand Medals of Honor.

An even more coveted honor fell to Delacroix two years later: he was, at last, elected to membership in the almighty Académie des Beaux-Arts. Six times over the preceding two decades he had been passed over in favor of many mediocre artists; now Ingres and his fellow Academicians withdrew their opposition to him, and the sacrosanct portals were opened. Not long afterward, Delacroix's friend Chenavard described an occasion when the two of them were en route to an Academy meeting. "Chance willed it that Ingres should be only a few steps ahead of us. As we were approaching the door, and those two irreconcilable enemies were just meeting and measuring each other with a look, Ingres suddenly extended his hand to Delacroix, moved by an impulse of secret sympathy which for a long time had been drawing together the natures of these two great artists. . . . I cannot tell you the joy that gripped my heart when I saw their two flags finally united by the embrace of friendship."

Delacroix enjoyed the fanfare of official acclaim, although less exuberantly than he would have in the prime of his powers. By the time of his triumphs at the Exposition and at the Academy, he had begun a conscious pursuit of privacy, and its pleasures became daily more appealing. Continued poor health—persistent coughs and colds and fever—deprived him of the hope of restoring his energies; he now tried only to conserve them. With this end in view, he decided to build a little studio with a garden on the Place Furstenberg near Saint-Germain-des-Prés, within easy walking distance of his work at Saint-Sulpice. More and more his life became polarized between the new studio and the rented retreat at Champrosay, which he finally bought in 1858. His declining vigor was a worry and at the same time a release from the grasp of unruly passions. At one point he wrote, with almost an audible sigh of relief, "How glad I am no longer to be forced to find my happiness where I had to search for it in the past! From what savage tyranny have I not been snatched by this weakening of the body?"

He found a growing measure of happiness in the company of Jenny Le Guillou. His friends found her too zealous a protector. "Don't be

angry with her," Delacroix would tell them, "she acts as sentry over my time and life. She is blind devotion itself." Jenny kept house for him, tended to his needs, and, perhaps best of all, was a good listener. He read Racine to her and explained the mysteries of Assyrian art to her at the Louvre. She was at his side, solicitously when he went to the seaside or a spa for his health, appreciatively when he walked through the woods around Champrosay and expounded on the delights of nature.

Steeping himself in nature seemed particular balm to his soul. He was transported by the smell of his neighbor's vegetable garden on a rainy spring night, giving off "an odor that reached back into my youth. . . . I walked back over the ground five or six times. I couldn't tear myself away." Sometimes in the summer he could hardly begin the day early enough: "I start out through the country at six in the morning. . . . I go to the bank of the river and make a sketch. . . . I bring back a sheaf of water lilies and arrowhead plants. I flounder about for nearly an hour on the muddy banks . . . in order to make my conquest of these humble plants." And there were other walks to discover "rocks, woods, and above all waters, waters of which one never tires, feeling an incessant desire to plunge into them, to be a bird, to be the tree that bathes in them." For Delacroix, nature was another major encounter: a stream to be plunged into, a conquest of water lilies. And there were so many things to scrutinize: two swallows walking on the grass with "a waddling gait," and "a Homeric little duel" between a spider and a fly. How else would he describe this miniature battle, addicted as he was to the classics, except to say, "I was the Jupiter contemplating the fight of this Achilles and this Hector"?

Along with these entries in his journal were hosts of others, for the journal itself had become an important source of pleasure. He had always wanted to be a man of letters, and now he had found a form of writing wholly congenial to him. "Why not make a little collection of detached ideas that come to me from time to time? . . . Montaigne writes by fits and starts. Those are the most interesting works." Inspired by the greatest of French essayists—Delacroix always kept good literary company—he poured out his observations in increasing flow. He wrote about his moods, his ailments, the books he read, the pictures he planned still to paint; he jotted down definitions for his projected dictionary—a work, regrettably, that he was never to finish. The journal, in its way, was an extraordinary piece of artistry, for Delacroix's pen produced a self-portrait in words as revealing as any on canvas.

He continued, meanwhile, to paint furiously. As always he found a welcome change of pace from his mural commissions in smaller easel paintings. One was the spectacular *Lion Hunt,* a tangle of beasts, horses and men, flashing with sabers and saturated with blood—a virtual abstraction of blazing, primitive energy *(pages 182-183).* With the completion of the Saint-Sulpice assignment he did a number of other works which gave proof that age had not narrowed the gamut of his interests: *Ovid among the Scythians, Arabs Skirmishing in the Mountains,* a final *Hamlet* and probably his last painting, *Tobias and the Angel.* "I have work ahead for another 400 years," he declared.

Rather than regarding photography as a potential competitor, Delacroix applauded its invention in the 1820s by Joseph Niepce and Louis Daguerre. He was among the first members of the *Société Française de Photographie* and used photographs to paint from. In 1850, having learned the rudiments of the new art, he made this photograph of a model in his studio.

One day in May 1863, Delacroix felt unusually fatigued by the short train ride from Paris to Champrosay and retired immediately to bed. After a while he was up and about, but continued to feel poorly. A month later he told Jenny, "If I get well, as I think I shall, I will do astonishing things." One of the projects he had in mind was to paint Noah and his family right after the flood, standing hopefully on the mountain, with the world still wet and glistening in the sunlight. But in July his strength failed suddenly. In order to be near the doctor, he was taken by carriage to his Paris studio, where Jenny nursed him day and night. He wrote faltering farewell notes to Madame de Forget and George Sand, thanking them for flowers and assuring them of his devotion, and he sent his respects to several other friends. On August 13, at seven in the evening, Delacroix died—probably of tubercular laryngitis. "He kept his calm and tranquil spirit until the last minute," Jenny wrote, "recognizing me, pressing my hand without being able to speak, and he breathed his last sigh like a child."

Some months before his death, Delacroix had prepared a long will, leaving sketches and keepsakes to friends who he thought would particularly enjoy them. But in a sense his primary bequest was to the world. Several days after his death a small group of his friends met in his studio and began the process of sorting some 6,000 paintings, drawings, engravings and lithographs. In line with Delacroix's wishes, these works were put up for public sale.

There was one encounter Delacroix wanted to make that his enemy, time, refused to grant him. "Ah, how I would like to come back a hundred years from now," he once wrote, "and find out what they think of me."

Could he have had his wish, what would he have discovered? He would have found himself almost as controversial a figure as he was in his own day. Among art critics, he is regarded as "problematic," a major influence on later artists who was nevertheless the last holdout for the grand manner in painting. Among artists themselves, he is widely esteemed—very much an artists' artist. Among the public, his stock soars, tumbles and fluctuates. Delacroix captured many new admirers with the magnificent exhibit at the Louvre in 1963 which marked the centenary of his death. There, with most of his lifework spread out in all its abundance and variety, it became apparent that his work is best appreciated in its totality.

Delacroix's importance, however, lies less in his art—marvelous though much of it is—than in his view of what art should do to the beholder. It was his belief that painting's function was to communicate directly to the soul. Nowadays, it seems, souls have gone out of style in favor of egos. But what Delacroix was saying, in effect, was that a picture must do more than present a literal image; it must stir us deeply, it must appeal to our senses, it must reach us in every possible way. The boundaries of art, he argued, must be expanded until they encompass all human experience. Through Delacroix and the men who subsequently took up this theme, the last barriers on the road to modern art were broken.

Delacroix was often photographed, and this portrait by Nadar, made in 1861, is one of the finest pictures of him. Nadar, who dabbled in painting, medicine, the theater, politics and journalism, finally specialized in photography when it was still a budding art. He made the first aerial photograph (from a balloon) and opened a large and extremely successful portrait studio where he photographed everyone from Sarah Bernhardt to Richard Wagner.

The Close of Day

In the final years of his life, Delacroix moved back across the Seine to the Left Bank, the scene of much of his childhood. He did so primarily because his failing health made it necessary to be nearer the enormous project that was sapping his strength: the murals for the Chapel of the Holy Angels at the church of Saint-Sulpice. In a charming and quiet neighborhood nearby, he rented an apartment with a leafy courtyard, where he had a studio built *(right)* with a southern exposure.

There he cut himself off from most of the social life to which he used to devote so much time, and concentrated on his work. When he was not at the church or reviving his energies at his country retreat in Champrosay, he painted at the studio, returning again and again to themes from his Moroccan journey and to the visions of violent animal and human combat which for so long had filled his mind. Over the years his style had become refined and purified; his colors were brighter now, and cleaner; his brush strokes were bolder, more vigorous and confident, his compositions simpler and more direct. And although he was obliged to conserve his strength and live tranquilly, his inner fires were burning more brightly than ever. Nor were they dimmed by the belated gestures of public and professional esteem which were heaped upon him. The lines that Dylan Thomas wrote a century later may be applied to Delacroix: "Old age should burn and rage at close of day; /Rage, rage against the dying of the light."

Delacroix's last studio and lodging are now used as a museum and a research center. Here, yearly exhibitions of his work are shown, a library is maintained and a complete catalogue of the master's work is being compiled.

The Many Meanings of Art

More articulate than most artists, Delacroix enjoyed writing nearly as much as painting. He combined these talents to produce an outpouring of his views on every aspect of art from its conception to its final impact. In 1857, the day after his election to the Academy, Delacroix began to assemble these thoughts in his journal under the tentative title *A Small Philosophic Dictionary of the Fine Arts*. The following extracts—from this unfinished work and from other parts of his journal—provide a sampling of his observations and definitions of a painter's world.

Art is not some sort of chance inspiration which comes from nowhere and presents only the picturesque externals of things. It is reason itself adorned by genius, but following a necessary course and controlled by higher laws.

Somewhere in the course of their career, artists must learn not merely to despise everything which is not entirely theirs, but must rid themselves completely of this blind fanaticism which drives us to imitate the great masters and swear only by their works. One must say: this is good only for Rubens, this Raphael, Titian or Michelangelo. What they have done is their business; nothing chains me to this one or that one. One must learn to be grateful for one's own findings: a handful of naive inspiration is better than anything else.

Fine works of art never age, because they are marked by genuine feeling. The language of the passions, the impulses of the heart, are always the same; what inevitably gives the stamp of age, and sometimes mars the greatest beauty, are the formulae which were fashionable at the time of creation.

Feeling must not be expressed to the point of nausea.

The more literal the imitation, the flatter it is, and the more it shows how impossible it is to rival the original. One can only hope to arrive at some approximate equivalent. It is not the thing itself which must be done, but only its semblance: and here again the effect must be for the soul and not the eye.

Of which beauty will you speak? There are many: there are a thousand: there is one for every look, for every spirit, adapted to each taste, to each particular constitution.

To be understood a writer has to explain almost everything. In a painting, a mysterious bridge seems to exist between its painted subjects and the spectator's spirit.

Skill is almost always fatal to feelings: the hand's dexterity, or simply a too-thorough knowledge of anatomy and proportions, gives the artist too much freedom; he no longer thinks the picture clearly; the ability to render it with facility or short cuts seduces him and leads him to mannerism. Schools rarely teach otherwise. Which teacher is capable of transmitting his personal feelings? One can only take his recipes.

Alas for the man who can only see a definite idea in a beautiful painting; and alas for the painting which shows nothing but finish to a man gifted with imagination. The merit of a painting is undefinable, and that is exactly what precision lacks; in a word, it is what the spirit adds to color and line that appeals to the soul.

Creation on the part of great artists is only their particular way of seeing, coordinating and rendering nature.

In painting, execution should always be extempore. Execution will be beautiful only on condition that the painter lets himself go a little, discovers as he paints.

Contrary to common opinion, I would say that color has a more mysterious and perhaps more powerful influence: it acts, as one might say, without our knowledge.

Color is nothing if it is not suitable to the subject, and if, in imagination, it does not add to the effect of the painting.

Gray is the enemy of all painting. Owing to its oblique position in daylight, a painting will always appear grayer than it really is: banish therefore all dull colors.

Style: It never takes long to say the things that are necessary to say.

It is only possible to speak in the language and in the spirit of one's time. One must be understood by those who listen, and particularly by oneself. Make Achilles a Greek! But, good God, did Homer himself do so? He made Achilles a man of his epoch. Those who had seen the real Achilles were long since dead.

Artists who seek perfection in everything are those who cannot attain it in anything.

The art of painting is to attract attention only to what is necessary.

Finishing a painting demands a heart of steel: everything requires a decision, and I find difficulties where I least expect them. . . . It is at such moments that one fully realizes one's own weaknesses and how many incomplete, or impossible to complete, parts comprise what man calls a finished or completed work.

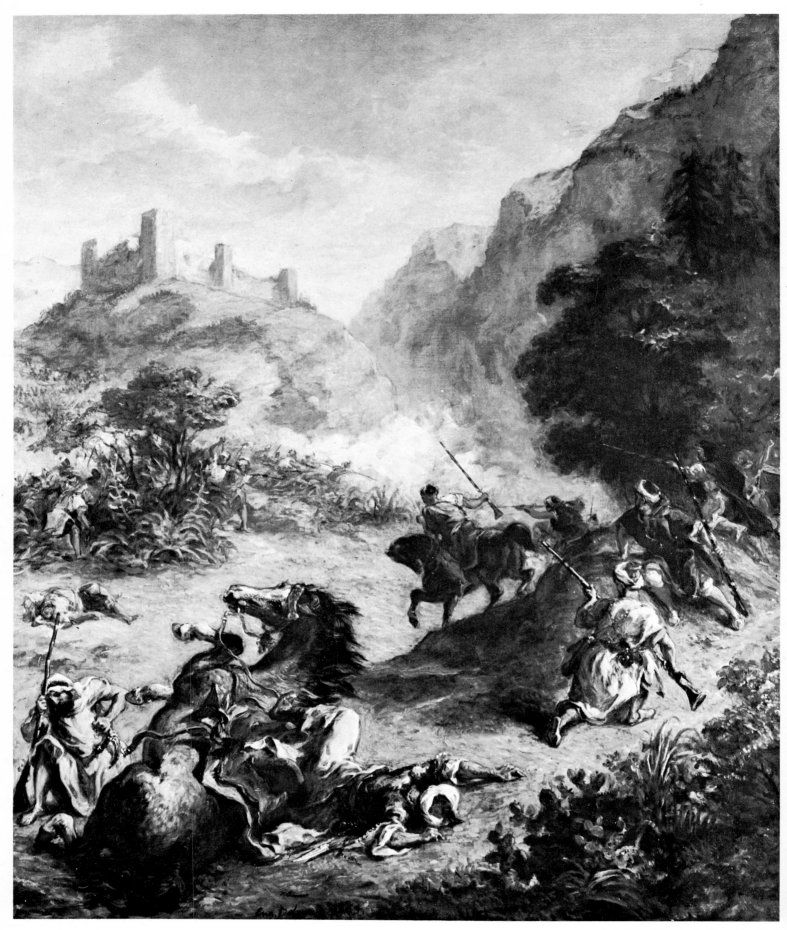

Arabs Skirmishing in the Mountains, 1862

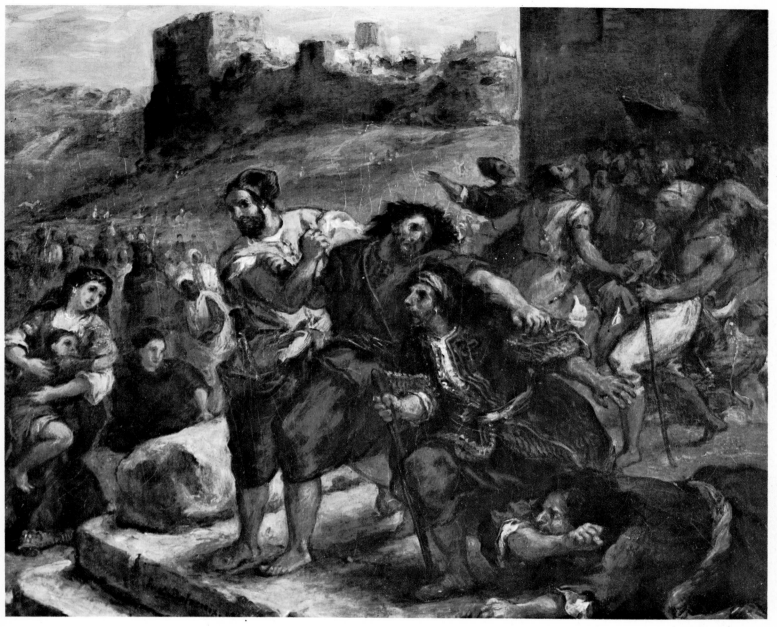

Fanatics of Tangier, 1857

In his final Moroccan pictures, painted nearly 30 years after his trip, Delacroix improvised freely on memories to create some new works, and repainted older subjects in new ways. He returned to the *Fanatics of Tangier*, which he had painted in 1838, in a new version in 1857. Whereas previously he had subdued the figures in their setting, playing off a contrast between the neat geometrical architecture and the writhing figures of the religious celebrants, in the later treatment he brought the people into greater prominence, drawing their contorted postures with whirling slashes of color.

Sinuous lines also play a part in his last important painting, *Arabs Skirmishing in the Mountains*, in which the composition zigzags like a flash of lightning from the citadel on the hill to the fallen horse and rider at lower left. This baroque S-shaped form had an important role in his late works, from *Medea* to his great murals for Saint-Sulpice.

Lion Devouring a Rabbit, 1856

Fight between a Lion and a Tiger, c. 1856

Lion Devouring a Wild Boar, 1853

A Return to Animal Combat

Throughout his life, Delacroix sketched and painted animals, like an athlete returning to a favorite set of exercises to improve his skill or virtuosity. As a true Romantic, he was of course fondest of the big cats, and the long hours spent in the zoo studying their anatomy and the poses into which they naturally fell gave him his material. He had, however, never seen them in real life —hunting, stalking or devouring prey—and it is remarkable that he could transform his studies of caged beasts into compositions of raging, fighting animals of the wild *(see next page)*. Yet so closely was his imagination attuned to these creatures that his studies are astonishingly accurate.

Of course, he had precedents in Géricault, Stubbs and Barye, whose horse and lion studies had taught him much. But his main guide was Rubens, who painted a number of lion hunt scenes in which every snort of a victim, and each quivering nostril pulses with life and animal reality. Delacroix had fine masters, but he may have surpassed them all.

Horse Devoured by a Lioness, 1840

Tiger Attacking a Horse, 1825-1828

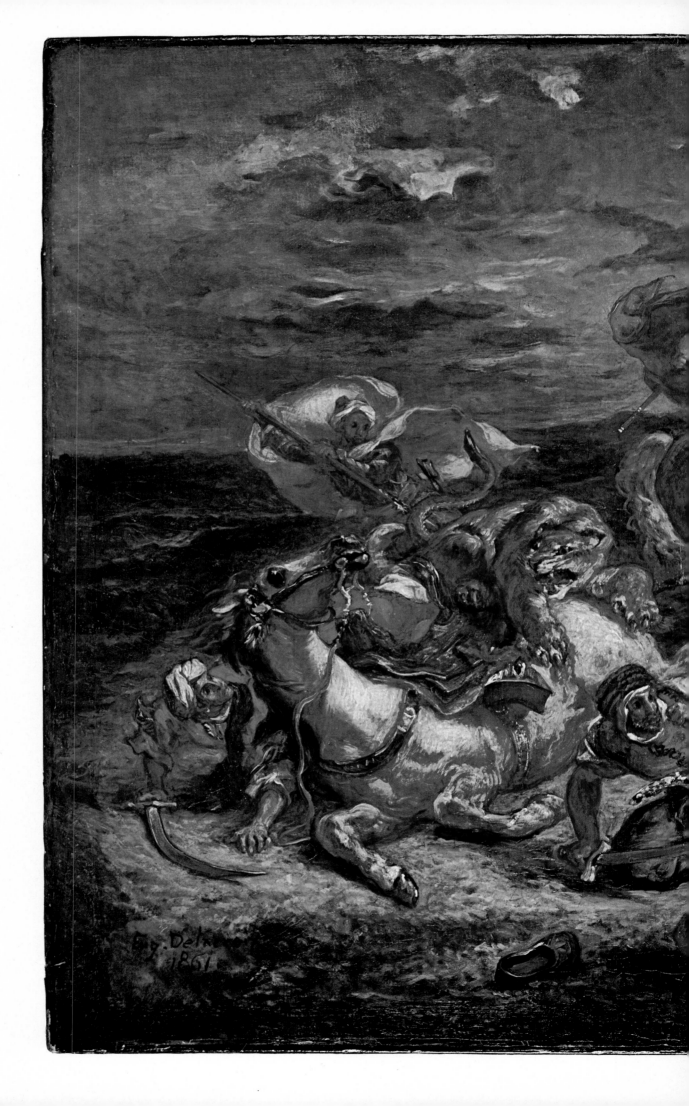

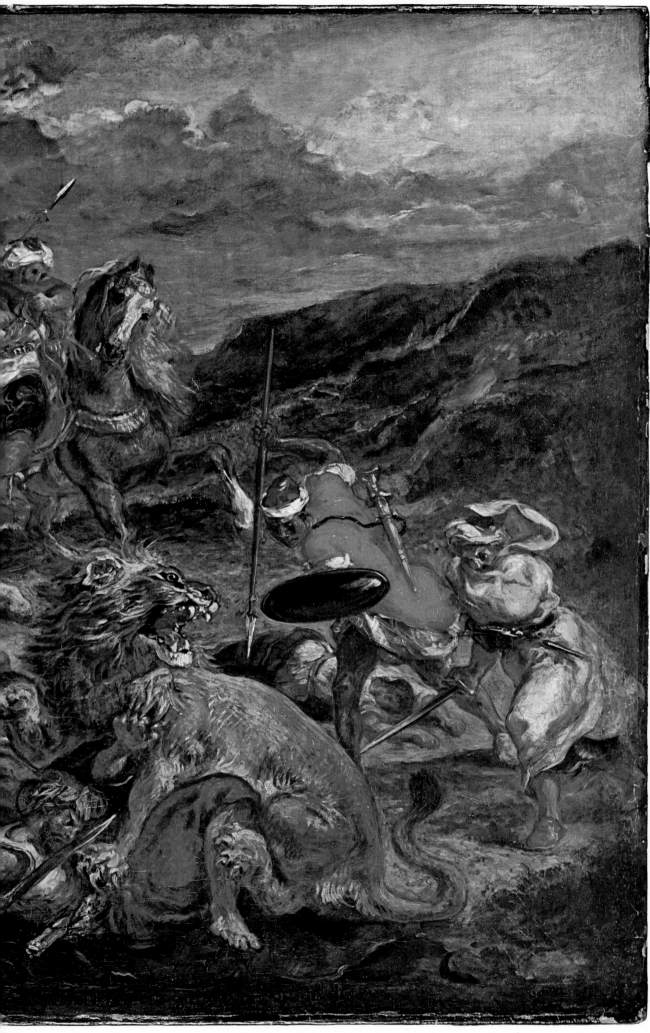

Lion Hunt, 1861

Heliodorus Driven from the Temple, 1856-1861

In the murals that he painted for the church of Saint-Sulpice, Delacroix climaxed his lifelong devotion to themes of encounter and violence. Taking scenes from the Old Testament, he dramatized their spirituality through the harshest reality of mortal combat. In *Heliodorus Driven from the Temple (above)*, he chose the moment when the avaricious Greek general is kept from looting Jehovah's temple by three avenging angels, one of them on horseback. While his henchmen cringe in terror, the general is stamped to the ground, his stolen treasure spilling away. Here, Delacroix demonstrates his mastery of the grand mural style. In an almost baroque

Jacob Wrestling with the Angel, 1856-1861

swirl of masses illuminated with flashes of light and color, he holds his cluttered and riotous scene firmly in place around the majestic central column.

In the second mural, *Jacob Wrestling with the Angel*, set in a quiet forest glade, the same swirling conflict prevails. Jacob, deserted by his men, grapples with the Lord's emissary. As if to emphasize Jacob's loneliness, Delacroix has made a low-key still life of his hat and scarf, spear and arrows *(detail, next pages)*. Today, this fragment seems like an epitaph to Delacroix himself who, soon after painting this scene, was to lay down his brush and palette, the tools and weapons of his art.

APPENDIX

Copies after Delacroix

One sign of Delacroix's greatness is the flood of copies his works have inspired. Copying may be deplored by the uninformed, but it remains an acceptable and useful learning guide for a young artist. Later painters have gone to Delacroix for lessons in form and color just as he had copied Rubens. Below are a number of direct copies of, or variations on, Delacroix paintings which appear elsewhere in this book. Although his work seems to have had the most impact on

Vincent van Gogh copied a lithograph of one of Delacroix's late paintings, a *pietà*. Van Gogh had earlier copied another Delacroix work and is known to have admired him for his vigorous color.

From 1954 to 1955 Picasso painted 15 different variations on *Women of Algiers*, some in many colors, others as almost monochromatic abstractions. This was done on January 24, 1955.

Renoir's version of the *Jewish Wedding in Morocco*, made in 1876, contrasts with the Picasso variation by being almost a stroke-for-stroke copy. Renoir also admired *Women of Algiers*.

men who immediately succeeded him, in particular the Impressionists, artists still seek him out.

At right is an interesting painting by Henri Fantin-Latour called *Homage to Delacroix*, made in 1864, in which a group of the master's admirers posed for the record. They include Fantin-Latour himself *(coatless)*, James McNeill Whistler *(standing left of center)*, Edouard Manet *(standing right of painting)* and the critic Charles Baudelaire *(right, foreground)*.

These two copies of *Greece Expiring on the Ruins of Missolonghi* span almost 100 years. At left is Odilon Redon's version, made about 1870; at right is a 1964 painting by Patrick Caulfield.

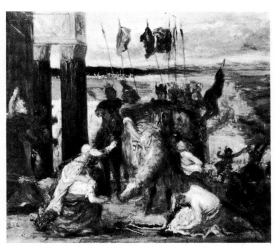

Dégas was an enthusiastic collector of paintings by recent masters, as well as a diligent copyist. He owned several Delacroixs and made this sketch of *Entry of the Crusaders into Constantinople*.

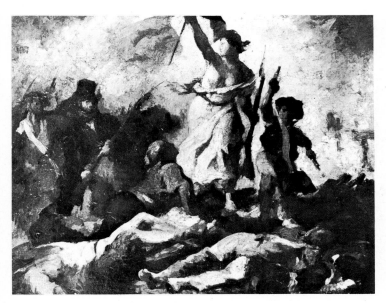

Cézanne made versions of several Delacroixs, including this one of *Liberty Leading the People*. Like Delacroix, Cézanne had studied Rubens and Veronese in addition to many great sculptors.

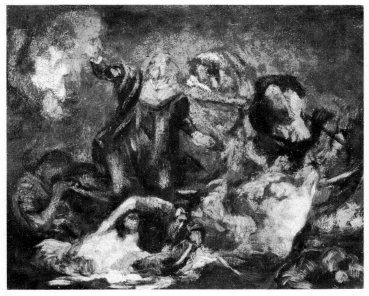

In 1856 Manet visited Delacroix and asked permission to copy the *Bark of Dante*, which was then in the Musée du Luxembourg in Paris. Receiving approval, Manet made two studies the next year.

189

Chronology: Painters of Delacroix's Era

Delacroix's predecessors and contemporaries are grouped here in chronological order according to country. The bands correspond to the life-spans of the painters.

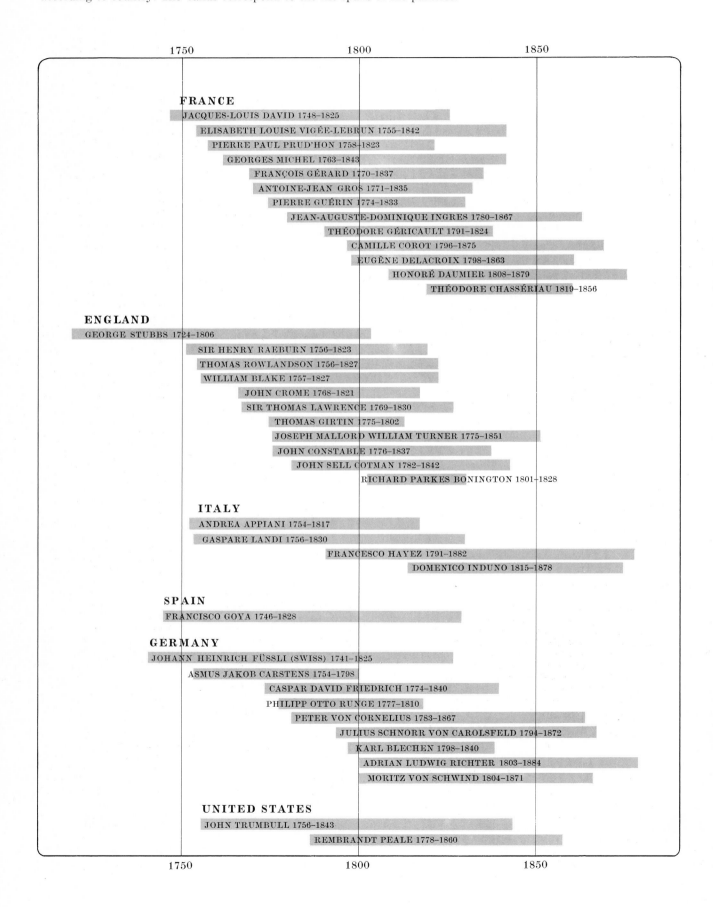

1750 **1800** **1850**

FRANCE
JACQUES-LOUIS DAVID 1748–1825
ELISABETH LOUISE VIGÉE-LEBRUN 1755–1842
PIERRE PAUL PRUD'HON 1758–1823
GEORGES MICHEL 1763–1843
FRANÇOIS GÉRARD 1770–1837
ANTOINE-JEAN GROS 1771–1835
PIERRE GUÉRIN 1774–1833
JEAN-AUGUSTE-DOMINIQUE INGRES 1780–1867
THÉODORE GÉRICAULT 1791–1824
CAMILLE COROT 1796–1875
EUGÈNE DELACROIX 1798–1863
HONORÉ DAUMIER 1808–1879
THÉODORE CHASSÉRIAU 1819–1856

ENGLAND
GEORGE STUBBS 1724–1806
SIR HENRY RAEBURN 1756–1823
THOMAS ROWLANDSON 1756–1827
WILLIAM BLAKE 1757–1827
JOHN CROME 1768–1821
SIR THOMAS LAWRENCE 1769–1830
THOMAS GIRTIN 1775–1802
JOSEPH MALLORD WILLIAM TURNER 1775–1851
JOHN CONSTABLE 1776–1837
JOHN SELL COTMAN 1782–1842
RICHARD PARKES BONINGTON 1801–1828

ITALY
ANDREA APPIANI 1754–1817
GASPARE LANDI 1756–1830
FRANCESCO HAYEZ 1791–1882
DOMENICO INDUNO 1815–1878

SPAIN
FRANCISCO GOYA 1746–1828

GERMANY
JOHANN HEINRICH FÜSSLI (SWISS) 1741–1825
ASMUS JAKOB CARSTENS 1754–1798
CASPAR DAVID FRIEDRICH 1774–1840
PHILIPP OTTO RUNGE 1777–1810
PETER VON CORNELIUS 1783–1867
JULIUS SCHNORR VON CAROLSFELD 1794–1872
KARL BLECHEN 1798–1840
ADRIAN LUDWIG RICHTER 1803–1884
MORITZ VON SCHWIND 1804–1871

UNITED STATES
JOHN TRUMBULL 1756–1843
REMBRANDT PEALE 1778–1860

1750 **1800** **1850**

Catalogue of Illustrations

191

Paris. P.161: *Study for Attila*, pen, 7″ x 9″, Louvre, Paris. P.162: *Pietà*, oil on canvas sketch, 12″ x 17″, Louvre, Paris. P.162-163: *Entry of the Crusaders into Constantinople*, oil on canvas, 32″ x 39″, Louvre, Paris. P.164: *Medea*, oil on canvas, 30″ x 65″, Musée des Beaux-Arts, Lille. P.167: *Page of Journal*, pen, 5½″ x 15″, Bibliothèque Nationale, Paris. P.178: *Arabs Skirmishing in the Mountains*, oil on canvas, 36″ x 29″, Private Collection. P.179: *Fanatics of Tangier*, oil on canvas, 18″ x 22″, The Art Gallery of Toronto, Toronto. P.180: *Lion Devouring a Rabbit*, oil on canvas, 18″ x 22″, Louvre, Paris. *Lion Devouring a Wild Boar*, oil on canvas, 18″ x 22″, Louvre, Paris. *Horse Devoured by a Lioness*, oil on canvas, 9″ x 12″, Louvre, Paris. *Fight Between a Lion and a Tiger*, pen, 12″ x 11″, Ehrmann Collection, Louvre, Paris. P.181: *Tiger Attacking a Horse*, watercolor with varnish, 7″ x 10″, Louvre, Paris. P.182-183: *Lion Hunt*, oil on canvas, 30″ x 39″, The Art Institute of Chicago, Potter Palmer Collection, Chicago. P.184: *Heliodorus Driven from the Temple*, oil and wax on plaster, 281″ x 191″, Chapel of the Holy Angels, Church of Saint-Sulpice, Paris. P.185: *Jacob Wrestling with the Angel*, oil and wax on plaster, 281″ x 191″, Chapel of the Holy Angels, Church of Saint-Sulpice, Paris. P.186-187: *Jacob Wrestling with the Angel* (detail). P.188: *Pietà*, lithograph, 7″ x 9″, Bibliothèque Nationale, Paris. Back end paper: *Corner of Studio*, sepia wash, 7″ x 11″, Louvre, Paris.

FANTIN-LATOUR, HENRI: 1836-1904. P.189: *Homage to Delacroix*, oil on canvas, 46″ x 98″, Louvre, Paris.

FUSELI, HENRY: 1741-1825. P.61: *Nightmare*, oil on canvas, 30″ x 25″, Goethe Museum, Frankfort.

GÉRARD, FRANÇOIS: 1770-1837. P.25: *Portrait of Madame Récamier*, oil on canvas, 88½″ x 58″, Musée Carnavalet, Paris.

GÉRICAULT, THÉODORE: 1791-1824. P.10: *Portrait of Eugène Delacroix*, oil on canvas, 24″ x 19″, Musée des Beaux-Arts, Rouen. P.29: *Officer of the Imperial Guard*, paper mounted on canvas, 20½″ x 15″, Louvre, Paris. P.48: *Sketch of Jamar and Delacroix for Raft of the Medusa*, pen and chalk on yellow paper, Private Collection. *Study for Raft of the Medusa*, oil on canvas sketch, 15″ x 18″, Louvre, Paris. P.48-49: *Raft of the Medusa*, oil on canvas, 192″ x 282″, Louvre, Paris. P.60: *Head of a Napoleonic Horse*, oil on canvas, 24″ x 19½″, Private Collection.

GIRAUD, EUGÈNE: 1806-1881. P.84: *Delacroix*, watercolor, Bibliothèque Nationale, Paris.

GRANDVILLE (JEAN IGNACE-ISIDORE GÉRARD): 1803-1847. P.85: *Artistic Tea Seasoned with Great Men*, engraving, Bibliothèque Nationale, Paris.

GROS, ANTOINE-JEAN: 1771-1835. P.26-27: *Napoleon Visiting the Pest-House at Jaffa*, oil on canvas, 209″ x 283″, Louvre, Paris.

GUÉRIN, PIERRE-NARCISSE: 1774-1833. P.26: *Aeneas Telling Dido the Disasters of the City of Troy*, oil on canvas, 116″ x 153″, Louvre, Paris.

HEIM, FRANÇOIS-JOSEPH: 1787-1865. P.68-69: *Charles X Awarding Prizes at the Salon of 1824*, oil on canvas, 68″ x 101″, Louvre, Paris.

INGRES, JEAN-AUGUSTE-DOMINIQUE: 1780-1867. P.28: *Portrait of Madame Rivière*, oil on canvas, oval 45″ x 35″, Louvre, Paris. P.71: *Oedipus Solving the Riddle of the Sphinx*, oil on canvas, 74″ x 56″, Louvre, Paris. P.135: *Madame Edmond L. A. Cavé*, oil on canvas, 16″ x 13″, The Metropolitan Museum of Art, Bequest of Mrs. Grace Rainey Rogers, 1943, New York. P.136: *Niccolò Paganini*, pencil, 12″ x 8½″, Louvre, Paris.

LAMI, EUGÈNE-LOUIS: 1800-1890. P.92: *Parisian Salon*, pencil and wash, Collection Albert Guillaume, Paris.

MANET, ÉDOUARD: 1832-1883. P.189: *Bark of Dante* after Delacroix, oil on canvas, 34″ x 41″, The Metropolitan Museum of Art, Bequest of Mrs. H. O. Havemeyer, 1929, The H. O. Havemeyer Collection, New York.

MARLET, CARLE: 1771-1847. P.32: *Art Students During Life Class* (detail), colored lithograph, 8″ x 10″, from portfolio done in 1810.

MARTENS, FRIEDRICH VON: 1809-1875. P.132-133: *Panoramic View of Paris in 1846*, daguerreotype, George Eastman House Collection, Rochester.

MARTINI, PIETRO: 1739-1797. P.66-67: *The 1785 Salon*, engraving, Bibliothèque Nationale, Collection Hennin, Paris.

NADAR (GASPARD FELIX TOURNACHON): 1820-1910. P.68: *Pierre-Charles Baudelaire*, photograph, Bibliothèque Nationale, Paris. P.173: *Delacroix*, photograph, Bibliothèque Nationale, Paris.

PHILLIPS, THOMAS: 1770-1834. P.80: *Portrait of Byron in Albanian Costume* (detail), oil on canvas, 29½″ x 24½″, National Portrait Gallery, London.

PICASSO, PABLO: 1881—. P.188: *Women of Algiers* after Delacroix, oil on canvas, 51″ x 64″, Mr. and Mrs. Victor W. Ganz, New York.

PICOT, FRANÇOIS: 1786-1868. P.70: *Amour and Psyche*, oil on canvas, 92″ x 115″, Louvre, Paris.

PRUD'HON, PIERRE-PAUL: 1758-1823. P.25: *Empress Josephine at Malmaison*, oil on canvas, 96″ x 70½″, Louvre, Paris.

RAPHAEL: 1483-1520. P.44: *La Belle Jardinière*, oil on wood, 48″ x 31″, Louvre, Paris.

REDON, ODILON: 1840-1916. P.189: *Greece Expiring on the Ruins of Missolonghi* after Delacroix, oil on canvas, 46″ x 33″, Courtesy of Ari Redon, Paris.

RENOIR, AUGUSTE: 1841-1919. P.188: *The Jewish Wedding* after Delacroix, oil on canvas, 43″ x 57″, Worcester Art Museum, Worcester.

RUBENS, PETER PAUL: 1577-1640. P.47: *Debarkation of Marie de' Medici at Marseilles* (detail), oil on canvas, 155″ x 116″, Louvre, Paris.

SAND, GEORGE: 1804-1876. P.18: *Delacroix*, pen, Private Collection.

STUBBS, GEORGE: 1724-1806. P.61: *White Horse Frightened by a Lion* (detail), oil on canvas, 40″ x 50¼″, Walker Art Gallery, Liverpool.

VAN GOGH, VINCENT: 1853-1890. P.188: *Pietà* after Delacroix, oil on canvas, 73″ x 60″, Stedelijk Museum, Amsterdam.

VILLOT, PAULINE: 19th Century. P.126: *Delacroix in Moroccan Costume*, pencil, Courtesy Raymond Escholier, Paris.

ANONYMOUS. P.13: *Classicists and Romantics*, lithograph, Bibliothèque Nationale, Paris. P.16: *Talma and Napoleon I*, colored etching, Bibliothèque Nationale, Paris. P.39: *Giraffe*, lithograph, Bibliothèque Nationale, Paris. P.68: *Denis Diderot*, engraving, Bibliothèque Nationale, Paris. P.131: *Delacroix's Studio, 54, Rue Notre-Dame-de-Lorette*, wood engraving from *L'Illustration*, 8″ x 9½″, Bibliothèque Nationale, Paris. P.168: *The Rebuilding of Paris* (detail), woodcut, Musée Carnavalet, Paris. P.169: *Five Stages of Parisian Life*, engraving, Bibliothèque Nationale, Paris.

Bibliography *Paperback

DELACROIX

Delacroix, Eugène, *The Journal of Eugène Delacroix*. Translated by Lucy Norton, Phaidon, 1951. (Also paperback, Grove, New York, 1948.) Selections from the three volumes of this unique document in art history.
Correspondance Générale d'Eugène Delacroix (5 vols.). Edited by André Joubin. Plon, Paris, 1936. The basic edition of Delacroix's letters.
Delacroix au Maroc. Mission Universitaire et Culturelle Française, Rabat, 1963. On the Moroccan trip.

Deslandres, Yvonne, *Delacroix: A Pictorial Biography*. Translated by Jonathan Griffin. Thames and Hudson, 1963. A brief biography.

Escholier, Raymond, *Eugène Delacroix*. Editions Cercle d'Art, Paris, 1963. A comprehensive monograph.
Delacroix et les Femmes. Fayard, Paris, 1963. The women in Delacroix's life, with letters.
Delacroix: Peintre, Graveur, Ecrivain (3 vols.). H. Floury, Paris, 1926. A lengthy, early study, rare.

Huyghe, René, *Delacroix*. Translated by Jonathan Griffin. Thames and Hudson, 1963. The fullest recent account, well illustrated.

Johnson, Lee, *Delacroix*. Weidenfeld & Nicolson, 1963. A general essay on Delacroix's color theory and practice.

Sérullaz, Maurice, *Mémorial de l'Exposition Eugène Delacroix*. Editions des Musées Nationaux, Paris, 1963. The fullest modern scholarly catalogue, with illustrations of the 1963 memorial show.
Les Peintures Murales de Delacroix. Les Editions du Temps, Paris, 1963. On Delacroix's decorative projects.

ART-GENERAL

*Barzun, Jacques, *Classic, Romantic and Modern*. Anchor Books, Secker & Warburg, 1961. A study of Romanticism.

Baudelaire, Charles, *Art in Paris 1845-1862: Salons and Other Exhibitions*. Translated and edited by Jonathan Mayne. Phaidon, 1965. Accounts of art exhibitions.
The Painter of Modern Life and Other Essays. Edited by Jonathan Mayne. Phaidon, 1964. General critical essays.

Berger, Klaus, *Géricault and His Work*. University of Kansas Press, Lawrence, Kansas, 1955. A general study, with illustrations.

Brion, Marcel, *Romantic Art*. Thames and Hudson, 1960. A well-illustrated, international account.

Canaday, John, *Mainstreams of Modern Art*. Thames and Hudson, 1959. A general survey of 19th Century art.

Courthion, Pierre, *Romanticism*. Translated by Stuart Gilbert. (The Taste of Our Time) Zwemmer, 1961. A brief international account of Romanticism, illustrated.

Friedlander, Walter, *David to Delacroix*. Translated by Robert Goldwater. Bailey Bros. & Swinfen Ltd., 1969. A classic account of French painting in the early 19th Century.

*Hauser, Arnold, *The Social History of Art* (Vol. II). Translated by Stanley Goodman. Routledge & Kegan Paul, Ltd., 1969. A comprehensive survey of art in its social context.

Keyser, Eugénie de, *The Romantic West, 1789-1850*. Skira: Zwemmer, 1965. A richly illustrated essay on art in the context of cultural history.

Leymarie, Jean, *French Painting: the Nineteenth Century.* Skira, Geneva, 1962. A concise general survey; color illustrations.

Lindsay, Jack, *Death of the Hero: French Painting from David to Delacroix.* Studio Books, London, 1960. An interpretative study, emphasizing problems of subject matter.

*Praz, Mario, *The Romantic Agony.* Translated by Angus Davidson. Meridian Books, New York, 1956. The effects of Romantic literature on art.

HISTORIES

*Cobban, Alfred, *A History of Modern France 1799-1945: From the First Empire to the Fourth Republic* (Vol. II). Penguin Books, Baltimore, 1961. A useful reference.

Dictionnaire de Paris. Librairie Larousse, Paris, 1964. An illustrated history of Paris.

Maurois, André, *A History of France.* Translated by Henry L. Binse and Gerard Hopkins. Farrar, Straus & Cudahy, New York, 1956. A comprehensive one-volume history.

Sédillot, René, *A Bird's-eye View of French History.* Translated by Gerard Hopkins. George G. Harrap & Co., Ltd., London, 1952. A good outline of French history.

Sieburg, Friedrich, *La France de la Royauté à la Nation: 1789-1848.* Translated from the German by François Ponthier. Arthaud, Stuttgart, 1963. An attractively illustrated study of this period.

*Wolf, John B., *France: 1814-1919. The Rise of a Liberal-Democratic Society.* Harper Torchbooks, Harper & Row, New York, 1963. The rise of the French nation after the Napoleonic Wars.

MISCELLANEOUS

Alexandre Dumas, *My Memoirs.* Translated and edited by A. Craig Bell, Chilton Co. Book Division, Philadelphia, 1961.

Maurois, André, *Victor Hugo.* Translated by Gerard Hopkins. Jonathan Cape, London, 1956. Both of these writers were important to the cultural life of Delacroix's times.

Acknowledgments

The editors of this book are particularly indebted to Robert Rosenblum, Professor of Fine Arts at New York University, whose advice and suggestions in the preparation of the text and picture essays were invaluable.

They also want to thank: Catherine Belenger, Service des Relations Extérieures du Musée du Louvre; Henriette Bessis, Chargée de Mission à l'Atelier Delacroix; Arlette Calvé, Assistante au Cabinet des Dessins du Louvre; Editions Albert Skira, Zurich; Raymond Escholier, Vice-Président de la Société des Amis de Delacroix; Beatrice Farwell, Senior Lecturer, The Metropolitan Museum of Art; Charles Feld, Directeur, Editions Cercle D'Art; Reverend Father Girard of Saint-Sulpice; Madame Guynet-Pechadre, Conservateur, Service Photographique, Musée du Louvre; René Huyghe de l'Académie Française, Professeur au Collège de France; Raymond Laurent, Président Administratif de la Société des Amis de Delacroix; Jacqueline Le Clerc, Service des Relations Extérieures du Musée du Louvre; Maurice Sérullaz, Conservateur du Cabinet des Dessins du Musée du Louvre; Joseph C. Sloane, Chairman of the Department of Art, University of North Carolina, Chapel Hill; Sotheby and Co., Ltd., London; Thames and Hudson Ltd., London; The Wallace Collection, London.

The author wishes to thank Mr. and Mrs. Boris Mera and Raymond Escholier for their hospitality and helpfulness in preparing this book.

Picture Credits

Color photographs of most of the paintings reproduced in this book were made by Eddy Van der Veen especially for the TIME-LIFE Library of Art. Mr. Van der Veen received generous cooperation from the Louvre and other French museums, and from various individuals who are named in the acknowledgments. The initials EVV in the list below indicate his contributions.
All sources of illustrations in this book appear below. Credits for pictures from left to right are separated by semicolons, from top to bottom by dashes.

SLIPCASE: Eddy Van der Veen

ENDPAPERS: *Front:* Archives Photographiques
Back: Giraudon

CHAPTER 1: 10—Bulloz. 13—From *Histoire Générale Illustrée du Théâtre* by Lucien Dubech, published by Librairie de France, 1934, Vol. V, p. 14, courtesy French Institute, New York. 16—Bulloz. 18—Archives Photographiques—Giraudon; EVV. 21—Courtesy National Gallery of Art, Washington, D.C., Samuel H. Kress Collection. 22 through 29—EVV except 23 right: Dmitri Kessel and 24 bottom: Fernand Bourges.

CHAPTER 2: 30—Giraudon. 32—The Bettmann Archive. 34—EVV—Giraudon. 35—Bibliothèque Nationale, Paris. 38—Eric Schaal. 39—Bulloz. 41—Archives Photographiques. 42, 43—Jerry Cooke; Archives Photographiques—EVV; Archives Photographiques. 44—EVV—Giraudon; Archives Photographiques. 45—Giraudon. 46—Pierre Boulat. 47—EVV(2)—bottom right: Robert Morton. 48, 49—Photo courtesy Galerie Claude Aubry—EVV(2). 50 through 55—EVV except 54 top: R. B. Fleming courtesy National Gallery, London.

CHAPTER 3: 56—Giraudon. 60—Bulloz—A. C. Cooper, Ltd. 61—Skira. 62—EVV. 67—Bibliothèque Nationale. 68, 69—Left: Bibliothèque Nationale; Archives Photographiques—Durand-Ruel. Right: EVV—drawing by Enid Kotschnig. 70, 71—Giraudon except center top: Archives Photographiques. 72—Courtesy Fogg Art Museum, Harvard University, Bequest of Grenville L. Winthrop—Giraudon. 73—From *Delacroix* by René Huyghe © Thames & Hudson Ltd., London reproduced by permission of the Trustees of The Wallace Collection. 74, 75—From *Delacroix* by René Huyghe © Thames & Hudson Ltd., London except 75 top: Paul Jensen courtesy Mr. and Mrs. George Heard Hamilton. 76, 77—EVV.

CHAPTER 4: 78—Giraudon. 80—Courtesy National Portrait Gallery, London. 83—Roger-Viollet. 84—Giraudon. 85—Photo Hachette. 86—Archives Photographiques. 89—Skira. 90, 91—Lee Boltin courtesy Metropolitan Museum of Art, Rogers Fund, 1917. 92, 93—Giraudon; Archives Photographiques (2). 94—Archives Photographiques; Karl Roodman courtesy Metropolitan Museum of Art, Rogers Fund, 1922. 95—EVV. 96, 97—EVV; courtesy Art Institute of Chicago, Gift of the Potter Palmer Family. 98, 99—From *Delacroix* by René Huyghe © Thames & Hudson Ltd., London.

CHAPTER 5: 100, 101—EVV. 102—Bulloz—Bibliothèque Nationale. 104—Bulloz. 106—Archives Photographiques. 108—Archives Photographiques. 109 through 115—EVV except 112 left: Skira. 116—Yves Debraine. 117—Giraudon—EVV. 118, 119—EVV.

CHAPTER 6: 120—EVV. 122—Stickelmann, Bremen. 124—Paul Jensen and Robert Morton courtesy Stacks Coin Galleries, New York. 126—Archives Photographiques—Archives Photographiques courtesy Thames & Hudson Ltd., London. 128—Jean Marquis. 129, 130, 131—Bibliothèque Nationale. 132, 133—George Eastman House Collection, Rochester, New York—map by David Greenspan. 134, 135—Top: Archives Photographiques except Léon Riesener: Giraudon. Bottom: left—Archives Photographiques; center—Giraudon; right—Giraudon; Robert Morton courtesy Metropolitan Museum of Art, Bequest of Mrs. Grace Rainey Rogers, 1943—Ciccione from Rapho Guillumette; Bulloz. 136—EVV; Alan Clifton courtesy Mander and Mitchenson Theatre Collection. 137—Skira courtesy Phillips Collection, Washington. 138—Lund Hansen—EVV. 139—EVV.

CHAPTER 7: 140—EVV. 145—Archives Photographiques. 147—Archives Photographiques. 148—From *Catlin's Notes of Eight Years Travel and Residence in Europe*, London, 1848, 3rd edition, Vol. II, pl. 16, courtesy Brooklyn Public Library—EVV. 151 through 156—Marc Lavrillier. 157—From *Delacroix* by René Huyghe © Thames & Hudson Ltd., London. 158, 159—EVV. 160, 161—Archives Photographiques—from *Delacroix* by René Huyghe © Thames & Hudson Ltd., London. 162, 163—EVV.

CHAPTER 8: 164—EVV. 167—Archives Photographiques. 168—The Bettmann Archive. 169—Flammarion. 172—Bibliothèque Nationale. 173—Archives Photographiques. 175—Robert Morton. 176, 177—EVV. 178—Minneapolis Institute of Art photograph reproduced courtesy Private Collection. 179—Courtesy Art Gallery of Toronto. 180—Giraudon except left center: Archives Photographiques. 181—EVV. 182, 183—Courtesy Art Institute of Chicago, Potter Palmer Collection. 184 through 187—EVV.

Appendix: 188—Bulloz; courtesy Stedelijk Museum, Amsterdam—Museum of Modern Art photograph reproduced courtesy Mr. and Mrs. Victor W. Ganz, New York; courtesy Worcester Art Museum. 189—Archives Photographiques—courtesy Ari Redon; Robert Fraser Gallery photograph reproduced courtesy Collection Alan Power, London; courtesy Collection Mouradian et Vallotton—courtesy Galerie Charpentier; courtesy Metropolitan Museum of Art, Bequest of Mrs. H. O. Havemeyer, 1929, The H. O. Havemeyer Collection. 190—Chart by George V. Kelvin.

Index

Numerals in italics indicate a picture of the subject mentioned. Unless otherwise identified, all listed art works are by Delacroix.

xxxxxx

Printed in Spain by Printer industria gráfica sa Provenza, 388, 5.ª Barcelona-25 Depósito legal B. 327-1978